English Domestic Brass

Frontispiece: A mid-eighteenth-century Rococo kettle and stand. See Plate 204.

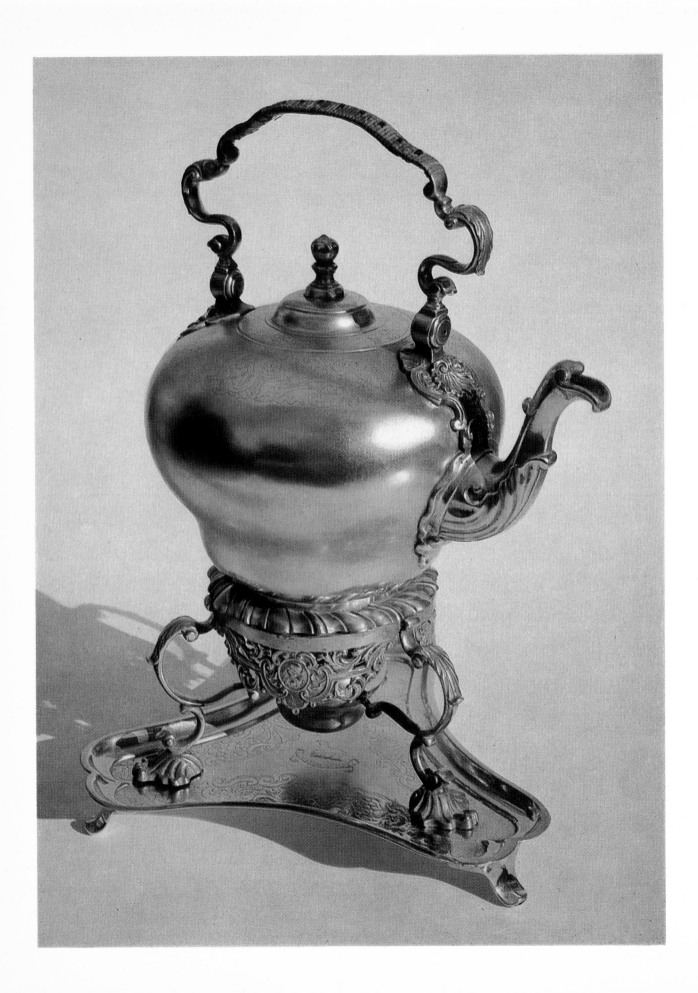

English Domestic Brass

1680-1810 and the History of its Origins

Rupert Gentle & Rachael Feild

Foreword by Graham Hood
Director of Collections,
Colonial Williamsburg Foundation

'. . . *for they are not looked upon to be of any
great worth in personalls, that have not many dishes
and much pewter, Brasse, Copper, and tyn ware;
set round about a Hall, Parlar, and Kitchen.*'

From a household inventory in Randle Holme's
Academy of Armoury, 1688

Paul Elek London

First published in Great Britain 1975 by
Elek Books Ltd
54–58 Caledonian Road
London N1 9RN

Copyright © 1975 Elek Books Ltd

ISBN 0 236 30906 4

Printed and bound in Great Britain by
The Garden City Press Limited
Letchworth, Hertfordshire SG6 1JS

For the folk in the little red hut on the hill
where all this began

Contents

The Illustrations

List of illustrations falling in the text

Foreword

Old brass has been collectable for about a hundred years now. Sensitive anti-quarians and collectors have recognised that it occupied an essential place in any reconstruction of the past, even if it never exhibited the brilliant virtuosity of furniture (and certainly never attained its nostalgic allure), nor embodied the precisely documentable characteristics of silver (or even pewter). Although brass lighting devices and hollow ware have not commanded much attention in the marketplace until recently, they have still been assiduously acquired over the last century. It is appalling that no serious and well-illustrated book should have appeared in all this time.

How conspicuously this volume fills the gap! Such a profusion of illustrated material forms a valuable resource in itself, while the combination of historical documentation and technological explication in the main text, and aesthetic com-mentary in the captions, completes the book's usefulness. It may well be another hundred years before a book comes along that is any better.

The authors trace the development of the English brass industry from Elizabethan times to its full flowering in the eighteenth century. Inventiveness in technology allied with inspiration in design to produce a multiplicity of attractive utilitarian objects that still have the feel of being well-made. From then on, it was a matter of ever greater production involving decreasingly satisfactory design. It was brass from Brum in the nineteenth century that made the great fortunes and gave the metal the bad name that it still labours under (more in England, I believe, than in America, which market the authors appropriately include and aim at).

It is fitting that the industry should have really started under the Virgin Queen, who gave her name to the initial colonising attempts in the New World. From the time that production became significant, in the late seventeenth century, through the succeeding century, America provided a significant market for the merchants. For example, in the fifteen years prior to the outbreak of the American Revolution, exports of wrought brass from a single English port, London, to just two of the colonies, Virginia and Maryland, averaged about 2,600 pounds sterling annually. When one thinks of what was exported to all the colonies from all of the English ports one sees the dimensions of a very sizeable industry.

Brass, of course, only rarely appealed to aristocratic tastes. Its history is dominated by the relatively anonymous middle and lower classes, making a book such as this even more difficult to write. It is to the authors' credit that this aspect of the metal is not ignored, and many wise saws and modern instances that are now part of English as it is spoken have been used in the text in illuminating ways.

This book has obviously been a labour of great affection. Not only are the authors antiquarians, with the keen eye for historical detail and enlivening anecdote typical of the genre, but they are also connoisseurs with a wide awareness of visual detail, and the strange things that can happen to inanimate objects to make them seem what

they are not. Certainly in this book the question of how much finely proportioned hollow ware was actually silvered or gilded at the beginning of its life is not begged. Whether a piece of brass that shows traces of silvering should be newly recoated is not, and may never be, decided.

More and more the voids in our knowledge of the past are being filled by good books such as this. When one thinks of how completely a normal part of life brass was in British societies in the eighteenth century, one is amazed that it has taken so long. But this book justifies the wait.

GRAHAM HOOD
Director of Collections
Colonial Williamsburg Foundation
Williamsburg, Virginia

1
Brass - the Two-Faced Metal

Brass is a base metal which looks like gold, yet has little intrinsic value. It is a decorative material with an industrial history, the origins of which are obscure and fascinating. Brass is an alloy of two metals, copper and zinc – yet though China was producing pure zinc metal in the twelfth century and probably much earlier, Europeans did not know how to distil zinc until the middle of the eighteenth century, and made their brass from lapis calaminaris, the crushed metallic ore. In the fourteenth century Austria, Germany, France and the Low Countries all had flourishing brass industries, and yet no brass was made in England until the end of the sixteenth century. Some of the few remaining examples of early English attempts at brass-making are still to be seen among church brasses. Up till the end of the sixteenth century brass plate was imported from Flanders and the Low Countries and engraved with those beautifully enigmatic figures by English engravers. But by the beginning of the seventeenth century brass of uneven thickness and inferior quality was being used, made by the first brass-foundries in England.

Apart from these few scattered examples little tangible evidence remains of the first hundred years of English brass-making, since during the Civil War accessible brass of all kinds was plundered by Royalist and Roundhead alike to make guns and ordnance. Yet from these late and unpromising beginnings, by the end of the eighteenth century England had grown to be the greatest brass manufacturer in the world, and English brass was supreme. Less than a century after its zenith, mass-production brought brass into such low repute that many of the finest objects made in England during the short period from the Restoration to the beginning of the nineteenth century were thrown on the scrap-heap, and along with them the reputation of brass as a decorative metal. This last calamity is mainly responsible for the lack of interest in brass among collectors until recently, and for the absence of any literature about this intriguing, underrated metal, whose origins belong in the hands of the alchemist, and whose downfall was its own popularity.

The history of most decorative art is relatively well documented, but tracing the ancestry of brass is difficult. Even the discovery of the alloy is obscure, and early references to brass tend to confuse it with bronze, which is undoubtedly of greater antiquity. Sand-cast bronze has been traced as far back as 3500 BC and the Hittites began to sink rudimentary shafts to mine copper around the Mediterranean. Tin came from the shores of the Aegean and from Iberia. The Phoenicians travelled to England for their tin in later centuries. Iron-smelting is believed to have been well-established in Mesopotamia before 2000 BC, and once the process of smelting and alloying tin and copper was perfected bronze was made and cast for doors and statues, ceremonial plates and ewers, for temples, tombs and palaces, by the

Egyptians, Greeks[1] and Romans. As the Romans added to their empire, the knowledge of mining and smelting spread across Europe, and silver, iron, lead, tin and copper, as well as coal and salt, were found and mined. Long before they succeeded in occupying Britain the Romans were using the old Phoenician trade routes from Brittany across the toe of England, trading Cornish copper and tin for Irish gold.

These ancient Western civilisations have left legacies of bronze statues and plate of a far higher standard than medieval European workmanship, for the secrets of making bronze and brass were lost in the turmoil of the Dark Ages, and only recovered in Italy in the thirteenth century. Bronze is a simple alloy of copper and tin, and it has a rich red-gold colour. But it is friable and breaks easily; it cannot be wrought like gold, and can only be cast. Brass, made from zinc and copper, is an alloy far harder to achieve than bronze, because of the difficulty of 'fixing' zinc, which is a very volatile metal. To make an analogy, brass is to bronze as steel is to iron: its production involves a greater knowledge of metals and a higher degree of skill. But that brass was being made in Europe, and perhaps even in England, before the Dark Ages, is certain. Pieces of Celtic horse trappings, brooches and pins have been recovered from the river Thames, dating from the fourth century AD: some of the rings from bridles and bits are made of iron encased in brass of a very yellow colour, showing that it is not copper mixed with small quantities of tin – a kind of bastard bronze – but a definite alloy of zinc and copper. From the way it has been worked it would appear to be thin sheet brass made with a high degree of technical skill.

The world after the Dark Ages was not sharply divided into East and West. The great middle kingdom of central Asia extended from the Hungry Steppes and Siberia in the north, to the Hindu Kush and Kashmir in the south; west to Turkey and the Mediterranean, and east to Mongolia and China – a civilisation infinitely more advanced than any other. The old Silk Road which ran from Peking through Samarkand and Baghdad to Damascus linked East and West with a river of trade which brought new materials and knowledge of many new skills into Europe from the Orient. At that time brass was being made in China, and in Persia, and in the Ottoman Empire. By the thirteenth century it was again being made in central Europe, but it is difficult to be precise about its manufacture. Here again references to brass and bronze are confusing, since most documents were written in Latin by scholars and monks, and the two words were interchangeable.[2] Before it became a science metallurgy was the province of the alchemist and therefore a hidden art; right up to the beginning of the eighteenth century brass-making was a closely guarded secret because the alloy so resembled gold, both in its colour and the way it could be worked.

In the Middle Ages the great mineral-mining centres of Europe were in Saxony, the Harz Mountains, the Tyrol and Bohemia, near the coalfields of Germany. The master-craftsmen who smelted and wrought the raw brass metal were centred at Dinant on the Meuse near Liège. This small town had a virtual monopoly in finished brassware until it defied the powerful Duke of Burgundy, who laid siege to it and destroyed it in 1466. In market towns and centres of commerce all over the Continent the cry of 'dindanerie' meant fine brass, and so much trade was carried on with England that the merchants from Dinant had their own guild hall in the City of London. After the town was destroyed Aachen took its place, and then Nuremberg,

though the Germans were never quite the equals of the master-craftsmen of Dinant.[3]

All brass made in Europe at that time was made with copper and crushed lapis calaminaris, zinc ore, with the exception of small quantities made with pure zinc metal from China; this was probably reserved for such trades as the scientific instrument makers. The first known reference to zinc as a pure metal was made by Paracelsus in the fifteenth century. 'There is another metal', he says, 'generally unknown, called zinken. It is of a peculiar nature and origin; many other metals adulterate it. It can be melted, for it is generated from three fluid principles; it is not malleable. Its colour is different from other metals and does not resemble others in its growth. Its ultimate nature is not to me yet fully known.'[4] Nor was the true nature of zinc known in Europe or the West, or the manner of its distillation discovered, until some two hundred years later. After the founding of the East India Company in 1600 small quantities of pure zinc were imported into England from the East under various names: 'tutenaque', 'tuttenego', 'calaem' and 'spiauter', from which it derives its generic English name 'spelter'.[5]

All trades of any consequence in England had a guild or company which checked the quality of goods, protected the trade from outside competition, established apprenticeships, elected masters, and kept records of their activities. Yet when brass at last began to be made in England in any quantity, no guild was established, no company founded, and there are no records of any check on the quality of finished brassware. And this at a time when controls of all kinds were strict, and the penalties often severe. Gold and silver were assayed, cloth was examined and stamped, raw wool checked for mixed staple, grain scrutinised, pewter tested for lead content, stamped and graded. But apart from weight checks on brass ingot, this enigmatic two-faced metal appears unmarked by Customs House or Assay Office. Some of the reasons will become apparent as the threads of its development are unravelled, but in one respect brass is unique. It is an industrial metal as well as a decorative material. It belonged to both worlds, yet came under the controls of neither.

The history of English brass begins in the reign of Queen Elizabeth I, at a crucial time for England. She was at war with Spain, the richest power in the world, her Treasury was empty, and she was isolated from the rest of Europe by religion, policy, trade and the sea. Moreover, the Spaniards were in the Netherlands, and the Antwerp wool market, on which England relied, was in total disarray. Spanish treasure ships were flooding Europe with such quantities of silver bullion from South and Central America that there was a slump in the whole elaborate trading structure of Europe, and all the traditional markets collapsed. England had always relied on trade with other countries rather than developing industries of her own. It must not be forgotten that Henry V had taken and held half France and nearly all her coastline, so that England had had no need to set up industries and foster crafts when all the resources of Europe were under her hand. But in the same year that Queen Elizabeth succeeded to the throne England lost Calais, her last toe-hold in France, and was thrown back entirely on her own resources.

Queen Elizabeth grasped one vital fact: Spain was not using her bullion to build up industry or develop agriculture in her own territories. She still had to buy her grain and her guns, and therefore her fleet of bullion ships was her Achilles heel. If England could build her own ships, make her own cannon and sink or capture enough Spanish galleons, she might even turn the tide and beat the Spanish. But first she had to become more self-reliant: weave her own cloth instead of selling raw fleece

wool, mine her own copper and make her own brass to make cannon and armaments. Queen Elizabeth began to formulate a mercantile policy for England which would make her more independent. The great German merchant banks had assumed great importance during the economic chaos of Europe, and the Queen turned to them for help. They had capital and expert knowledge of mining, smelting and brass-making. What is more, the northern Germans were Protestants – Lutherans – and were sympathetically inclined towards England. With their help, two great companies were founded by Queen Elizabeth and her Secretary of State, William Cecil, later Lord Burleigh: the Company of the Mines Royal, and the Mineral and Battery Works. The English brass industry has its roots in these two companies, which represented an important step in England's development from a purely pastoral country to an industrial nation.

From the foundation of these two companies in 1568 to the outbreak of Civil War in 1642 the history of brass is seamed with intrigue and beset by monopolies and petty politics like that of any other industry or trade of the time. But the brass industry was largely financed by foreign money and employed a large number of foreign workers, and so the story was further complicated by the peculiar climate of English economic development, as well as by religious intolerance and prevailing social unrest. The brass industry received little encouragement from Crown and Parliament, who did more to hinder the struggling existence of this particular trade than they ever did to help it. Individual branches of the trade were forced to accept poor-quality raw brass from the monopoly-holders, and huge quantities of zinc ore went abroad in exchange for copper which was imported to make cannon and ordnance although good copper was being mined and smelted by the Mines Royal in the north of England. And because of the large numbers of foreign workers employed in the brass industry, its growth was further complicated by special legislation for aliens who worked or traded in England.

It is possible to piece together some of the early history of the industrial face of brass from documentary evidence, but of its decorative face virtually nothing remains. During the Civil War both sides looted and plundered in order to maintain their respective armies. Silver and gold were melted down and minted into coin to pay the soldiers. Brass and bronze were ripped from churches in the name of the Lord, but more precisely to be cast into cannon. Plate and objects of craftsmanship which had survived until then as treasured objects in humble homes and Royalist manors alike were thrown into the melting-pot. At the end of the Civil War almost no trace survived in England of the results of the first fifty years of brass-making, except for a few candlesticks which were essential to life after dark under either King or Protector. And many of those that did survive were melted down later during the Restoration, when fashions flowered with a new elegance and new techniques and skills made it possible for craftsmen to work brass more beautifully and intricately than ever before. Elsewhere, some early examples of English brass have been preserved. Dutch and Flemish craftsmen and their families who had fled across the Channel to escape religious persecution in Europe, fled again across the vaster seas of the Atlantic during the Civil War when they found themselves embroiled in yet another conflict. A few pieces of early English brass have come to rest in museums and collections in America, the only tangible evidence of fifty years of experiment and setback, discovery and conflict, which marked the beginning of English brass.

With a few rare exceptions, almost all the early fine brass still to be found in

England dates from after 1660 and the Restoration. Between Queen Elizabeth's earliest efforts to make England independent and the end of the eighteenth century lies the tangled history of English brass – the history of England's industrial development in microcosm. A fascinating chain of chance and circumstance links England's late and chaotic development from a bankrupt, isolated island to her emergence as the world's greatest trading nation in just over two hundred years. Some of the links of that chain are forged of brass.

Notes

1 The Greeks obtained most of their copper from Cyprus, which takes its name from the Greek *kupros*.

2 The word *aes* was used to describe brass, bronze and copper. 'Brass' itself derives from the Saxon *braes*.

3 The central shipping port for finished brass goods until 1585 was Antwerp. When that city was finally crippled by levies imposed by the Spaniards, the brass trade transferred to Amsterdam and Rotterdam, and the great revival of Flemish brass began.

4 Paracelsus, *Liber Mineralum* II.

5 Georgius Agricola, *De Re Metallica*, 1556. Translated and edited by H. C. and L. H. Hoover, 1912. Confusion between the two metals zinc and Paktong arose because both were imported in billets and assumed to be the same. Paktong is in fact an alloy specially developed by the Chinese for its sonorous qualities and was used for making bells and gongs. Alfred Bonnin, *Tutenag and Paktong*, O.U.P., 1924.

2
The Mines and the Mines Royal

Up to the end of the Middle Ages crafts and industries in Europe developed in unexpected places, often far from any accessible markets, for very simple reasons. The raw materials were there, and the men who found them stayed to work them. If the land was good pasture, there would be sheep for wool, if there were vines, wine-making grew up round vineyards. Where there was timber, iron could be smelted, glass could be blown.

The folklore of the mountainous regions of northern Germany, Saxony and the Tyrol is peopled with dwarves and trolls who mined gold and silver, smiths who forged magic swords and armour, and dragons who guarded treasure in hidden caves beneath the mountains. Here, where the earth was barren and unkind, the people burrowed down into the dangerous underground regions for their riches. In these bleak rocky lands, the miners of Europe searched for precious metals, mined coal, forged iron, harnessed mountain rivers to drive their primitive machinery, and traded their raw materials down the main arteries of the Ruhr, the Rhine and the Meuse, into the flat lands of Artois and Flanders. Here lived the craftsmen, silversmiths and metalworkers, in scattered colonies and small pockets of civilisation which had escaped the destruction of the Dark Ages. Over the years these colonies had been gradually augmented by workers drifting north from the great Venetian centres, often following the glass-makers as they migrated with the shift of power away from land-locked Venice and her battles against the Turks, towards the Low Countries and their newly opened trade links with Spain's new conquests in South America.

But while other countries grew more skilled in making artifacts of every kind, making use of the networks of roads laid down by the Romans to transport their goods to trading ports and markets, England remained a pastoral country, depending almost entirely on wool for the nation's prosperity, leaving the rest of her natural resources untapped. There were a few exceptions: whoever owned the land owned anything that lay beneath it and some of the powerful aristocracy, like Lord Falmouth and Lord Leicester, owed their riches to the tin and coal which lay under their estates. Precious metals were the Crown's, however, and since time immemorial all mining rights for gold and silver had been vested in the Crown, which had preferred to rely on conquest and taxes rather than exploit the rich mineral wealth which lay under the home land. Copper, which is only to be found in conjunction with silver, had therefore also remained almost untouched. Edward III had brought over some German miners to work the copper-fields in Cumberland, but the workings were closed in the thirteenth century because of lack of funds. Henry VIII had needed bronze for cannon, and Lord Falmouth's land had yielded a little copper

as well as tin, but he was not encouraged to improve the mines, whose shafts flooded quickly and were soon abandoned. The rest of England's copper lay untouched: wool from the sheep which grazed over it paid for foreign copper to be brought in instead.

There were some profitable iron-workings in the Wealds of Surrey and Kent, traditional home of ironworkers, glass-blowers and charcoal-burners since Roman times, and some iron also in the Forest of Dean. The only mineral mined in any quantity was lead, which England exported through the Merchant Adventurers and her other chartered companies to Russia, Scandinavia, Turkey and Persia. In the main, though, England was content to sell raw fleece wool and unfinished cloth through Antwerp in exchange for brass from Dinant and Aachen, cannon from Portugal and the Low Countries, glass from Venice and Bohemia, wrought gold and silver from Genoa, woven cloth and linen from Flanders, wine from France and spices from the Levant.

The old trading customs must change if England was to become more self-supporting. Queen Elizabeth realised this, and ever since her accession she had been encouraging foreign craftsmen to come to England and set up their trades. Work of all kinds was desperately needed at home, for unemployment was a rising, piteous problem. Wool had become an obsession with the rich landowners. Sir Thomas More wrote in his *Utopia* that sheep were 'devourers of men. They unpeople towns and villages, turning the best inhabited places into solitudes; tenants are turned out of their possessions and either beg or rob. One shepherd can look after a flock which will stock an extent of ground that would require many hands if it were to be ploughed and reaped.' From our vantage-point we may be able to see that More's picture is one-sided, but many villages and hamlets were deserted as countrymen uprooted their families and left their homes to look for work. The monasteries and priories, once the haven of the poor and homeless, had all gone, and the dispossessed and drifting population converged on the cities at an alarming rate, sleeping in the streets and scavenging for food.

These were no starving people: these were the 'sturdy beggars' who frightened the townspeople and worried the Queen and her ministers. The Merchant Adventurers were implored, wherever they went, to seek markets which would take goods whose manufacture would bring employment to their countrymen at home. Foreign artisans were encouraged to come to England to set up their trades and teach the new townsmen their crafts, in particular cloth-making, dyeing, glass-making, and more delicate work such as ribbon- and silk-making.

But it was one thing to encourage small crafts and trades to cross the Channel, and quite another to find foreigners who would undertake major capital investments in England. And even if she could find the money to exploit her almost virgin mineral wealth, England had no knowledge of sinking deep mine-shafts, no experts in metallurgy to smelt copper and no machines to make the brass and bronze she now so desperately needed. Above all, copper was needed, and in huge quantities, to arm her fighting ships and drive off the Spaniards. The ironworkers in the Weald of Surrey had not yet discovered how to cast cannon in one piece – the cannon which were later referred to as 'one of the principal jewels in Elizabeth's crown' – and England was still dependent on Flanders 'brass' for ordnance. 'Brass' was in fact a misnomer, since an account of 1628 states that 'whereas bell-metal is composed of 20 lb. or 23 lb. of tin to 100 lb. of copper, the proportion for ordnance is 12 lb. of tin to

100 lb. of copper'. Although tactics at sea were changing, and Admiral John Hawkins's new fighting ships carried fewer cannon than, for instance, Henry VIII's *Great Harry*,[1] he relied on the long-barrelled culverins and demi-culverins for the passing broadsides and stand-off tactics which finally drove the Armada from the Channel. These cannon were cast in one piece – in bronze. With supplies of foreign copper denied her, England needed capital investment and experts in mining urgently if Elizabeth was to achieve her goal.

The richest and most powerful European merchant bank was the House of Fugger, which had at one time financed Henry VIII, but Queen Elizabeth had little hope of raising a massive loan, for England had no security to offer. But a certain Daniel Hochstetter, of Haug and Co., a subsidiary company of the House of Fugger, had had dealings in cloth and wheat in the City of London, and had expressed his interest in the possibilities of copper-mining to Henry VIII. At that time the House of Fugger had a virtual trade monopoly on copper ore in Europe, and was looking for new sources of supply to meet its heavy commitments; but as Henry had no intention of ceding his Crown mineral rights, nothing had come of Hochstetter's advances. William Cecil, Queen Elizabeth's Secretary of State, was aware of Fugger's interests, and shrewdly suggested to the Queen that if she now offered Haug and Co. her royal mining rights, she would not only get capital investment, but mining experts as well. And so, when Queen Elizabeth extended an invitation to Hochstetter and to Master Thurland of Saxony, leaving no doubt about her intentions, it was a foregone conclusion that they would be only too eager to come.

Daniel Hochstetter, his associate Hans Louver, Master Thurland and Ludwig Haug himself came to England from Augsberg in 1564 to negotiate mining rights with the Queen and her Secretary of State. Samples of ore from the mines in Cornwall and Cumberland were sent back to Aachen to be analysed by German chemists, and the Cumberland ore was found to have a far higher potential yield than had been expected. Hochstetter decided to reopen the old copper-mines in Keswick, Cumberland, and the following year another rich copper-mine was discovered in the Newlands Valley nearby. New shafts were sunk, and tools, machinery and equipment were brought to England. Furthermore, Daniel Hochstetter was given permission to bring in about four hundred German workers. The government was greatly concerned that the foreigners should be welcomed, and in view of the national conditions of unemployment and poverty, they had good cause to be concerned. A letter was sent from the Privy Council to the Mayor of Newcastle, instructing him and his officers 'that where there be presently certaine Almaynes, to the nomber of XL or L, looked for to arryve at that towne within theese X dayes, they are willed to cause the sayd Almaynes to be for theyr monny curtesly receyved and used, and by theyr good ordre guydyd and conducted from Newcastle to Keswyk in Cumberlande, the place where they ar appointed to rest and woorke.'[2]

Slate was quarried at Applethwaite and stone brought from Borrowdale to build houses for the foreign workmen. They were good houses too, and better than those of the dalesfolk, for the colony had its own glazier who glazed the windows of the smelters' huts, a luxury the English could not afford.[3] The 'Almaynes' were exempted from some taxes, given permission to fell timber for smelting, and allowed to police their own colony – privileges which led to considerable ill-feeling among the dalesmen, for there are several reports of riots and assaults, and Hochstetter himself complained that his workmen were being unfairly treated by the English.

But they were extremely businesslike at Keswick and keenly aware of what was needed to make the colony a success. In accounts kept for 1569 is the following entry: 'To Anthony Dediman, if he finds coal mines near Keswick, one and a half English miles from Smelt-houses, to have £20, of which now £4 in hand and 3/4 earnest money.'[4] Timber of all kinds was in very short supply and fuel for smelting was essential. Difficulties between the dalesfolk and the foreign workers gradually eased, and by 1567 nearly a score of marriages were recorded between German miners and English girls. Local trade was booming. Quantities of Spanish and German wine were imported into Kendal, Cockermouth and Newcastle, and a brewery was built at Keswick to supply the miners with good German beer.

Hochstetter had put up large sums of money and taken a big capital risk, and was now anxious to have his endeavours underwritten. In 1568 the whole undertaking was formally incorporated under the title of the Mynes Royall Society. Hochstetter and his associates were granted the sole right of mining all mines 'of precious metals' and sole rights to mine copper in the counties of Westmorland, Cumberland, Lancaster, Cornwall, Devon, Gloucester, Worcester, York and the Principality of Wales. The company was divided equally between English and German shareholders: 'the hole mass of the Minez Royall waz divided intoo xxiiij equal parts whereof Thurland, for the English, had xij parts, and Daniel, for the Straungersz, had the other xij. The English parts again divided too partnersz and intoo porcionz as foll'weth . . .' The original shareholders of the English 'porcion' included such men as the Earls of Pembroke and Leicester, Lord James Mountjoy, William Humphrey, Assay Master of the Mint and founder member of the Mineral and Battery Works, Thomas Smith, Customer of the Port of London, and the 'Lord Treazorer' Burleigh himself. As to the Germans 'the rezidu of the parts whearof most be at the dispozicion of Daniel, hoow he hath bestowed them or what remayneth with him, not yet certeinly known'.[5]

In 1569 the Earl of Leicester sent in some colliers from his Shropshire coalmines to work at Keswick, perhaps to ease local ill-feeling over the employment of so much foreign labour. These poor colliers were evidently in a state of bondage, not to put too fine a point on it, for there is an entry in the Keswick accounts: 'to the bailliff and two constables, watching the colliers that they should not run away'. Miners in Europe were masters, but in England they were considered little better than animals.[6]

Hochstetter and his family arrived to take up residence in Keswick in 1571, and he was at once greatly disturbed by the high cost of transport in England. He paid £8.10.0 to bring three coppersmiths half across Europe from Augsburg to London, and it cost him another £2.10.0 to get them up to Keswick, and that was by sea, which was far cheaper than by road. His plans to open up the Cornish copper-mines had to be abandoned, because the constant sea-battles up and down the Channel between the Spanish and English fleets made carrying fuel and ore by sea hazardous and impractical. Only two years later, far from having made his fortune, he was almost distraught by the prospect of bankruptcy. His luck turned at last when his associated company, the Mineral and Battery Works, made a good find of zinc ore in Nottinghamshire which opened up the possibilities of making brass at Keswick. He therefore sought permission from the Mineral and Battery Works, to whom Queen Elizabeth had granted the sole rights of brass-making, to incorporate a battery works at Keswick. Briefly, battery was the method of beating brass and copper into thin

sheets with huge water-driven hammering machines, and for making pots and pans and simple domestic hollow ware. The whole subject is dealt with in detail in the next chapter on the Mineral and Battery Works.

There was plenty of water-power from the Derwent to drive Hochstetter's hammering machines, and Keswick began to make finished brass and copper battery goods. A small amount of silver was found, and the lead-mines were also drawn into the organisation, which at its height was said to employ upwards of 4,000 men.[7] At the peak of Keswick's prosperity the list of its products was impressive, and included the production of chemical substances and raw materials for the production of glass 'colours of all kinds, oils fit for the lamps of princes and noblemen, enamelled and other earthenware etc., rock and various other mineral salts etc.'[8] as well as a wide variety of brass and copper ingot, plate, wire and rods.

The charter of the Mines Royal was the essential break in the Crown's stranglehold on mineral mining in England, but Hochstetter had not foreseen the difficulties, of investing in a country with no established industries, whose trading policies were ruled by the big merchant charter companies or governed by political expediency. In Germany Hochstetter could dispose of as much copper as his mines could produce, most of it to the brass industry. But in England brass-making was virtually non-existent when he opened the Keswick mines, and so slow to develop that at no time could it absorb enough English copper to make mining financially rewarding. And in spite of the fact that Hochstetter could not find enough buyers for English copper, the merchant companies continued to import Swedish copper in order to protect their trade routes to the Baltic.

These Baltic trade routes were particularly important to the Merchant Adventurers, who in 1567 achieved an incredible trading coup under the noses of both the Dutch and the Spanish by negotiating a ten-year contract with the Hanseatic League to trade in the Baltic. This was important in more ways than one, since all other trade routes from the Port of London meant that merchantmen had to run the gauntlet of the Channel, where Elizabeth's small but indefatigable navy was harassing the Spanish galleons in fierce sea-battles which greatly endangered peaceful shipping. The Merchant Adventurers could sail unmolested on their regular twice-yearly voyages from the Port of London, east across the North Sea, up through the Skagerrak and into the Baltic. It is not difficult to see why they needed to keep Sweden content and maintain trade with her.

Hochstetter's troubles were further exacerbated by the poor state of the roads and the exorbitant cost of transport. Most of his finished goods went by sea from Newcastle to London, since it was cheaper to ship goods coastwise than to send them by road to towns and cities in the provinces. But in London the merchants were interested in little else but wool and cloth, for which there was always a ready market. Though the Dutch could offer olive oil and spices from the Spanish trading ships in the Netherlands, and herring and whale oil from her 'fissery' fleets in the North Sea, English wool and cloth had little competition. Russia and the Baltic ports would buy quantities of the thick coarse cloth which England was now beginning to make herself and which the Dutch, now deprived of English short-staple wool, could no longer supply.

The big chartered companies often traded regardless of England's economic policies at home, in spite of repeated exhortations to heed their fellow countrymen's plight, and were too powerful to be controlled by Parliament. The Merchant

Adventurers were so influential at that time, and so skilled in manipulating European finance, that it is said they managed to delay the sailing of the Spanish Armada for a whole year by their dealings on the foreign money-markets. They took orders from no one, and traded their wool and cloth in exchange for whatever merchandise was profitable, whatever effect it might have on trade in England.

Over the years that followed Hochstetter tried every means at his disposal to take advantage of the rights incorporated in the Charter of the Mines Royal. He injected more capital, and when that failed, he leased his mining rights to individuals like Thomas Smith, a fellow shareholder, in order to try and revive the Cornish copper-fields. But Smith had no more success than Hochstetter, and the Cornish mines remained largely unproductive. Hochstetter imported his own merchants' cloth from Aachen to Newcastle and tried to create a market for it in order to recoup some of his outlay, but apart from the demand from his own workpeople for linen, woollen and sacking, he did very little business. The cloth-merchants did not take kindly to interlopers. His main problems were outside his control: continuing imports of Swedish copper, lack of interest in his merchandise among the big London merchants, and the disastrously slow development of the Mineral and Battery Works in setting up brass-manufactories which could take his copper. The gun-foundries of the Weald of Surrey had killed the demand for 'brass' ordnance with their great skill in casting iron cannon, and laws governing 'straungerz' trading did not allow him to export his copper to the Continent. For all Hochstetter's efforts, the only really successful venture of the Mines Royal Company was the Keswick colony.

In 1640 Hochstetter's descendants Daniel and Joseph were industriously working the Goldscope Copper Mine in the Newlands Valley when the Scottish Covenanters rose against Charles I and the first savage attack by their militia heralded the Civil War. Cromwell was still biding his time in London when the Covenanters swept over the Border, and he shrewdly judged it best to dissociate himself from their brutal attacks in Cumberland, Westmorland and Durham. It was not Cromwell's troops but the Scottish soldiers, fresh from their bloody battles as mercenaries in the Thirty Years' War, who attacked the Keswick mining colony. They gave no quarter and razed the colony to the ground, burning the smelt-houses and destroying the mines. Ironically, though the Mines Royal was a bitter target for anti-Royalists, all the workers at Keswick were Protestant, and many of them were foreign. Those who managed to escape quickly joined the anti-Royalist cause, but the damage had been done. More than fifty years' endeavour was wiped out and one of England's only sources of brass and copper was totally destroyed.

Notes

1 The armament of the *Great Harry* is listed as including four brass cannon, probably 50-pounders, three brass demi-cannon (32-pounders), four brass culverins (long-barrelled 17-pounders), two brass demi-culverins (9-pounders) and six lighter brass pieces. (Peter Padfield, *Guns at Sea*.)

2 Acts of Privy Council of England. New Series, vii, 1558–1570, p. 229.

3 *Elizabethan Keswick*. From the Keswick Journal of 1569. London, Collingwood, 1912.

4 *Ibid.*

5 List of shareholders presented to Mr Secretary Walsingham, 1580. Quoted in Grant Francis, *The Smelting of Copper*, 1881, pp. 35–6.

6 As late as 1565 Queen Elizabeth authorised the impressment of workmen into the mines. Men press-ganged into the navy were, to quote Admiral Vernon in the eighteenth century, 'condemned to death, since they are never allowed again to set foot on shore, but turned over from ship to ship.' Not until an Act of 1799 were miners totally emancipated from being bonded into service.

7 Moses Stringer, *Opera Mineralia Explicata*, 1713.

8 *The Resources, Products and Industrial History of Birmingham, and Midland Hardware District*, ed. Samuel Timmins, 1865.

3
The Mineral and Battery Works

The foundation of the Mines Royal Company was only one step towards Queen Elizabeth's ultimate aim of making England independent and able to manufacture her own brass and bronze instead of relying on foreign supplies. Copper was only one ingredient of brass, and the Mines Royal Company had no rights for mining zinc ore or manufacturing brass; in any case England was so backward in development that there were no machines available to turn raw brass into sheet, wire or battery goods. There were also other urgent problems to be solved. If the wool merchants were to be dissuaded from exporting raw fleece wool, they must be provided with woven cloth to sell instead; but such small quantities of cloth had been made in England before this radical change in trading policy that all the tools for the weavers had been imported from Flanders. Before cloth could be manufactured in any quantity, England had to make her own wool-cards, the most essential tool in cloth manufacture. And before she could manufacture wool-cards, she needed wire-drawing machines. For wool-cards were made of iron wire, or better still, brass wire, which lasted longer and did not rust.

The Flemish weavers of East Anglia were based on Colchester, where wool was made in considerable quantities, using combed long-staple wool which was made up into frieze cloth and worsteds. These weaving colonies, which date back to the fourteenth century when John Kempe of Flanders was granted letters patent by Edward III, also imported their wool-combs from Flanders. The combs were cumbersome affairs, shaped like a T and measuring at least 12 inches across. The teeth were like man-traps, set in four or five rows, each tooth about 9 inches long and viciously sharp. The wool was combed into long strands and then woven into fine soft materials. But there is about eight times more short-staple wool than long-staple in every fleece, and the bulk of raw wool was made up into 'cloth', thick felted material in which the warp and weft were indiscernible.

Wool-cards were like a handbrush or dog-brush, 5 inches long and 12 inches wide, with a stout leather or wooden backing into which the short wire teeth were set. The wool was brushed and teased until the short strands crossed in every direction, and then stripped off in fleecy rolls or 'slivers' each 12 inches long. The slivers were then spun into coarse yarn, a hundred slivers to a length. The 'cloth' made from carded wool was usually 'unfinished' or woven from natural undyed yarn. The cloth trade, which now began to supersede the wool trade, dealt almost exclusively in this material.

English cloth-makers, men like Thomas Blanket,[1] Jack of Newbury,[2] William Stumpe and Tuckar of Burford, each of them employing as many as five hundred people in all the various stages of weaving, were now encouraged by Parliament to

card and spin their own wool in quantity instead of relying on small cottage outworkers to provide them with yarn. The demand for wool-cards in the great sheep-rearing counties of England was therefore overwhelming, and if wool-cards could no longer be imported, they would have to be made.

William Humphrey, Assay Master of the Mint and one of the original share-holders of the Mines Royal Company, was in a good position to understand the implications of Queen Elizabeth's economic policy for England. At the same time as negotiations were proceeding with Hochstetter for the mining rights, William Humphrey was in close touch with a certain Christopher Schutz, head of a zinc-mining company in Saxony. In 1565 together they petitioned Lord Cecil for the sole right to mine zinc ore – lapis calaminaris. In return for this privilege Christopher Schutz undertook to bring into England water-powered machines for battering metal into sheets and for drawing wire. The only method of drawing wire in England at that time was incredibly primitive: two men sat on swings with a thin strip of iron or brass attached to a girdle fastened round their waists. Between them was a stump, or a heavy stone, and by pushing against the stump with their feet and pulling against each other the strip was laboriously stretched into wire. Now that wool-cards were needed in large quantities wire-drawing machines were essential, and it was this which interested William Humphrey more than the brass-making rights, for there were clearly large profits to be made in wire for wool-cards.

Two grants were issued to Humphrey and Schutz, one to mine for minerals in any county of England not reserved to the Mines Royal, and the other to set up brass and battery works and wire-drawing manufactories. Humphrey and Schutz had assumed that deposits of lapis calaminaris would be easy to find, but it proved more difficult than they had expected. Hochstetter, for reasons of his own, refused to co-operate, and the search for zinc ore became so protracted that Humphrey was considering entering into an agreement with Schutz to import it from Aachen when rich deposits were found in Somerset, in the Mendip Hills. As the wire-drawing works were to be the main source of profit, reasonable supplies of iron for iron wire would be needed until such time as brass could be made satisfactorily; fortunately, good deposits of iron ore were found in the Forest of Dean, and there was coal for smelting within a mile of Bristol. The Earl of Pembroke lent them Bristol Castle, and it seemed at first an ideal site. But the water-power available proved to be too weak to drive the new machines for drawing wire, and Humphrey and Schutz moved to a site near Tintern Abbey, on the banks of the river Wye.

In 1568 Humphrey's efforts were officially recognised by the Charter of Incorporation for the Governors, Assistants and Society of the Mineral and Battery Works. Although the Charter of the Mines Royal may have sounded the more important of the two, with its privileges of working precious metals and copper, in fact Humphrey and Schutz had pulled off a far greater coup: not only had they secured the rights to mine zinc ore in all the counties of England and Wales not granted to the Mines Royal – they had also been granted the sole right to manufac-ture and produce brass in ingot, sheet and finished battery goods as well as obtaining an exclusive monopoly in wire-drawing with the special water-driven machines supplied by Schutz.

Humphrey was clever enough to realise how necessary it was for him to obtain political as well as financial backing for the Mineral and Battery Works in the fast-changing climate of trade and industry, and he succeeded in persuading not only

the Lords Pembroke and Leicester and Lord Cecil himself to become shareholders in his new company, but also some of the new breed of wealthy merchants[3] who were looking for new outlets to invest their capital. For a while Humphrey's charter was divided into two parts, one dealing with wire-drawing, and one with brass-making. The two were separately financed and managed.

To begin with, the brass-making side of the company was not very successful; three years of trial and experiment passed before brass of a reasonable quality was being produced at Tintern, and by then Humphrey had lost interest. The wire-drawing works soon began to produce good quantities of iron wire, and naturally Humphrey was anxious to protect this side of his venture while his brass-making was still in difficulties. He tried to get a protective act through Parliament for manufacturing and supplying iron wire, but he was opposed by representatives of merchants who were importing wire and wool-cards from the Continent.

Mining zinc ore was not in itself a very costly business, for calamine stone lies fairly close to the surface, together with lead. But the preparation of the ore for smelting with copper was a lengthy and laborious process. The crude ore was first 'buddled' or washed, to get rid of earth and impurities.[4] When it had been washed and turned several times, the calamine stone and lead were separated and washed again in wire sieves. During this washing, the lead sank to the bottom, the dross floated to the top, and the calamine stone settled in the middle of the sandwich. The calamine and lead were separated by hand, and then the calamine stone was heated in calcining ovens, similar to bakers' ovens but much bigger. The ore was baked for four or five hours, dried, laid out on planks and beaten to powder with long iron hammers. This powder was then mixed with charcoal, moistened with water or urine (which gave the brass a better colour), fired once, removed from the furnace and stirred well 'with a crooked Instrument'. After that, salt was added and it was put into pots or 'pipkins' with small copper pieces and stood in great heat on a fire of coals. The resulting molten brass was poured off into a stone mould, or sometimes simply into a hole in the ground lined with stone, and allowed to cool. It needed years of practice and expertise to produce an alloy which was of the right colour and purity, and which would not break in the wire-drawing machines or crack under the pounding of the battery hammers.

Christopher Schutz was reputed to be 'of great Cunning, Knowledge and experience in the composition of the mix'd metal commonly called Latten'.[5] Latten[6] was sheet brass, sometimes called black latten or metal prepared. This meant that it did not have the marks of the huge battery hammers on it, but had been further finished by hand-hammering and 'planishing' with dish-shaped hammers. Latten was used for making simple containers with folded joints, frequently cylindrical in shape, with flat or rounded bottoms, and was the material from which all domestic hollow ware was made, as well as larger vessels for tanners, dyers, brewers, distillers and makers of all kinds of everyday commodities. Making battery goods required considerable skill and, like Hochstetter, Humphrey and Schutz brought workers over from Germany to operate the machines, make finished brass goods and teach their skills to English workmen.

It seems that Humphrey had little patience with the brass-making side of the works at Tintern, though he did lay out some extra capital in order to build houses for his German workers for fear they would leave him and return home. In the main, however, he concentrated on the extremely lucrative iron-wire works, and left the

brass-making venture to grind to a halt. Mounds of crude calamine ore were left lying about in heaps near Tintern Abbey, and were used up many years later to repair a dam. Although brass of all kinds was desperately needed, Humphrey had a rich market for iron wire on his doorstep, and when he found that brass-making was complicated and difficult, he neglected it almost entirely in favour of drawing iron wire to make wool-cards for the cloth-making counties of Wiltshire, Gloucestershire, Somerset and Devon. Imported brass wire cards might be far better, but Humphrey's iron wire cards were cheaper and far more easily available. Transport to the main market centre, Gloucester, was almost entirely by water up the Severn Estuary. The new wire-drawing machines could turn out wire of varying thicknesses at good speed: strips of sheet metal were fed into holes in an iron block to produce the required thickness, and drawn through by a water-driven wheel. It was not surprising that Humphrey did not persevere with making brass when he had such a profitable captive market for iron wire on his doorstep.

In 1582 the Mineral and Battery Works leased that part of their grant which concerned brass-making to John Brode, Alderman Martyn, Andrew Palmer and a group of other interested investors. John Brode had been experimenting with brass-making for several years, and had succeeded in convincing Alderman Martyn that it would be an excellent investment for his capital. A brassworks was set up at Isleworth, and Brode, evidently more skilled than Humphrey, soon made a success of the business. But he failed to honour his agreement to work with Martyn 'for the good of both' and began some double-dealing which led to argument and litigation. The case was eventually taken to the Privy Council, who ordered that 'the said Brode shall not at any time hereafter take in hand the use of the Calamine stone or exercise or use any of the engines or tooles which heertofore were practised, put in use or anyway used by Christopher Schutz and William Humphrey.'[7] This extreme decision was only taken after Brode had been given several chances of setting matters right financially, because both the Mineral and Battery Works and Lord Burleigh were most anxious to foster all brass-making enterprises.

By this time the good prospects for brass-making in England had attracted the attention of other investors, in particular a group of Dutch merchants.[8] The Dutch were to play a vital rôle in the whole history of English brass, both as craftsmen and investors. Over the succeeding years they brought machinery and techniques into England which had been in use for many years in Europe but were still unknown to English metalworkers. In 1596, Abraham van Herwick, a Dutch merchant, was one of the principal leaseholders of a new agreement made by the Mineral and Battery Works for a brassworks at Rotherhithe – and so became one of the first of many Dutchmen to be directly involved in the English brass industry.

In 1597, in an effort to encourage brass-making in England, all official imports of wool-cards from Germany and the Low Countries were banned. This had little effect on the big charter companies, however, and the irrepressible Merchant Adventurers' trade journals of 1601[9] show that they were still in the habit of importing copper and latten, wire, toys, pans and kettles in considerable quantities into the Port of London. These big companies were still a formidable obstacle to the shaping of a new mercantile policy, and however hard Parliament tried to help the struggling infant brass industry it was unable to control the merchants, who still traded very much on an *ad hoc* basis and did more or less as they pleased.

Other conflicting interests bedevilled the Mineral and Battery Works, which had

the problem of trying to protect their own interests against foreign imports of brass, while at the same time failing to produce raw brass of a sufficiently high standard to satisfy the craftsmen who worked it. The wire-drawers, wool-card makers, girdlers, buckle and clasp makers and the pin-makers protested again and again that they would prefer to work imported brass rather than the poor-quality metal being supplied by the Mineral and Battery Works. Just what was wrong with English brass is not precisely stated; but in particular the pin-makers were vociferous in their demand for foreign wire instead of the rough metal they were being forced to use as a result of bans on imported brass. The pin market was a large one, and the pin-makers were a powerful pressure-group, organised into a company, which most other trades using brass were not.

The use of the term 'brassworks' in the sixteenth and seventeenth centuries is confusing, since it was applied both to the places where the raw material was made and cast into ingot, plate and sheet and to the manufactories where wire was drawn and raw brass was made into finished merchandise. Both Tintern and Rotherhithe would appear to have made cast plate and ingot which they sent to small groups of outworkers who in turn made it into finished goods. These two brassworks also seem to have made sheet and wire. Foreign wire could be bought from merchants, however, when it was available, and small groups of people could set up 'brassworks' of their own, using foreign wire to make finished goods themselves. These small independent 'brassworks' often farmed out small quantities of wire and sheet to outworkers to return to them as finished goods which they in turn sent to the merchants. Thus it was extremely difficult for the Mineral and Battery Works to protect themselves against every infringement of their privileges, and a number of pirate 'brassworks' were set up at the beginning of the seventeenth century.

One such establishment was run by an enterprising gentleman by the name of Steere, who was himself a merchant employing outworkers to make mousetraps, birdcages, chains, rings and kindred delights, using imported brass wire. He set up a highly productive brassworks at Chilworth, near Southampton, keeping within the letter of the law by using horses to drive his wire-drawing machines instead of water, which was a method exclusive to the Mineral and Battery Works. However, he soon found that horses were not strong enough to drive the machines, and he adapted them to be driven by water-power. Immediately the Mineral and Battery Works pounced. Instead of encouraging Steere to use their own raw brass and so increase their business, they took him to the Court of Exchequer, and in 1603 Steere's brassworks 'passed into the hands of the Company'.[10]

James I, struggling to raise money through an increasingly unco-operative Parliament, gave his active support to the Mineral and Battery Works, no doubt hoping that home-produced ordnance would be easier to lay his hands on for his unpopular wars than imported cannon. In 1609 he gave additional privileges to the Mineral and Battery Works, and in the Acts of the Privy Council for 1613–14 he declared himself much concerned 'both for the honor and benifite of the realme, to have those workes [i.e. brass and copper works] continued and set on foote, being by meanes thereof furnished with brass both for the offyce of the ordnance and other necessarie uses of this estate, which formerlie wee stood in want of, and could not bee provided of, but by favour of divers forraine princes, and that oftentimes upon unequall condicions'.[11] Naming no names, the 'forraine prince' mostly responsible for the 'unequall condicions' at that time was the King of Sweden, whose

brass-merchants were exporting brass wire to England at £5.5.0 a cwt. and forcing the English brassworks to bring down their prices to compete. As soon as English brass reached this low price, the Swedish merchants immediately increased their price again, knowing that English brass-workers would buy their brass whatever the cost.

Steere was not the only one to encroach upon the privileges of the Mineral and Battery Works. Two very enterprising ladies, Dame Mary Hamilton and Dame Elizabeth Savage, managed to set up a thriving brassworks near one of the calamine fields, using imported copper from Sweden. In 1635 they claimed 'to have attained to perfection in the manufacture [of brass] whereby the plenty of calamine here lately found may have fuller vent'.[12]

The case of Mr Lydsey provides a good example of the political intrigue which crops up again and again in the history of the first hundred years of the brass industry. In 1630 Lydsey leased the rights of a brassworks from the Mineral and Battery Works, and in 1635 he paid £500 out of his own pocket for the renewal of the pin-makers' charter, which they had allowed to lapse. In return, the pin-makers guaranteed to take 200 tons of brass wire annually from his brassworks. Lydsey then successfully petitioned Parliament to forbid the import of foreign wool-cards and wire, and to increase the duty on imported raw brass. A Parliamentary proclamation declared that the manufacture of brass wire was an essential industry and that English wire was superior to foreign 'especially for the makeing of goode and stiffe pinnes whereof great quantities made here have of late been transported out of this kingdom'. Some quantities of English pins had indeed been exported because the pin-makers were dissatisfied with the quality of metal from which the pins had been made.

Lydsey, having eliminated foreign competition and with the pin-makers in his pocket, at once raised the price of his brass wire from £6 to £8 a cwt. The pin-makers bitterly regretted the agreement they had made with Lydsey, for they were now in a helpless position and it seemed as if they would have to pay his price. However, they enlisted the help of the Merchant Adventurers, who were only too willing to help them. At that time they were importing a staggering amount of brass wire, toys and other goods from Aachen, to the total value of about £40,000 a year. The pin-makers and the Merchant Adventurers jointly brought a lawsuit against Lydsey to break his stranglehold on supplies of brass wire. Charles I personally intervened in the dispute, hoping to reconcile the two sides, and at the same time seeing the possibility of culling a profit and replenishing the royal purse, which was yet again dismally empty. In an elaborate agreement, the pin-makers agreed to buy wire direct from the King at a fixed price of £8 a cwt. The King in turn would buy it from Lydsey at £6.12.0 a cwt. and would impound all foreign wire to protect everybody's interests.[13] But as this agreement was only reached a few years before England erupted in Civil War, nothing came of it in the end, and the Pin-Makers' Hall, which Charles I promised them for good measure, was never built. But cases like this one serve to show the total lack of co-operation in the brass industry as a whole, and go a long way to explaining the slow progress it made in the first hundred years of its development.

To be fair, the Mineral and Battery Works had difficulties of their own. In order to make brass, two minerals had to be mined, and copper and calamine were found in different parts of the country. Transport, preferably by water, had to be found to take the crude ore to a site where there was coal for smelting and water-power to

drive the wire-drawing and battery machines. The site of the brassworks itself had to be within easy reach of the metalworkers and the markets which it would supply with finished goods. No wonder the officers and governors of the Mineral and Battery Works tried to impose tighter restrictions and protect what little progress they did manage to make. No wonder they were jealous of the few markets to which their finished goods had access. And no wonder, either, that interlopers were a constant threat. One symptom of the growing challenge to the Crown in the years before the Civil War was the open flouting of exclusive privileges granted by it. In the brass trade it was a simple matter to buy up foreign brass in its raw state and open up a brassworks employing a handful of aliens. If 'shruff', or scrap brass, was melted down with newly-smelted raw brass, who was to say whether it came from abroad or from the Mineral and Battery Works' brassworks? The personal intervention of the King was of little help in protecting the fragile monopoly in raw brass, and the hard-eyed men who were gathering in Parliament under Cromwell's leadership had other, more pressing business than the protection of the interests of the Mineral and Battery Works. The brass industry as a whole was left to manage as best it could.

Notes

1 The blanket is erroneously attributed to Thomas Blanket, but it is more likely that he took his name from it: in 1382 the Sheriff of Lincolnshire bought cloth 'at the rate of 3s. for an ell of blanket'. Thomas Blanket lived 150 years after this date.

2 Real name John Winchcombe – a legendary figure who still held pride of place as central effigy as late as the end of the seventeenth century in the London cloth-workers' pageant.

3 A sixteenth-century writer complained that 'the breeding of so many merchants in London, risen out of poor men's sons, hath been a marvellous destruction to the whole realm' – meaning that money was no longer confined to the rich guildsmen. In addition, there were laws circumscribing profits made by 'aliens' ensuring that their money was reinvested in England and not sent abroad.

4 Georgius Agricola, *De Re Metallica*.

5 Moses Stringer, *Opera Mineralia Explicata*.

6 *Laiton* is still the French word for brass.

7 Acts of Privy Council of England, xxvii, 1597.

8 Alien merchants were strictly controlled in their attempts to invest in England's basic trades and commodities. The brass industry in England, itself an outlandish affair at that time, was not restricted to English investors alone, since it was founded on foreign money.

9 A. Anderson, *An Historical and Chronological Deduction of the Origins of Commerce*. London, 1787.

10 See *Victoria County History – Surrey*.

11 Acts of Privy Council of England, 1613, 1614.

12 Quoted in Henry Hamilton, *The English Brass and Copper Industries to 1800*.

13 State Papers – Domestic, 1639–1640 Calendar.

4

Fuel and Fire:
Brass in the Interregnum

The foundation of the Mines Royal and the Mineral and Battery Works at the end of the sixteenth century coincided with a serious timber shortage in England. Not only was there scarcely enough good timber to build 'the wooden walls of England' and provide Elizabeth with a fleet of ships to set against the huge Spanish galleons: in many parts of England there was also an acute shortage of wood for charcoal and fuel. The charter companies received instructions from the Queen to search for wooded shores which might provide good timber for the shipyards, but there was little that could be done to provide enough charcoal for hearths and furnaces. At that time charcoal was the only fuel which produced enough heat for smelting, for the use of coal was not yet fully understood in England.

It is unfair to blame the glass-blowers for the shortage of timber for charcoal, as many have done, since they only 'lopped and topped' following in the wake of the ironworkers, using timber which was too small for the iron-foundries. The iron-workers were stubbornly conservative, and even when other metalworkers had begun to use coal quite successfully, in many parts of the country the ironworkers continued to use charcoal, regardless of exhortations from Parliament, until they were finally forced by law in 1615 to stop using wood in their 'blow houses' and blast furnaces. Long before then, local acts prohibited tree-felling to conserve the little standing timber that remained. But in many parts of the country timber was in such short supply that forges and hearths grew cold and iron and steel could not be smelted. Even cooking became a communal affair, with families depending on bake-houses to cook their dinners.

As the crisis grew, the iron-masters and metalworkers began to experiment with different kinds of fuel to fire their furnaces. By the time the act was passed in 1615 there were probably many foundries and steelworks using a variety of different methods to smelt and cast. The Keswick colony certainly knew how to use coal for smelting, for their 'Shrovetide Reckoning' of 1569 includes regular entries for 'sea or stone coal' in considerable quantities. '92 horse loads at 3/4d; carriage of 42 loads Cockhermut to Keswickh at 9d. and 50 to Smelthouses at 10d. 30 horse loads from Worckhingthon . . .'[1] But it was not until 1632 that an Englishman, Edward Jorden, took out a patent couched in the most patriotic of terms:

Whereas Edward Jorden, Doctor in Phisick, by his Peticon to us exhibited, hath informed us that the great quantity of tynne, iron, lead and copper w'ch hath bene and is made within theis our dominions, the oare hath ever hitherto bene melted with wood or charcole, w'ch in tyme wilbe a great destructon of the woode of this kingdome, and that he, by his industry, hath found out A Way to Melt Tynne, Iron, Lead and Copper Oare with Pitcoale, Peate and Turffe, and will

therewith extct out of like Quantities as much or more than can be made with any Fewell, and do it with much lesse charge than is nowe expended in melting same.[2]

And in 1633 a group of Germans, Dutch and Englishmen, namely 'Williams, Van Wolfen, Hanchett, Van Wolfen, Williams, Reignolde, Browne and Van Wolfen',[3] found another way of preparing fossil fuel to make it suitable for smelting. It was not until 1636, however, that Sir Phillibert Vernatt discovered a means of 'makeinge, melting or smelting, casting, founding, fineing, nealinge, beating and workeing of iron, steele, brasse, copper, tynne, lead, and all other kind of oar-mettles . . . with fire of sea cole, pitt cole or stone cole . . . without mixeing the same with charcole or charking the said sea cole'.[4] 'Sea cole' was not a marine variety of fossil fuel, but simply coal which had been brought by sea from the coalfields. Supplies of coal now became an integral part of the setting up of any smelting-house or brassworks, thus adding to the complications of transport.

However, at the beginning of the Civil War in 1642 the various components of the brass industry had begun to establish themselves with reasonable efficiency in geographical locations where waterborne transport was available for the heavy traffic of ore, coal and raw brass. There was a big smelting works at Neath, using Welsh coal and supplied by calamine from the rich fields in Somerset which came by water up the Avon and then by sea to Neath. There were wire-drawing works at Tintern, using iron from Wales of a special quality known as 'Osmond' iron. The almost independent Keswick colony was flourishing, and there was a brass and battery works at Nottingham which also drew wire and made wool-cards. Copper was being mined in Cornwall, Wales and Cumberland, and calamine in Somerset and Nottinghamshire. There was also coal in Cumberland, Wales, Staffordshire, Tyneside and the Forest of Dean, all reasonably accessible by waterborne transport to the brass- and copper-smelting works. Supplies of heavy raw materials into the Port of London were well established, and smaller brassworks, started by lessees of the Mineral and Battery Works, had been established at Chilworth, Rotherhithe and Isleworth, where battery goods were made and brass sheet was hand-hammered into latten and planished before being worked up into small articles by outworkers.

The Civil War destroyed these promising beginnings. Apart from the desecration of Keswick and the laying waste of England's only flourishing and profitable copper-mines, whole parts of the country were cut off, so that supplies of raw materials could not be transported to the smelting-houses and brassworks. Cornish tin and copper stayed in Royalist hands, while the coalfields of Staffordshire, Tyneside and Newcastle, and the brass and battery works at London, Nottingham and Bristol were in Roundhead territory. Brass-making, with the exception of guns and ordnance made from looted plate by both sides, was virtually at a standstill.

There had been a steady trickle of foreign workers leaving England ever since the discontent and unrest of Charles I's reign first became apparent, and with the advent of Civil War it rose to a flood. Not only foreign immigrants, newly arrived in England after fleeing from the Thirty Years' War, but disillusioned Englishmen, weary of the atmosphere of civil and religious discord, took ship across the Atlantic. The English do not readily leave their island, nor did the newly settled foreign workers want to uproot themselves again, but conditions in England had become so uncertain that in the first few decades of the seventeenth century over 80,000 English-speaking emigrants risked a hazardous passage across the Atlantic in search

of a new and freer world. By the end of the Civil War skilled metalworkers were scarce.

During the Interregnum the rich Royalist guilds, companies and foundations were heavily taxed to raise funds for Parliament; by the end of the war, members of the Mines Royal Company had been so severely penalised that practically all its operations were suspended, and there was no money available to resuscitate the copper-mines. Such was the state of the brass-making industry in 1649 that an order was given to one of the state brass-founders for casting a hundred pieces of iron ordnance and only *ten* of brass, with Parliament undertaking to find the brass.[5] With these hundred pieces of iron ordnance and ten of brass, Cromwell set out for Ireland, where he forfeited all claim to the title of 'Protector' with the bloody massacres of Drogheda and Wexford.

On the Continent, the Thirty Years' War had dragged to an end, and a new crop of 'straungerz' began to cross the Channel, seeing England as a Protestant haven in a Catholic-dominated world. There were clearly good prospects for men with knowledge – and capital – in a country whose trade was dislocated and whose merchants were a growing power in Parliament. Daniel Dametrius and Jacob Monomia were two of the many aliens who arrived in England in 1649. They settled in Esher, where they opened a brassworks on which they laid out no less than £6,000. The business flourished, but in about 1688 'to their own ruin and to the prejudice of the kingdom in losing so beneficial an art, having here the best copper and calamine of any part of Europe'[6] the Esher works were closed. The records give no hint of the reason. But that year James II's Catholic excesses reached their height, religious persecution was at its worst, hangings and deportations were instigated and there was again talk of Civil War. London was perhaps no longer a healthy place for avowed Protestants.

Little attention was paid to the plight of the mines during the years of the Commonwealth. Cromwell was intent on uniting England with other Protestant causes in Europe, and trade was left to look after itself. The merchant fleets were again endangered, both by the Dutch, who went to war against the Navigation Acts of 1652, and by the Royalist English navy which had turned privateer and harried both sides impartially in search of likely prizes. In 1658 Cromwell sent a contingent of English soldiers to Flanders and succeeded in capturing Dunkirk, which England held until Charles II sold it back to France under the ignominious Treaty of Dover in 1662. But for four years Dunkirk was an English foothold in Europe, as Calais had once been, and the flow of Dutch and French Protestants increased.

The Dutch influence in England was strongly reinforced by the patronage of the King himself who, on his restoration to the English throne, brought his own court painters, silversmiths and cabinet-makers with him from his exile in The Hague. With Charles II came also Prince Rupert, his brilliant cousin and field commander of the Royalist troops during the Civil War. For a time at the beginning of the Civil War Prince Rupert had succeeded in holding Bristol against the Parliamentarians, and here, in the original headquarters of the Mineral and Battery Works, where brass-making was one of the principal trades, Prince Rupert had an opportunity to indulge his interest in metallurgy. He discovered a new alloy, 'Prince's Metal' or 'Rupert's Metal', but guarded it so jealously with protective patents that the secret of its composition died with him. He also devised a new method of boring cannon which was put into use at the Temple Mills Brass Works at Hackney Marsh.

Amongst many other favours Charles II made him Governor of the new United Societies, formed in 1668 from an amalgamation of the Mines Royal and the Mineral and Battery Works companies.

In spite of the fact that England had suffered the bitter effects of Civil War, had executed her King, formed a Commonwealth and, in 1652, provoked war with the Dutch – the first purely mercantile war, fought in the name of neither patriotism nor religion – she was by now the hub of much of the shipping and trade in Europe. Though England's industries suffered, both during and after the Civil War, through lack of capital and disruption of working communities, trade prospered under the democratic ideals of the Commonwealth. Records of the great storm of 1661 provide a fascinating chronicle of the shipping which lay in English waters at one time.

At this time it happened that, together with the Russian fleet, a great fleet of colliers, near 400 sail, were just put out of the river Tyne; these being deep unwieldy ships, met with hard measure, though not so fatal as expected. Such of them as could run into the Humber got shelter under the high lands of Cromer and the northern shores of the county of Norfolk; the greater number reached Yarmouth Roads. At Grimsby, Hull, and other roads of the Humber lay about 80 sail. At Yarmouth there rode at least 400, mostly laden colliers with Russian men, and coasters from Lynn and Hull. In the Thames, at the Nore, lay about 12 sail of the Queen's hired ships and store ships, and only two men of war. Sir Cloudesley Shovel was just arrived from the Mediterranean with the Royal Navy. With 12 of the biggest ships he was coming round the foreland to bring them to Chatham. At Gravesend there rode five East Indiamen and about 30 sail of other merchantmen, all outward bound: in the Downs 160 sail, merchant ships outward bound. At Portsmouth and Cowes, three fleets, transports and tenders bringing the forces from Ireland that were to accompany the King of Spain to Lisbon, victuallers' tenders, store ships and transports and 40 merchant ships – in all almost 300 sail. In Plymouth Sound, Falmouth and Milford Haven were several small fleets of merchant ships, homeward bound from the islands and colonies of America. The Virginia Fleet, Barbadoes Fleet and some East Indiamen lay in one port; in Kinsale in Ireland there lay near 80 sail of homebound West Indiamen not yet unladen.[7]

This prosperity and growing trade was laid low by the doubleheaded axe of Plague and Fire a few years later.

The Plague was greatly feared by every country in Europe. As it took hold of London, European countries imposed embargoes on London for their own ships, and forbade English merchantmen to dock in their ports. Neither France, Holland, Spain nor Portugal would touch any ship from London, or any merchandise which had been packed or handled by people who might be infected, for the Plague was contagious. The Port of London came to a standstill, except for coastal traffic. Coal came in from Newcastle, and grain from East Anglia, but the ships discharged their cargoes down at Gravesend, not daring to come closer. Exaggerated reports and rumours of the state of affairs in London were, regrettably, encouraged by Dutch traders who took advantage of the situation and sneaked into several markets which had traditionally been held by the English. In retaliation the merchant companies moved their headquarters to the outports which were not affected by the general ban on ships from the Port of London. Bristol, Exeter, Liverpool, Manchester and Plymouth were used by fleets plying across the Atlantic to the American colonies, the West Indies, Spain, the Canaries and Guinea. Colchester, Yarmouth and Hull

took up the trade with Holland, Hamburg and the Baltic. Before 1665 some of the outports, in particular Bristol and Liverpool, had had subsidiary offices and warehouses to the big companies' headquarters in London, but all the main business of trade had been centred on the Port and City of London.

During the Plague Year manufacturers tried to keep their workers employed, stockpiling goods against the time when the Port of London would again be open. But only the richer clothiers and weavers, dyers and spinners could afford to keep their workrooms open and pay their workers. Up and down the country small craftsmen employing only a handful of people went bankrupt and closed down. The warehouses could hold only so much, and when they were full there were no more buyers. And then came the Fire of London, destroying all the warehouses stacked with goods, waiting for the ban on English shipping to be lifted.

The dreadful toll of Plague and Fire was reckoned in hundreds of thousands of deaths, and in a nation of only five and a half million, the loss of life was catastrophic. So too was the loss of markets abroad and valuable merchandise at home, and the complete disruption of industry, which took many years to recover. Events in the brass trade reflected the state of industry as a whole: 'Vagabondious persons, void of habitation, were travelling from place to place, collecting old [wool] cards from which they drew out the teeth, scoured them, turned the leaves of the cards and reset the teeth in them, fixed them on new boards, and having counterfeited the marks of substantial card-makers, sold them to the country people.'[8]

The brass industry suffered badly, from loss of money, craftsmen, and markets, and in 1668 the newly formed United Societies petitioned Parliament for assistance, couching their appeal in terms of ordnance, which both the King and Parliament were anxious to procure to fight the Dutch at sea. English brass, they declared, was a special case, and it was no longer possible to tolerate the traffic of calamine stone to Sweden in return for imported Swedish copper and brass. Good English pins were being sold abroad – to Spain, France, and Germany – because of Swedish imports, they said. If the brass and latten wire trade were encouraged, the United Societies argued, then the country would have the security of a native supply of brass for ordnance. But Parliament chose not to help. For one thing the United Societies, like the old Mineral and Battery Works, were not being very successful in producing good enough raw brass; the brass-workers objected to the low standard, organised themselves into trade groups and formally protested at the poor quality of English brass, and did not help the United Societies' case with Parliament when they declared they would prefer to work the better metal imported from Sweden. To protect their interests, the United Societies again pressed Parliament to restrict and prohibit imports of brass wire, and to impose heavy duties on imported brass and copper ingot. When Parliament at last complied, the restrictions did nothing to encourage the brass-workers to use the United Societies' brass. On the contrary, when no foreign brass was obtainable they stopped production altogether, and for a time finished brass goods of all kinds had to be imported, because even the supply of essential commodities dried up completely.

Although the newly formed United Societies did manage to stir up activity in the moribund brass industry, they did nothing to resuscitate the mining side of the joint company. The mines in Cumberland had not been reopened, and in 1684 it was estimated that at least £10,000 was needed to put Keswick back into production. The United Societies, lacking capital of this calibre, could do little except lease their

brass-making rights to independent groups and continue to protest at the importation of copper. But with so little copper being mined by their own company, it hardly made a persuasive case.

The power of Parliament was growing, and although Charles II tried to oppose many of the new measures being brought in traditional royal favours and privileges were gradually being whittled away. On the accession of William of Orange in 1689 as the first constitutional monarch of England, Parliament at last had full powers to administer the country as it thought fit. Monopolies and charters granted by past monarchs were swept away; Prince Rupert had died in 1682 and even the United Societies no longer had friends at Court to protect them. In 1689 the Mines Royal Act was passed, declaring that 'no mine of copper, tin, lead or iron should in future be considered "royal" even if those mines should be found to contain silver or gold'. 1689 also saw the end of the Merchant Adventurers' monopoly in the cloth trade, though they had done their best to keep in favour with the Parliamentarians, diplomatically subsidising Cromwell's cause and being rewarded in 1656 by having their charters ratified by the Protectorate.

The exclusive rights for working zinc ore and making brass originally granted to the Mineral and Battery Works had been openly violated for nearly half a century but because of the lingering royal prerogative of granting new monopolies to the United Societies copper-mining had remained at a standstill since the beginning of the Civil War. The new merchant classes[9] had realised for a long time that mining was potentially very profitable, and were only waiting for the opportunity to invest their capital. Once the Mines Royal Act was passed, freeing all mining from protection and monopoly, a large number of private companies were floated and new mining ventures were soon under way.

The original Mines Royal Company had served its purpose in breaking the royal prerogative on mineral mining, and the Mineral and Battery Works had brought foreign machines and skills to England whose application was not limited to the brass industry alone. England in 1690 was still very backward in many respects compared with the rest of Europe, although the Civil War had hastened her development by breaking down many rigid structures and freeing her from many hidebound traditions. In the brass industry, the United Societies served only as a holding company or bridge between the old England and the new. For by the end of the seventeenth century England's new colonies on the other side of the Atlantic had widened her vision and changed her patterns of trade. All kinds of new materials were being brought in to the looms and factories of her fast-growing industrial towns. Cotton to Liverpool, tobacco to Bristol, tea, coffee, chocolate, rum, sugar and silk meant changes in England's whole way of life. She was not only catching up with Europe at last, but beginning to set the pace.

The passing of the Mines Royal Act in 1689 meant that mineral mining could at last be exploited as a commercial proposition. Foreign copper was expensive; if England could mine her own she could provide her colonies – and herself – with a whole range of luxuries and essentials in exchange for far more exotic goods. Copper-mining, smelting and brass-making began to be organised by private enterprise, and capital was at last available for investment in the brass industry as a whole. Very little time or money had so far been spent in experimenting with new methods or developing the many different processes involved in making brass. Such changes as had taken place were the result of methods and skills brought over by

Opposite: A page from a household inventory in Randle Holme's *Academy of Armoury*, 1688, printed from the unpublished manuscript by the Roxburghe Club, London, 1905. The key to the illustrations is reproduced below.

1 A Covered Salt seller.
2 A Salt Seller with an open cover.
3 A Jugge.
4 A Chamber pot, or a Bed pot.
5 A flower pot, or a jugge with two eares . . . earthen weare called Tickney ware.
6 A viall, or viniger bottle, or a cruce . . . being a Glasse bottle.
7 An ewer . . . it differed nothing in shape from a Jugge, saue it was of a purer mettle, viz, siluer or pewter; having a Gutter side on ye further side of the mouth . . .
8 A cup-Ewer.
9 A square salt or dish stand.
10 A capsula or a little chest or coffer.
11 (i) A Capsula.
 (ii) A Chopping Knife.
 (iii) A Ladle Skellet.
12 A Knife case.
13 (i) A Turks Knife.
 (ii) A Bibby Knife . . . used by Scotch foote merchants . . .
14 A Doubel cocus nut . . . with a silluer, gould, Copper; or pewter head, full of holes screwed thereon, to put either meale, bruised peper or sugar therein, which is dusted out of the holes as cookes or housekeepers haue occasion.
15 A siluer dust or peper pot.
16 A Dish . . . this is a vessell or instrument, or what else you please to call it, much in use in all houses, and famileys; both for necessary use (as, for putting meate into them) to serve vp to tables; as also to adorn their country houses, and court cuberts; for they are not looked vpon to be of any great worth in personalls, that have not many dishes and much pewter, Brasse, Copper, and tyn ware; set round about a Hall, Parlar, and Kitchen.
17 An ovall dish.
18 (i) A potinger.
 (ii) A fire or grate Rack.
19 A Stand or a stand for a dish.
20 A low footed candle stick.
21 A candle stick betweene a socket and a saue-all or a prolonger.
 PARTS OF A CANDLE STICK
 The sockett, is the place where the candle is sett.
 A nose, is the length from the sockett to the broad rime around the middle of it.
 The buttons or Knops are those out swelling or workes made on the nose or shanke or neck of the stick to adorne it.
 The flower, is the round rime, or broad Brime, sett in the middle of the stick; on which the tallow dropps.
 The bottome, is all the remaining part of the stick from the flower to the edge it stands vpon.
 The edge, or cord, or florish round the bottome, if there be any.
 The Hollow, is the In part, or vnder side of the bottome.
22 A Lanthorn.
23 A spoone.
24 (i) A Scummer . . . The scummer is a large round plate made of either Tyn brasse copper or siluer 10 or 12 Inches in diameter,

set orderly with holes that a rush may goe through . . .
 (ii) A cake padle or Back spittle.
25 A Ladle between a paire of Racks; . . . some call them broach Racks, or Fire Racks, or Goberts.
26 A Fire shovell.
27 A paire of Tonges.
28 A paire of Tonges.
29 A paire of Bellowes.
30 A three square Trevett . . . They are also called Brandretts, Brand Irons, Iron Crowes, with three feet.
31 A Trevett or a Tripode.
32 A Triange Crow.
33 A Square Trevett.
34 (i) An Engine Rack.
 (ii) An oval dripping pan.
35 A square dripping pan with handles.
36 A Forke, or a Flesh forke.
37 Two table forkes; or two toasting forkes.
38 A Flesh pott or a Brasse pott.
39 A paire of hanging pot hookes.
40 A pott rack.
41 A Grid-Iron.
42 A Chimney; or Chamber fire grate.
43 A Besom or a Beazon . . . a Back, a Rush . . .
44 A possett pott, or a wassell cup, or a sillibube cup . . . either made of earth or mettle . . .
45 A Stoole pan, or a close stoole pan.
46 (i) A Stew pan.
 (ii) A paire of spectacles.
47 An Houre glasse.
48 A glasse bottle.
49 A Lampe.
50 A Lampe.
51 A Lampe.
52 A Lampe (flaming crescent).
53 (i) A cullander.
 (ii) A chaffeing dish.
54 (i) A warming pan.
 (ii) A frying pan.
55 (i) A Ferris, or steele to strike a fire . . .
 (ii) A jack broach.
56 A Morter and Pestell.
57 An old Morter.
58 A Tub or Turnell with handles.
59 A Basket or round Twiggen Basket.
60 A cushion Garnished with flowers and branches (or a Turkey worke cushion.)
61 A Loseng cushion.
62 A pollow or boulster.
63 (i) A bodkin.
 (ii) A combe.
 (iii) A broken combe.
64 (i) A Lady's Bodkin.
 (ii) A combe.
65 A Cabinett, garnished or laced, Lock and feete.
 This cabinett is such as Ladyes keepe their rings, necklaces, bracett, and Jewells In; it stands constantly on the table (called the dressing table) in the Bed Chamber.
66 A Trunke, or coffer or caskett bound with plates or iron hoopes.
67 A Throne.
68 A Chaire.
69 A Turned chaire.

70 (i) A Chaire.
 (ii) A Settle chaire.
71 A Stoole.
72 A Joynt stoole . . . It is so called because all made and finished by a Joyner, having a wood cover.
73 A Turned stoole.
74 A Countrey stoole.
75 A round three footed stoole.
76 A nursing, crickett, or low stoole or a childs stoole.
77 A Joynt Forme or Bench.
78 A Long Table, couered.
79 A Table couered with a carpet.
80 A Bed Royall.
81 A Bed with a head, or . . . Truckle bed, because they trundle under other beds.
82 A Voyder Baskett, or a night Baskett for day clothing.
83 A Cloathes Baskett, or a Burthen Baskett, or a Twiggen Baskett; common called a coale or dirt basket . . .
84 A hand baskett.
85 A fruite Baskett.
86 A round Twiggen Arme Basket for Yeomen, for eggs and butter . . .
87 An egge basket or Butter Baskett.
88 (i) A Port Mantle . . . A Bugett, or Snapsack or Snapbag is all made of tanned leather having Buckles, Strappes, Staples, Lock and chaine.
 (ii) An Arke, or safe, is a kind of little house made of wood and couered with haire cloth, and so by two rings hung in the middle of a Rome, thereby to secure all things put therein from the cruelty of devouring rats, mice, Weesels, and such kind of vermine.
89 A couered Cup.
90 A hanging Kettle.
91 A Stand.
92 An And-Iron or Land Iron . . . These are things made of Brasse, which are sett on each side the Chimney more for Ornament than profitt . . .
93 A Tub.
94 A Possnett.
95 A smoothing Iron or a Landresses Iron.

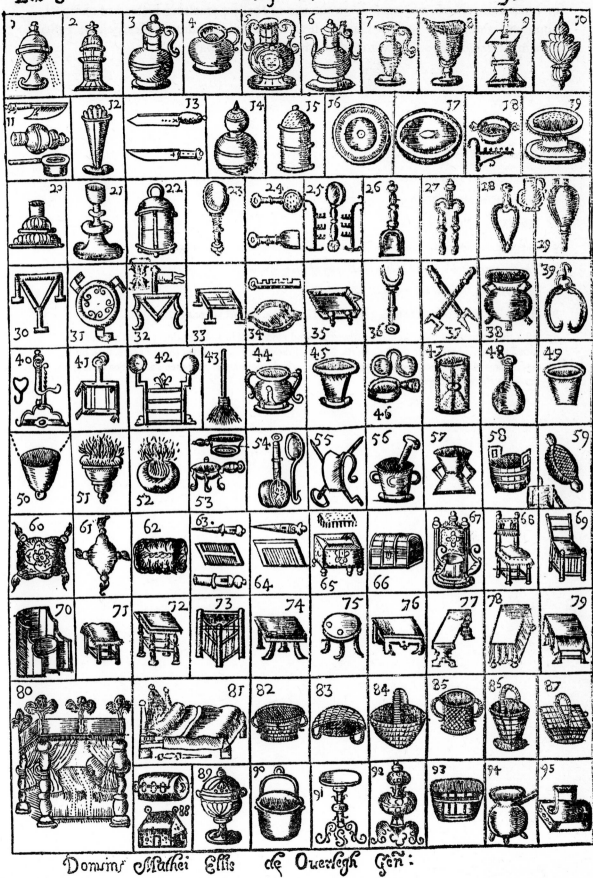

Domini Mathei Ellis de Owerlegh Gen:

foreign metalworkers, and apart from the use of coal for smelting instead of charcoal, a hundred years after Jochim Gaunse first wrote his account at Keswick in 1580 brass in England was still being made in much the same way.

Notes

1 *Elizabethan Keswick*, pp. 30–4.

2 Patent Office. Patent No. 61.

3 Patent Office. Patent No. 65.

4 Patent Office. Patent No. 91.

5 State Papers – Domestic, Council of State Proceedings. Calendar 1649–1650.

6 *The Resources, Products and Industrial History of Birmingham* . . .

7 Daniel Defoe, *Journal of the Plague Year*.

8 Historical Manuscripts Commission. House of Lords Mss. Report vii, p. 153.

9 After the Restoration there were over three thousand merchants in London alone, to which must be added the merchants in the main outports. Many of these were the younger sons of gentlemen, or descendants of the sixteenth-century merchants who had 'risen out of poor men's sons'. See E. Lipson, *Economic History of England*.

5

The Makers: the Genesis of the English Brass Industry

Men like Jochim Gaunse were esteemed quite differently from other metalworkers of the sixteenth century, and in Europe at least were held in considerable awe. Did they not, in the smoke and gloom of their furnaces, take red copper and transform it into gold? Brass-making was like alchemy in this respect, and the secrets of the miraculous transformation were very closely guarded; the methods were passed on by word of mouth and were not written down until nearly a hundred years after the Keswick colony was established. Basically, brass was made by the cementation method – that is to say, with raw copper and crushed calamine stone – and its preparation was fraught with difficulties and dangers. Impurities in either of the raw materials resulted in poor-quality brass which could not be worked. The standard of English zinc ore and its preparation seems never to have been in question. It was with copper that difficulties arose, and it was many years before English copper was smelted satisfactorily to produce a good workable alloy which could compete with foreign brass.

Copper ore was full of impurities, many of them lethal. Sulphur, for example, was 'a mynerall substance w'ch verie quicklie taketh fire, and wilbe consumed in smoke by blast' which, according to Gaunse, made copper black and brittle 'so that it wilbe broken w'th the hammar, in mannar like glasse'. Arsenic, antimony and vitriol were also given off, dangers to which Elizabethan smelters were keenly sensitive. Copper ore was therefore crushed to powder, roasted and then washed. 'For the water doth not onlie carry the vitriall from the powder or ure, but also carrieth w'th it the burnt powder or sinder of the sulphur, arsenique and antimony.'[1]

The earliest descriptions of brass-making in England were not written until a hundred years after the Keswick colony was founded. Sir John Pettus, Deputy Governor of the Mines Royal in 1655, was a close friend of Prince Rupert's, and at his request he wrote his famous *Fodinae Regales* or 'The History of Laws and Places of the Chief Mines and Mineral Works in England, Wales and the English Pale in Ireland . . .' which was published in London in 1670. Alas for his Royalist zeal, Sir John Pettus was eventually imprisoned for debt as a result of his generosity to the King's cause. Undaunted, while he languished in prison he translated *Fleta Minor* or 'The Laws of Art and Nature . . . in . . . assaying, fining, refining . . . of confin'd metals' from the German of Lazarus Ereckens, Assay Master General of the Empire of Germany. This was published in 1683 and contains the following description of brass-making:

In one of these Ovens they set 8 pots or pipkins at once, and let them be warm and hot, and when they are so, they take them out quickly and put the calaminaris in them, also they have a shovel

made on purpose, that therewith they may take up and know how to distribute near 46 pounds in such eight pots. They then lay in every pot upon the Lapis Calaminaris 8 pounds of small broken copper pieces, and set in the pots again, and then let them stand 9 hours in a great heat, and in this 9 hours are to be taken one heap and a half of Coals, and when such coals are burnt out, then stir the stuff in the pot with an iron.[2]

After a time the pots were taken out of the oven, and all the brass was poured into 'one hole'. Before it cooled it was broken and left so that the pieces lay close to each other. It is also known that at that time some plates of brass were made by the incredibly crude process of taking copper plate, laying upon it ground lapis calaminaris ready prepared, and heating both together in a furnace, in the hope that the zinc from the ore would fuse directly into the copper sheet. This method was not a great success.

Sheet brass was made from plates cast in moulds made from massive slabs of stone brought over from St Malo in France, each weighing a ton or more. The slabs were bound together with iron bands and slightly inclined so that the molten brass could be poured more easily into the mould. These plates were then beaten into thin sheet by gigantic water-powered hammers. Because of the difficulties of transport and the lack of suitable water-power to drive the machines, more often than not the early battery works were alongside the brassworks which produced the finished raw materials.

The battery works produced pots and pans, kettles for heating 16–20 gallons of water at a time, vats for making soap, distilling, melting tallow and dyeing, as well as ordinary household utensils. The methods were crude but effective: discs of sheet metal, four or five at a time, were laid over a curved iron or stone mould and simply battered into shape. It is not unreasonable to suppose that this was the origin of the French term *batterie de cuisine*.

In 1671 a manufactory of brass plates for kettles and frying-pans was set up at Wandsworth in Surrey by a Flemish family called, confusingly, Hallen or Holland. Their secret was to make no less than nine frying-pans at a time, in a nest. This was done at one heating of the metal, using anything up to twenty different hammers to complete the process, which involved very careful regulation of heat to allow the metal to become malleable enough to mould, yet not hot enough to fuse all nine plates together. It was an extremely efficient and profitable business, and various members of the family opened works at Keele in Staffordshire, Newcastle-under-Lyme, Coalbrookdale, Stourbridge, and finally in Birmingham at the beginning of the eighteenth century.[3]

In principle, one might call the battery products of the brass trade the 'heavy industry' which had its own set of difficulties and limitations. Neither the battering nor the wire-drawing could by any stretch of the imagination be called the work of craftsmen, although the actual making of the brass was still a highly skilled trade. But wool-cards, pins, ordnance and basic hollow ware were the bread-and-butter of the brass trade. On them depended the profitability of the industry as a whole, and setbacks in this area made it difficult for skilled craftsmen and metalworkers to obtain good-quality brass for decorative work.

England was not lacking in skilled metalworkers, for wrought iron which was equal and in many cases far superior to European work was being made in England

as early as the twelfth century. A sixteenth-century diarist, John Leland, describes the area around 'Berminghame towne' as being full of smiths and cutlers 'that use to make Knives and all mannour of cutting tooles, and many Lorimers that make Bittes, and a great many Naylors, soe that a great part of the Towne is maintained by Smithes who have their Iron and Sea-Cole out of Staffordshire'.[4] And a later commentator finds the town 'swarming with Inhabitants, and echoing with the noise of Anvils, for there are great numbers of Smiths, and of other Artificers in Iron and Steel, whose performances in that way are greatly admired both at home and abroad'.[5]

The Thirty Years' War which raged across Europe from 1618 to 1648 provided the first real stimulus for English craftsmen to attempt to produce all kinds of decorative articles which until then had been imported in large quantities from the Continent. At the same time Protestants fleeing from the carnage and persecution of the war were seeking asylum in England and searching for suitable places in which to settle and start up their own crafts and trades. Some of these refugees were metalworkers, who naturally gravitated towards Birmingham and its surrounding area, particularly since the brassworks centred round London and Surrey were in difficulties. The price of coal shipped from Newcastle to the Port of London had doubled as a result of James I's war with the Dutch at sea and many established brass-workers had been thrown out of work. The Birmingham metalworkers saw their opportunity to take over the markets which the London brass-makers had always regarded as their own, and they welcomed the arrival of men who were skilled in working brass, a metal still unfamiliar in Birmingham. The newly arrived 'straungerz' found themselves at home among kindred trades, in a town where forges were as common as bakehouses and supplies of fuel and metal were relatively easy to come by. They settled down and began to pass on their skills to the English.

As the Thirty Years' War dragged on, cutting off supplies of finished brass goods of all kinds, Birmingham began to provide England with many of the decorative and ornamental things which could no longer be brought in from the Continent. The English metalworkers became more confident and started to experiment – cautiously at first. They began to incorporate a little brass with steel, embellishing locks, knives, swords and boxes with gold metal overlaid on dull steel.[6] The gunsmiths followed suit, decorating stocks and locks of guns and muskets with restrained design. It seems certain that émigrés from the Liège district, famous for firearms, joined their fellow gunsmiths in and around Birmingham, for the English metalworkers' designs became more ambitious.

This core of Protestant émigrés and like-minded workers was disrupted less than most working communities by the upheavals of the Civil War. It was wholeheartedly in favour of Cromwell, and was a valuable source of arms to the Parliamentarians[7]. Even when Prince Rupert set up his battle headquarters at Camphill the people of Birmingham resolutely refused to supply him with swords, though half the town was burned down in reprisal.[8] The Civil War only served to bind the community together more tightly, and with the Acts of Uniformity in 1662 and the Five Mile Act of 1665, Birmingham began to consolidate from a group of loosely-knit small towns into a single city.

The Acts of Uniformity imposed the Prayer Book of Queen Elizabeth on the clergy, and demanded from all teachers in schools and universities a declaration 'to conform to the Liturgy of the Church of England as it is now by law established'.

Nearly two thousand ministers refused to comply and were deprived of their livings. They continued to preach in the open, and in 1664 a second act was brought in to prevent them from gathering congregations of their own. Finally the Five Mile Act of 1665 forbade them to go 'within five miles of any City or Town Corporate or Borough'. Although these were purely religious and political acts, they had a profound effect on many working communities, particularly those which had collected round Dutch, German, Flemish and Huguenot immigrant colonies of craftsmen and artisans. Driven from the cities and corporate towns, they followed their exiled ministers to smaller communities where they could continue to worship according to their own belief. The working populations of many large cities were considerably reduced and small market towns gained large numbers of new inhabitants. The brass trade in particular was deeply affected, and many of the Dissenters left London, Bristol and Nottingham to settle in Birmingham, which was not yet a corporate town despite its growing importance. Small brass and battery works were set up by Protestant workers in Derby, Wigan, Shrewsbury, Norwich, St Albans, Hertford and Tewkesbury – all small market towns not entirely suitable for industry, but none of them corporate or borough towns, and all of them on or near rivers to provide the brassworks with transport and water-power.

But for all the skills available in the growing communities of metalworkers, there was still very little brass being made in England. During the Protectorate there was little encouragement for capital investment, and a great deal of money was needed to restore the old brassworks which had been closed by the Civil War. The great brass-founding and battery works at Nottingham were reported by Sir John Pettus to be almost derelict when he visited them in 1670.[9] Keswick had been totally destroyed, and copper-mining was virtually non-existent. The Cornish mines were producing copper ore, but it could neither be smelted nor made into brass anywhere near the mines. Crude zinc ore was too expensive to transport down to Cornwall, and smelting was equally uneconomic because of the high cost of shipping coal, for there was none to be had in the West Country. The output of copper ore was also erratic because of the problems of flooding, which constantly closed down promising Cornish mines. The brass trade was therefore almost entirely dependent on brass imported from Holland, France and Germany. Sweden went on sending copper to England, while to the dismay of many a hopeful investor, great quantities of fine English zinc ore still went abroad as ballast. Until the end of the seventeenth century, principally for reasons to do with the supply of raw materials, such brass-making activities as there were centred near the Port of London where imported brass was unloaded. Outside the Home Counties there was little activity: there was a small copper-mining company at Ecton Hill in Derbyshire, owned by Lord Devon and some Dutchmen, another successful battery works on the Thames at Bisham Abbey, and a small pirate company near Bristol.

There were other factors too which hindered metalworkers from experimenting with expensive foreign brass until the Restoration. The Protectorate left its mark on many traditions and habits of the English people from which some say it has never recovered. Puritan morality forbade excessive ornamentation of any kind on clothes and prohibited excesses of appetite. Frivolous buttons and bows were forbidden, traditional feast days were abolished, pies, puddings and sauces banned from the table. Though many took little notice of the zealots beyond making temporary sacrifices and keeping a wary eye and ear open for the militia, the majority

conformed and for nearly twenty years the general fashion of the English people was for plain kerseys and broadcloths, laced or fastened with good plain bone buttons, and their tables reflected a strict moral tone by being set with plain and wholesome food, lacking much seasoning or colour. Hardly an encouragement for the brass-workers to make anything but the plainest, most simple goods for the home market.

Other metalworkers were in difficulties over raw materials too. If the brass-workers had to rely on expensive imported copper, the ironworkers were now having to pay heavily for imported pig-iron from Sweden. The natural supplies of easily-smeltable ironstone were beginning to be worked out, and ways of smelting the more difficult, less calcinous ironstones had not yet been discovered. But by this time Europe was not the only source of supply for raw materials, nor the only market for English trading companies. The East India Company had opened up the Pacific and the Indian Ocean, and trade with the Plantations, the West Indies and Africa had extended England's trade routes until they circled the globe. The Birmingham iron-founders judiciously petitioned Parliament for the encouragement of iron-mining in the new colonies, and a circular traffic began. Ships carried brass wire, rods, rings, and, so the saying went, bibles and missionaries to Africa. From Africa they took gold and slaves to provide labour in the sugar plantations of the West Indies and in the tobacco and cotton fields of America. They returned with rum, raw cotton and tobacco, with pig-iron as ballast on the home run.

The climate changed when William of Orange came to the throne in 1688. All trade with France was stopped. England was now committed to a war against France, William's bitterest enemy – a war which was the first sign of England's growing power. Ramilles, Oudenarde, Malplaquet and Blenheim were battle honours which raised Marlborough to his height and showed the rest of the world that England was a military force to be reckoned with again. But one of those curious circumstances which pushed the brass trade forward in spite of itself had occurred a few years before. Louis XIV had revoked the Edict of Nantes in 1685 and a wholesale persecution of Huguenots in France had sent yet another wave of refugees fleeing across the Channel to England. Again, many of them came from the metalworking communities on the borders of France and the Low Countries; and so, just when England badly needed craftsmen to make all the many things which had always been brought in from France, they were already settling in Birmingham and the other English metalworking centres.

For this reason it is almost impossible to pinpoint the actual place of origin of a great number of brass articles made during this period. Newly-arrived émigrés from the Continent were making what might be called 'French' or 'Dutch' brass, but they were working in England. And English metalworkers were making what might equally well be called 'English' brass from new designs brought in by the émigrés, and sending it out of England and back to the Continent. For in spite of the political situation, and the shortage of raw brass and general depression of the trade in England, the brass-workers of Birmingham and the other centres of decorative metalwork had a living to make. If there was a growing demand in their own country, there was also a big market abroad, and the merchants from the big trading companies were only too willing to buy up all the fine brass they could find.

With the passing of the Mines Royal Act in 1689 and the ending of the monopoly in copper mining in England many new companies were floated, all eager to exploit the growing demand for copper and brass, and to capture the market from

overseas competitors. Birmingham was again high on the list of petitioners for the encouragement of copper-mining in England and Wales. The quality of English brass was improving, imported brass was expensive, and the markets were too good to lose. By this time there were five large copper-smelting foundries capable of producing good-quality copper ingot. Of these Dockwra's Copper Company is probably the best-known: it pioneered a basic form of rolling-mill to produce sheet-metal, and also set up a brassworks in the neighbourhood of Esher, around the time that Daniel Dametrius and Jacob Monomia's brassworks closed down – quite possibly on the same site.

In 1699 an act of Parliament forbade the colonies to set up any manufacturing industries, and laid down a strict mercantile policy for England. Raw materials were brought from the colonies to feed England's growing industries, and finished goods were then exported back to the colonies. Everything America needed had to come from the factories in England, including tools for crafts and trades such as cabinet-making, ship-building, leather-work, printing and so on which did not come under the ban on industrial development.

But brass was still in short supply, and in 1701 the situation worsened. France took and held all the Channel ports, and supplies of imported copper from Germany and other Eastern European countries coming through the ports dwindled from 85 tons in 1694 to a mere 9 tons in 1710.[10] Heavy import duties had been imposed on Swedish copper in 1689 in order to stimulate the English copper-mines. These were indeed difficult times for the brass trade in England.

Few craftsmen among the smaller trade groups could afford to specialise in brass alone. Individual trades, such as the candlestick-makers, harness-makers, lorimers, naylors and cutlers made a few articles in brass as well as other metals: Bell Metal in particular was used for making a whole range of articles never before made in this alloy. In the main it was the immigrant workers who made the most use of what brass there was. Many of them had been button and buckle makers in their own countries, and until 1720, when English raw brass was at last freely available, there must have been many small hearths turning out a few small objects for sale to travelling merchants. It is not difficult to imagine these skilled foreign craftsmen collecting what their English counterparts would dismiss as useless shruff[11] or old brass, and melting it down in small crucibles to work up into buttons, buckles and small 'toys'.[12]

So if the buttons on the uniforms of Marlborough's glorious armies were brass, and the statesmen and courtiers paced the corridors in buckled shoes, it was due to the ingenuity of the small forges in Birmingham – and the first good-quality English raw brass at last being made at the turn of the century in a new brassworks in Bristol. Most of the brass being made in the Surrey brassworks would have been needed at the Royal Arsenal at Woolwich, and in Birmingham the demand for swords, harness and weaponry was the only one which interested Parliament. In 1704 Abraham Darby and his partners Benjamin Cool and Edward Lloyd opened a big brassworks at Baptist Mills, Bristol, and the English brass famine neared its end.

At Baptist Mills there was at last an outlet for Cornish copper, for it could be brought in by sea to Bristol. There was still plenty of calamine in the Mendips, coal within a few miles of the mills, and water to power the machines and transport the heavy materials. Brass wire for pins and wool-cards was greatly in demand at Gloucester, Bristol itself was crowded with merchantmen, and Birmingham would

take all the brass which Baptist Mills could make. In 1709 Darby moved his mills to a larger site at Coalbrookdale, but difficulties over the quality of brass set in, and for a time it looked as though the whole enterprise would fail. Darby could not find skilled workmen to make the brass for these huge potential markets. Once again, England turned to Europe and brought in foreign workers from Germany and the Low Countries. In 1711 Edward Lloyd imported to work in the mills eight families whose names have come down through generations of workers in Bristol. As late as the beginning of this century, the Bristol Brass Company had a 'Dutchy Ollis' on its payroll. At about that time it is thought that the founders of Baptist Mills were joined by John and Thomas Coster, and by Nehemiah Champion or Champion, one of the most important names in the whole history of English brass.

Baptist Mills was soon renamed the Bristol Brass Company, once the foreign workers had begun to produce good-quality brass, and by 1721 the new company had taken over a brass wire mills at Esher, probably the old Dockwra Copper Company's works. In the years that followed new works were opened up at Keynsham, Chew Mills, Siston in Gloucestershire, Upper Redbrooke in Monmouthshire, Barton Regis and half a dozen other places. No doubt this expansion was due to a great extent to Sir Abraham Elton and Gabrielle Wayne who started a copperworks close to Bristol which by 1711 was producing considerable quantities of good-quality smelted copper. But while the Bristol Brass Company was still in difficulties over the quality of its brass, the English brass trade continued to rely almost entirely on imported copper from Sweden, and in 1714 it suffered another crippling blow when Sweden stopped all exports of copper and brass to England.

1714 was the year George I came to the throne, and one of his first actions was to borrow the English fleet to settle an old quarrel. The Hanoverian Electors had long been jealous of Sweden's possession of the North German ports, and George I intended to take them back. These Baltic ports had great strategic and commercial importance, and although it was not a very important campaign for Europe, whose eyes were elsewhere, its effects on the industrial towns of England were disastrous. However, this was a short-lived calamity, and the last major setback that the English brass trade was to suffer. The Bristol Brassworks soon began to produce high-quality raw brass and the merchants discovered, somewhat to their astonishment, that English brass had already begun to earn itself quite a considerable reputation abroad. Once the investors realised that there was a big demand for English brass the copper companies had no difficulty in raising capital to finance new mines to produce the necessary copper and put up enough money to allow for experimenting with different methods of brass-making. It was stated in 1712 that £45,000 had been expended in the building of copper and brass works, and £150,000 lost before the manufacture of brass was brought to perfection.[13]

In 1719 Lord Falmouth leased mining rights to Thomas Coster, partner in the Bristol Brassworks and associate of Nehemiah Champion, and copper was soon being produced in reasonable quantities from these new mines. That same year, Thomas Patten of Warrington founded the Cheadle Brass Works at Bank Quay, in association with a Welsh copper-mining company, and at last brass was available in quantity for Birmingham, now indisputably the main source of small finished goods in England. 1720 was the year of the Great South Sea Bubble. Investing was all the

rage. Joint-stock companies had arrived: the mining, smelting and brass-making companies began to amalgamate into organisations which combined to produce, control and sell the raw materials of industry. The real roots of England's Industrial Revolution lie in this period, though it was a hundred years before the effects of this consolidation of capital began to be felt.

Whatever it is that governs the tides of creation and invention in a nation, be it heredity, circumstance or challenge, England's greatest age was stirring. Christopher Wren, Isaac Newton, Henry Purcell, John Milton and Sir Peter Lely had shone like small sparks of phosphorescence in a dark and stormy sea, in a land barren of native talent, torn by dissension and dissatisfaction through the long years of the seventeenth century. The Dutch had been the innovators, the creators and the explorers, producing men like Van Dyck, William van de Velde, Christian van Vianen, the Quellins, de Ruyter and van Tromp. The cartographers, scientific instrument makers, printers, engravers, ship-builders, explorers, landscape artists, cabinet-makers, tapestry-makers, glass-workers, clock-makers and metalworkers of the seventeenth century were, with few exceptions, Dutch to a man. By the mid-eighteenth century, however, a Dutch merchant, sadly chronicling the waning glory of his country, could write: 'We are now no longer innate inventors, and originality is becoming increasingly rare with us here. Nowadays we only make copies, whereas formerly we made only originals.'[14] It was England now which produced a crop of outstanding talent and creativity which had not been seen since Queen Elizabeth's day, and which has not been equalled since. This was the age which gave us William Kent, Capability Brown, the Adam brothers, Chippendale, Hepplewhite and Sheraton, Hogarth, Reynolds, Gainsborough, Morland and Rowlandson, Daniel Defoe, Jonathan Swift, Alexander Pope and Dr Johnson, William Pitt and Charles Fox, Matthew Boulton and James Watt. In every field of the arts and sciences, English design and invention led the world. There was more talent to the acre of England's expansive, elegant countryside and newly landscaped towns than ever before or since.

There was excellence in everything that was done, from trimming a hedge to building a mansion. Every joiner became a craftsman, every metalworker an artist, every builder an architect, every gardener a landscape designer. And in order to arrive at the perfection of finish and design, new methods had to be explored, new machinery invented, capable of making things of beauty, not one at a time, but by the hundred. For not only did the English gentleman need furniture and porcelain, damasks and paduasoys, snuff-boxes, buttons and buckles to suit his admirable taste and raise him to the level which this era of gracious living required; Europe was eager for the products of England's new industry and brilliance. At the beginning of the eighteenth century Birmingham was sending so much brass to continental Europe that the London importers complained that 'the extraordinary late improvement and nicety in all sorts of brass wares, great and small, in and about London, Birmingham and divers other parts of England' had earned English brass a great reputation abroad. Holland, Italy, Venice and Germany all bought their share, but France was the chief market where, according to a contemporary report, 'English watches, clocks, locks, buckles, buttons and all sorts of English brass toys are in great esteem'.[15] And on the other side of the Atlantic, the New World was no longer a collection of hardy settlers fighting for survival. It was a great society in its own right, now well established and longing for the gentle touch of fine fabric, the gleam of

brilliance in furnishings and adornment, and all the marks of distinction which were needed to show off its growing emancipation.

Notes

1 Quotation reproduced in Grant Francis, *Smelting of Copper*, 1881.

2 An almost identical description of German brass-making from Christopher Weigel's Treatise on Professions and Crafts, published in Regensburg in 1698, is quoted in Hans Ulrich Haedeke, *Metalwork*.

3 Arthur W. Cornelius Hallen, *An Account of the Family of Hallen or Holland*, 1885.

4 John Leland, *Itinerary*, 1538. Oxford, Thomas Hearne, 1710–12.

5 William Camden, *Brittania*, 1586. 1722 edition ed. Edmund Gibson.

6 Early examples of this work can be seen at the Victoria and Albert Museum, notably a steel casket made between 1688 and 1694 for William and Mary.

7 It was said that they manufactured 15,000 swords for the Earl of Essex. See a letter written from Walsall . . . concerning Birmingham in Henry Hamilton, *The English Brass and Copper Industries to 1800*.

8 R. K. Dent, *Old and New Birmingham*, 1800.

9 Sir John Pettus maintained in his *Fodinae Regales* that 'this great Mineral and Battery Works undertaking gave employment to no less than 8,000 daily'.

10 House of Commons Committee Reports. Appendix 37, p. 727.

11 Scrap metal, known as *schrott* in Germany and *mitraille* in France.

12 The origin of the word 'toy' is obscure, but the O.E.D. notes that it was used around 1300 and then vanished from use, to reappear as a description of small metal objects made in Birmingham. It possibly derives from a sixteenth-century Dutch word *toi* meaning ornament, and later *speeltuig* – a play-tool or implement, plaything or toy.

13 Quoted in E. Lipson, *An Economic History of England*.

14 Quoted in exhibition *The Dutch in London*, The London Museum, 1973.

15 *A Brief Essay on the Copper and Brass Manufactures of England*, 1712. See also Defoe, *A Plan of the English Commerce*, 1728.

6
The Methods: the Machinery of Eighteenth-Century Brass-Making

In the early eighteenth century the brass trade was beginning to organise itself into distinct trades as far as the 'industrial' side was concerned. The brassworks at Esher, for instance, specialised in wire for pins, and the workers were all brought together in a manufactory. Fourteen different processes were involved in making pins, including drawing, cutting, nealing, pointing, heading, whitening with tin, polishing, filling pin-cards and tying them up into bundles. A good team of pin-makers could produce as many as 24,000 pins in a day. Making wool-cards was also done under one roof, by registered card-makers, and the bulk of hollow ware was produced in the battery works, which still used water-power to drive the giant hammers. All these large brassworks and mills had been established in places where raw materials and finished goods could be carried a large part of the way by water. For the devastatingly bad state of the roads was a major handicap to industry in England, and for some time the trend among independent metalworkers was away from bulky articles and towards smaller products because of the cost and difficulty of getting finished goods of any size to London and the other main market centres.

Arthur Young, the agriculturalist, writing in 1770 of his journey from Newport Pagnell to Bedford, describes the dreadful conditions: '. . . if I may venture to call such a cursed string of hills and holes by the name of a road; a causeway is here and there thrown up, but so high, and so very narrow, that it was at the peril of our necks we passed a waggon with a civil and careful driver'. And in Lincolnshire he travelled down a turnpike, supposedly kept in good repair by tolls: '. . . we were every moment either buried in quagmires of mud or racked to dislocation over pieces of rock which they term "mending" . . .'[1]

The main routes which radiated from London in the sixteenth and seventeenth centuries were still the principal connections between centres of any importance: through St Albans, Dunstable, Coventry, Lichfield, Chester, and up through Denbigh to Caernarvon; north from Lichfield to Warrington, Preston, Lancaster, Kendal, Keswick and Cockermouth; west through Reading, Newbury, Chippenham and Bristol; and a great curving road through the Thames Valley by way of Maidenhead, Dorchester, Gloucester, Brecknock and up to St David's on the coast. In the 1670s Bristol was of such importance, in wool as well as in brass, that a plan was put forward to link the Thames with the Severn, leaving out eight miles where the terrain was too difficult. However this was too ambitious a project for a country still backward in most engineering skills, and nothing came of it.

Transport by water was at least a third cheaper than carriage overland, and a great deal quicker, and so whenever possible rivers were used to carry heavy cargoes. The West Midlands made great use of the Severn and the Avon, as well as shipping freight down the coast. When the Cheadle Brass Company went into operation, one main consideration must have been the transport available. The Severn, the Derwent and the Trent were all navigable for barges a good part of the way, making it easy for fuel and ore to be carried between Warrington and Wolverhampton, Sheffield and Birmingham. Bristol too was well placed to send raw brass down to Gloucester and wire or finished wool-cards down the Avon into Somerset. Coal came into Bristol by sea from Wales, and copper ore from Cornwall.

Whereas Bristol incorporated wire-drawing and battery with its brassworks, Cheadle began operations as a brass manufactory for sheet and ingot only. Bristol was in the wool country, where wire for wool-cards and pins still took up a large part of the market. There were woollen mills in Bristol itself, and after the 1699 act forbidding any manufacturing trades in the new colonies, the output from the Bristol mills for export to America was one-fifth of their total production. They, like other West Country mills, were famous for the 'Bristowe red' worn by British soldiers. The redcoats could have been equipped entirely from Bristol wool and brass – cloth, buttons, epaulettes, braid and all.

Cheadle, surrounded by the outworkers and forges of locksmiths, cutlers, clock-makers and the like, made very little brass wire to begin with; most of its output was plate, sheet and ingot. A record of the Cheadle works later in the century shows clearly where its main markets lay. It also shows how little the methods of making brass had changed since the days of Jochim Gaunse and Sir John Pettus.

The brass for wire and sheets was cast into 'plates' which weighed from 96 to 100 pounds each and varied in dimensions from 5 feet 2 inches to 5 feet 10 inches long and 11 inches to 15 inches broad. The moulds in which these plates were cast were formed of two massive slabs of granite of at least 6 feet 4 inches long by 2 feet 9 inches broad and about 8 inches thick. . . . The brass intended for 'latten' consisted, as nearly as possible, of two parts copper and one part zinc, as also did the wire, denominated 'pale' and used for various purposes; but the wire intended for pins contained a little more zinc as also did the ingot brass. There were four qualities of ingot made at Cheadle:
BB Made of best copper, and same quantity of zinc as the plates for latten.
BC Inferior copper and slightly more zinc.
AM Some copper and calamine, tainted with lead.
YY Made of ash metal and other inferior materials.
The BC ingots were always broken through the middle, and known as 'BC broke'. Wolverhampton and Sheffield took the YY ingots – not much of it was made, and Sheffield also took some BB. The great bulk of all the rest went to Birmingham which took about 350 tons of brass in ingot, latten and wire per year. The rest went to London, Gloucester, Warrington and Manchester principally as wire for pins.[2]

Cheadle began to make wire when changes in the wool trade brought about a demand for wool-cards in the north of England. Yorkshire wool-merchants and clothiers began to make their own cloth instead of sending raw staple down to East Anglia and the south and west, and wool-cards were needed in large numbers to supply to the woollen 'factories' of Yorkshire which began to turn out vast quantities of broadcloth. The northern mills, however, were not noted for their quality. In 1724 Yorkshire obtained a contract with merchants for supplying the entire cloth

quota for the Russian army. The cloth was despatched and made up, but when the Russian soldiers paraded in the rain, the Yorkshire cloth shrank 'from a soldier to a page'. For a long time after this unfortunate event, there was a saying current among clothiers and merchants in England: 'to shrink as Northern cloth – a giant to the eye, a dwarf to the use thereof'.

Although brass was now being made in some quantity, complaints were still coming in from Norwich, Wigan, Shrewsbury, Tewkesbury, Hertford and St Albans about the quality of raw English brass. The users of brass wire were more than happy with the quality of English wire, but the trades which used plate and ingot complained that the metal was 'so hardy, flawy and scurvy that it won't make several sorts of goods as it ought, particularly buttons'.[3] Nor was English plate and sheet brass good enough for making larger items such as hollow ware, kettles and other battery goods.

One might draw the conclusion that since English brass wire was considered even better than foreign wire, and since the raw metal for both wire and sheet was the same, it was perhaps the process of battery in the huge hammering-mills which caused the deterioration in quality. Cheadle does not seem to have concerned itself overmuch with improvements and innovations, but the men of Bristol were constantly looking for new ways of making and processing raw brass. There is positive proof that the quality of brass, particularly for battery goods, was causing concern at that time, for Nehemiah Champion of the Bristol Brassworks took out a patent for a new method of converting copper into brass and, a new way of nealing the plates and kettles with pitt cole, which softens and makes the brass as tough and fine-coloured as any nealed with wood and wood coale'.[4]

In 1720, the year of the Great South Sea Bubble, a great number of companies were floated 'for the improving of English copper and brass'. Few of them survived the subsequent panic and collapse of the stock market, but they show the growing interest in the industry and willingness to invest in its future. This sudden boom was due to the soaring prices of shares in the Temple Mills Brass Works at Hackney, originally established by Prince Rupert. At the height of speculation, shares in the brassworks issued at £10 were changing hands for £250. Temple Mills apparently survived this heavy speculation, for in 1740 it was still producing pots and pans and kettles.

With capital now freely available, there was money to spare for experimenting with new methods and new machines to take the place of the old. Inventions of all kinds were registered at the Patent Office, many of them variations on existing methods, some of them advances which were to play an important part in the change-over from manpower to machinery which took place in the second half of the eighteenth century. One patent, which seems to have attracted little attention at the time, was taken out by John Payne of Bridgwater, near Bristol, in 1728. It was for a new method of 'applying the heat or fire made of pit coal, wood or turf . . . for the melting of all sorts of metalls and metalline ore'; almost as an afterthought, Payne added a method of drawing metal 'into barrs or other forms, att the pleasure of the workman, and those or other barrs being heated . . . are to pass between two large mettall rowlers (which have proper notches or furrows on their surfass) by the force of my engine hereafter described . . .'[5]

Here was the forerunner of the rolling-mills for making sheet of an even thickness, a technique which was to change the methods of making an infinite variety

of brass articles, from buttons to saucepans. Sir Phillip Howard and Sir Francis Watson, back in 1687, had devised a way of 'drawing lead into sheets' for sheathing ships,[6] but John Payne was the first to apply the principle to less ductile metals. Payne's machine was extremely complicated, however, and relied to a large extent on air pressure for its power, which perhaps explains the fact that of all the Bristol Brass Works manufactories, only windy Keynsham adopted rolling-mills at that time. Cheadle is known to have used rolling-mills at a later date, for when Prince Rupert's secret alloy was rediscovered in the eighteenth century, small quantities of rolled sheets of Prince's Metal were being made at Cheadle.

Bristol was the source of innovation and development in mining as well as brass-making at that time. The Bristol men worked closely with the Cornish miners, from whom they obtained their supplies of copper ore. Ore was crushed in the Cornish mines principally by women, and a tough breed they must have been. These 'bal-maidens', as they were sweetly called, hammered the ore and threw out the useless rock, and 'cobbed' the ore into 'doles' or piles of manageable-sized pieces. It was slow, hard work, and perhaps it was not only for the sake of efficiency that Nehemiah Champion invented an overshot water wheel for ore-crushing which was still being used in an updated form well into the beginning of this century.[7]

The patterns of trade, the policies of Parliament and the growing power of the merchants and manufacturers were also having their effect on the brass industry. It was almost as if England, in her newfound strength, could afford to leave the 'local' markets to the ageing giants of Europe. The Channel had shrunk to a ditch, across which there was a lively two-way traffic, but more in the manner of coastal traffic than as a main artery of trade. The Atlantic and the Pacific were England's hunting-grounds in the eighteenth century. Spices came from India and the Spice Islands – the Levant was no longer so important. Copper came from Africa, pig-iron from America. And so Birmingham brass went to India, America and the new colonies, where there was little competition from England's new trade rival France. However, the East India Company's fleet plied the Indian Ocean with much the same disregard for industries at home as the Merchant Adventurers had done a century before.

Chief among their return goods at the end of the seventeenth century were finished printed cottons from Madras and Ceylon, and finished silks and calicoes from China and India. The Lancashire cotton manufacturers, making up raw cotton from the Plantations, petitioned Parliament to protect their interests, and in 1700 imports of wrought silks made in India, Persia and China were forbidden, as well as calicoes 'painted, dyed, printed or stained there'.[8] The wool trade was still a power to be reckoned with, and Ireland was forbidden to send woollen textiles abroad to any other market than England, thus dealing a death-blow to a promising cloth-manufacturing trade and causing many of Ireland's working people to emigrate to America and the colonies. They were not able to set up as weavers or clothiers when they reached their new homes, for the 1699 act forbade 'wool, woollen yarn, cloth, serge, bays, kersies, friezes, druggets, cloth-serges, shalloons or any other drapery, stuff or woollen manufacture whatsoever' to be exported from the colonies, or even transported from one colony to another. Further to placate the jealous English clothiers, the Methuen Treaty of 1703 allowed the export of English cloth to Portugal, on condition that Portuguese wines were allowed into England at two-thirds of the duty levied on French wines. A broadsheet of the day, the *British*

Merchant, smugly asserted that 'the preserving of our looms and the rents of Great Britain was of greater consequence to the nation than gratifying our palates with French wine'.[9]

The merchants and the big trading companies were behaving in much the same way as they had always done, only now they had the blessing of a Parliament anxious to preserve and promote England's growing commercial power in the world. But the brass industry was mercifully free from interference and did not suffer from any controls or restrictions which might impede its progress. On the contrary, for as the flow of trade and the passage of ships brought China and the Orient closer to England, information filtered through to the energetic experimenters in Bristol, whose wharves were closest of all to the East. Somewhere along the trade routes of the East India Company, someone let slip a secret which was to put England a long way ahead of her nearest competitors in the brass industry. In 1738 William Champion of the Bristol Brass Company took out a patent for the distillation of pure zinc. The Germans, who had the finest chemists, metallurgists and scientists in Europe, had been experimenting with metals for centuries.[10] Yet an Englishman was eight years ahead of the German chemist Marggraf in discovering the process. How did William Champion stumble on the secret?

It is true that the Bristol Brass Company was constantly searching for better methods of making brass, smelting copper and working the alloy. But the distillation of zinc was a matter of science, and nowhere in the records are there any hints that the English were carrying out experiments to discover the secret which other nations, who had been making brass for generations, had failed to discover. England's fiercest competitor Sweden was still importing zinc from the East in 1745. That year a ship carrying a parcel of ingots consigned from Canton to Sweden went down in Gothenburg harbour. Some of the ingots were salvaged in 1872 and found to be metallic zinc of 98 per cent to 99 per cent purity.

It was certainly not in the East India Company's interests to divulge the secrets of zinc distillation to an English manufacturer. The Company had been importing small quantities of pure zinc at no less than £260 a ton, though by the beginning of the eighteenth century the price had begun to fall as imports increased. Once William Champion set up his first zinc manufactory, he forced the price of zinc down by four-fifths 'to the dismay of many an honest trader', as one East India man plaintively pointed out. The actual wording of William Champion's patent gives a strong clue as to the origin of his information. 'For the reducing and rendering of a metallick sulphur from calamine or other sulphureous British mineral or minerals into a body of metallick sulphur known by the name or names of *spelter* or *toothaneg* . . .'[11] The European name for the metal was *zinken*. But the name given to the curious white metal imported from China as long ago as the thirteenth century was recorded by Paracelsus as 'spiauter' or 'tuteneque'.

While the Bristol Brass Company continued to expand and develop, opening new hammer-mills near Bath and on the river Chew, Birmingham struggled with problems of its own. The backbone of most travel and transport was up and down the Great North Road, from London up through Coventry and Lichfield. Birmingham lay about four miles off the main route of the Great North Road – little enough today, but as remote as Wales for a merchant making his way down what passed for roads in those days. It seems incredible that one gentleman who lived in Hertfordshire and kept a team of six horses took two days to get to London. Off the

main roads, things were worse still. 'Before the establishment of turnpikes on the road to Poole in Dorsetshire, such was its plight that, in order to go from a gentleman's seat not six miles off to that port for coals, the wagonner used to get up early in the morning, and it was often late at night ere he could get home again. In winter sometimes the wagon stuck fast, and both men and horses could not get it on.'[12] The appalling state of the roads was not only inconvenient: it added enormously to the cost of both raw brass coming into Birmingham from Bristol and Cheadle, and finished goods being sent out by the brass-workers. In consequence, as we saw, they began to make 'smalls' – objects which could be carried out by the merchant in his own saddlebag, or which were light enough to be taken by carrier. However, once William Champion had opened his first zinc manufactory, new possibilities presented themselves. Raw copper and raw zinc metal could now both be had in ingot, and the whole business of making brass suddenly became a relatively simple affair. In 1740 a family called Turner opened a 'Brass House' in Coleshill Street, the first named brassworks in Birmingham, bringing the supply of raw material right into the town itself.

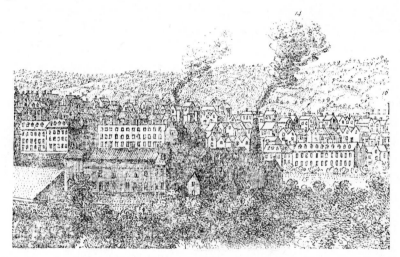

Detail from Samuel and Nathaniel Buck's prospect of Birmingham from the east, 1753, showing 'The Brass Works' – No. 14 in the key at the bottom of the engraving. There is no record of another brass works having been built in Birmingham at that date, so presumably this is Turner's famous Brass House, first recorded in 1740.

Both the Cheadle Company and the Bristol Brass Company, seeing their prize market about to be snatched from them, did everything they could to ruin the Turners and close their brassworks. They began an intensive war of undercutting prices, hoping to force the Brass House out of business, and they might very well have succeeded had it not been for the remarkable community spirit which existed among the metalworkers of Birmingham, who continued to support and encourage their own brassworks and refused to do business with the big companies. Eventually Cheadle and Bristol 'condescended to effect a reconciliation and persuaded their opponents to enter a Grand League for the sole purpose of advancing metals'[13] – in other words, forced an amalgamation. But at least Turner's Brass House retained its own identity within the 'Grand League'.

Cornish copper was still the best – and indeed Cornwall was still almost the only source of supply for both Cheadle and Bristol. In 1754 a smelting works was opened at Hayle in Cornwall as a logical step in cutting the cost of raw materials. Coal was

shipped round Land's End by coasters from South Wales and copper, either smelted or crude ore, was the return freight back to Bristol. The Cornish were very suspicious of this practice and maintained that crude ore was taken to Bristol, not because of the shortage of fuel for smelting, but to conceal the profits being made. There was worse trouble in store for them, however. So far there had been very little competition with the Cornish copper-mines, but in 1768 the Cheadle Company's associated mining company made a quite remarkable find of copper at the famous Parys Mine in Anglesey. Although the copper here was slightly inferior to that in Cornwall, this Welsh El Dorado of a mine, where copper could be picked up by hand from great open seams on the surface, supplied Cheadle with as much raw material as it needed. Cornish mines suffered accordingly, and depression hit the mining villages as many mines were closed down and miners thrown out of work.

Brass-workers began to experiment with ways of producing larger quantities of small objects more efficiently. In 1769 John Pickering, a London coffin-maker, found that the press-and-die principle could be applied to metals, and took out a patent for 'a new method of performing that kind of work comonly called chasing, for the working in Gold, Silver, Brass, Tin and other metals, of various Things, particularly Coffin Furniture, Ornaments for Coaches, Chariots, Sedans and other Carriages, for Cabinet work and other Domestic Furniture and other Articles'.[14] The process raised a stamped impression on sheets of metal laid over a die, or raised a model of the pattern, quickly and cheaply, whereas before it had laboriously been done by hand. London was the main centre for making coffins and coffin mounts: grand funerals were the preserve of the rich, the famous and the noble, who were usually brought to London for burial. But Birmingham had its own coffin-maker, Thomas Richardson, Tinplate Worker and Coffin Plate Chaser, of the Bull Ring, who according to his trade card made all sorts of coffin ornaments, either 'flat, chased or embossed, in silver, copper, brass, pewter or tin as cheap as London'. No doubt it was through him that John Pickering's stamping process reached Birmingham.

A few months after Pickering had patented his method, Richard Ford of Birmingham took it a stage further, incorporating John Payne's invention of rolling with the stamping process. He applied this principle not just to small articles such as furniture and coffin mounts, but also to larger articles such as 'Scale Pans, Sauce Pans, Warming Pans, Basons, Plate covers, Kettles, Ladles and various other things out of silver, copper and other metals'[15] which he raised and stamped out in one operation. In 1770 John Smith, also of Birmingham, was granted a patent for stamping out buttons in quantity using the same methods.[16] Button-making had been a lengthy business, involving several different stages of manufacture, the design and decoration being added by hand by an engraver. The stamping process meant that the buttons could be raised, stamped out of the sheet and impressed with the design simultaneously.

Buttons were all the rage. Button-makers had followed the pin-makers in forming themselves into a trade group, and their interests had been protected under Queen Anne, when a fine of £2 for every dozen covered buttons sold or set in garments had been imposed. Once metal buttons could be turned out in quantity, they were almost too much *à la mode*. It was said that 'tradesmen were aping their betters with myriads of gold buttons and loops, high garters, shoes and overgrown hats'. When foreign competition had been eliminated, partly through protective duties and partly from the 'lack of that development of the manufacture abroad which has since so

enormously progressed', then Germany, Holland, France, Portugal and America were 'all in favour of Brummagem buttons'.[17]

In 1777 Marston and Bellamy of Birmingham put a machine into operation which would stamp out patterned furniture-fittings, lock-plates and dozens of other small objects in large numbers.[18] And the runaway success of mechanised production did not stop at stamping. The next development was the steel 'swage block' through which brass wire or strip could be pulled or drawn so that its cross-section or profile was of ornamental shape. In 1779 William Bell further perfected this technique by impressing decorations directly on to the ribbon with die-cut rolling-cylinders.[19] This ornamental metal ribbon was shaped into small frames, such as those used for holding Battersea and Bilston enamel plaques, and for decorating the edges of small boxes. The ladies of England were devoted to patches at this time, and none too discriminatingly either, according to Misson, a Frenchman, who wrote 'The use of Patches is not unknown to French ladies; but she that wears them must be young and handsome. In England, young, old, handsome, ugly, are all bepatched until they are bed-rid. I have often counted fifteen patches or more upon the swarthy wrinkled phiz of an old hag three score and ten upwards.'[20] It can't have been a pretty sight, but the little boxes in which they kept their patches are a delight.

All these new inventions grew out of a desire to do what man's strength alone could not do, and slowly the brass industry became independent of the tight demands which nature had imposed when there were only the elements to provide power to do the work. Gone at last were the days when smelting furnaces had to be sited on hills in order to get enough draught to fire them. Gone the days when men laboured in fume-filled forges with primitive tools, or were deafened by the sound of the crashing of battery hammers. Machines were doing more than the ancestors of these eighteenth-century metalworkers could ever have imagined.

In spite of the fact that Birmingham was still handicapped by lack of water power and isolated by the atrocious condition of her roads, by 1700 its brass-workers already had a considerable reputation. Once Turner's Brass House was established in 1740, nothing could hold it back, and by the second half of the eighteenth century, Birmingham and fine brass were practically synonymous. The fame of Birmingham tends to eclipse the other brass centres in the British Isles in the eighteenth century, for up and down the country, in Bristol, Bridgwater, Chester and St Albans, there were craftsmen producing objects every bit as fine. But none in such great quantities as Birmingham – the toyshop of Europe.

Notes

1 Arthur Young, *A Six Months' Tour Through the North of England*. London, 1770–1.

2 *The Resources, Products and Industrial History of Birmingham* . . .

3 Quoted in Henry Hamilton, *The English Brass and Copper Industries to 1800*.

4 Patent Office. Patent No. 454.

5 Patent Office. Patent No. 505.

6 Patent Office. Patent No. 254.

7 Patent Office. Patent No. 567.

8 The weavers were so incensed by the popularity of cotton that they openly attacked people in the streets who wore cotton dresses, calling them 'Calico Madams' or 'Calico Picts' and tearing their clothes from their backs.

9 Quoted in E. Lipson, *A Short History of Wool and its Manufacture*.

10 The first Continental zinc-manufactory was not established until 1807, at Liège.

11 A mysterious Scotsman, Dr Isaac Lawson, is mentioned by some of the early German and Swedish metallurgists as having made a voyage to China expressly to discover the secret of smelting zinc, but Beckman, in his *History of Inventions and Discoveries* (1797), says '... in 1737 Henkel (a German chemist) heard that it was then manufactured in England with great advantage. Of this Lawson I know nothing more than what is related by Dr Watson'. Dr Watson himself was not able to 'learn with certainty' whether Lawson was indeed the Englishman who went to China or not. The mystery of Champion's discovery remains.

12 Arthur Young, *A Six Weeks' Tour through the Southern Counties of England and Wales*. 2nd edition 1769.

13 *A Serious Address to the Merchants and Manufacturers of Hardware, and particularly the Inhabitants of Birmingham and the adjacent towns, 1780*. Quoted in *The Resources, Products and Industrial History of Birmingham ...*

14 Patent Office. Patent No. 920.

15 Patent Office. Patent No. 935.

16 Patent Office. Patent No. 989.

17 Quotations from *The Resources, Products and Industrial History of Birmingham ...*

18 Patent Office. Patent No. 1165.

19 Patent Office. Patent No. 1242.

20 Frederick Misson, *A New Voyage To Italy, London*. 1714.

7
Birmingham and the Merchants

Birmingham was a most unsuitable place to be the centre of the brass industry, but it must be remembered that it had a tradition of metalworking which began long before either water-power, coal or roads played any great part in the production of the articles made there. In the early days of its existence the Romans and those who came after chose the area because it was hilly, and not, as later industrial towns were, situated on a river. This was because the furnaces and blow-houses needed strong currents of air to generate enough heat to smelt iron, the only metal worked in any quantity in Birmingham's early days. When changes came, Birmingham adapted as best it could to the new conditions, relying more than many other towns on chapmen and merchants to carry goods from the hearths and forges to the outside world. Without these links, the collection of towns and villages which were later to merge into the most important brass centre in Europe would probably have withered and died, as the metalworkers gradually moved away to more suitable towns, with better roads and communications and enough water-power to drive the new machines.

Cattle, sheep, butter, cheese, grain, wool and cloth all had their traditional local market towns, each one centred on its Butter Cross, Cloth Fair, Bull Ring or Cornmarket. But smaller trades relied almost entirely on chapmen or factors – travelling men who linked the makers to the merchant traders. These middlemen had considerable power, for they not only took merchandise to the London markets, they also frequently advanced money to craftsmen, who had to pay interest as long as their goods remained unsold. Nevertheless, although the West Country weavers, for example, loathed the factors and called them parasites on their industry,[1] it is difficult to see how they or many another craft and trade in isolated parts of the country could have survived if it had not been for the factors and their grander counterparts, the merchants. And long after most other trades had integrated themselves into smoothly-running organisations the metal trades in particular continued to depend on middlemen and merchants.

Merchants were a hardy race, and their value was acknowledged in Elizabethan days, when they took ship as representatives of the Merchant Adventurers and other big trading companies and sold whatever they could wherever they could. A great deal of self-sacrifice was expected of them apparently, for in Elizabethan instructions to one merchant, he is exhorted 'to remember he belongs to England and send back word of all he learns at every opportunity, so that, should you live or die, your country shall enjoy the things you go for, and not lose the expense of sending you.'[2]

During the sixteenth century there was a change in the structure of the wool trade as the amount of cloth being manufactured increased. Spinning and weaving moved away from the cottages where outworkers owned their own looms and tools, and

into centralised 'factories' employing large numbers of people. During the seventeenth century this movement was echoed as many other trades began to centralise, and it became the practice for one larger master to farm out tools and raw materials to outworkers, who made up finished goods and returned them to the master, who in turn sold them to the merchants. As the demand for finished goods increased, this method of organisation became more or less the rule, particularly in times of depression when single craftsmen or small groups of workers could not hope to remain self-supporting.

But in Birmingham it was much the same as it had always been. There was very little organisation of any kind, except in the established trades of the cutlers, naylors, lorimers and so on, who worked in iron and steel. The foreign workers brought methods with them which were unknown to the English, and worked up small quantities of brass, sharing forges perhaps between two or three families. They made 'smalls' and 'toys', boxes, buckles and buttons which they had traditionally made in their own native countries. The factors and merchants who took the trouble to find these 'straungerz' and bought their exquisite work to take to the London markets were understandably jealous of their contacts, and highly secretive about the forges and hearths which produced such beautiful objects.

These early travellers were free agents, for there were no laws, rules or regulations to which the goods they sold had to conform. The brass industry had been neglected as a craft, and most attention had been focussed on the vested interests of its industrial side. This meant that fine brass had no overseeing of any kind – no guild, like the Pewterers, Goldsmiths, Silversmiths and other crafts, and no quality control except that which the metal itself imposed.

There seems to be no good reason why this situation should have existed: indeed there would appear to have been a very good argument for overseeing raw brass, until one remembers its early days. It was not in the interests of Crown or Parliament to listen to the workers' complaints about the poor quality of the raw brass being made by the Mineral and Battery Works. And although the brass-workers found themselves time and again unprotected against the merchant companies who imported goods already being made in England, and forbidden to work good imported brass in order to improve the quality of their finished articles, it was in nobody's interest to enquire too closely into the actual state of affairs. England depended on the big chartered companies for more than just trade. They supplemented the fleet in times of war, and filled the Exchequer with money levied from duties and taxes. The workers in the brass trade were insignificant compared with the benefits gained by leaving the chartered companies to trade freely. Equally, from the brass-workers' point of view, many of them were aliens and subject to different laws from English workers. Craftsmen who managed to find supplies of foreign brass risked being penalised if they were discovered. Over and above all these factors, it is very likely that controls, taxes and duties were too difficult to impose on an alloy whose components could be foreign copper and English zinc, or whose final composition could include a large quantity of unidentifiable shruff.

As for the failure of the metalworkers to organise themselves into trade groups, it is unlikely that there were very many who made brass articles alone. Like piece-workers today, they worked up different metals depending on what the merchants would buy. Where more than one workman was needed to produce a finished article – as in the case of pins, buttons, buckles and clasps – they worked together in

'factories', and it was in these trades that guilds and societies were formed. For the small hearth and the single craftsman with perhaps one or two metalworkers and an apprentice, there was no one trade to which he solely belonged. He worked with iron and steel and brass, functional metals with no intrinsic value, and if sometimes he made beautiful 'toys' he saw no reason to put his mark on them any more than he might on a steel lock or an iron key.

In all its history, there was only one attempt to oversee the quality of brassware, in 1617, and then it only covered imported battery goods, kettles and finished brass. Complaints had been growing about the poor quality of some foreign workmanship and the fraudulent practices of foreign suppliers. James I appointed a 'searcher' to check the brass coming into England. Fine-quality brass articles had to be stamped, bad-quality battery goods were slit at the edges, presumably to prevent them from being sold. It was a brave attempt, but doomed to failure because of the irregular trading habits of the merchant companies. In 1634 it was reported that the office of searcher had fallen into abeyance and needed to be revived.[3] But nothing was done, either then or later. It was a hundred years before the Company of Armourers and Braziers obtained authority to examine brass and battery goods produced in London, and by then London was no longer the principal producer of brass.

The amount of brass being made in Birmingham before the Civil War was small, and confined to candlesticks and a few 'toys' made by foreign workers. But the practice of 'small masters' employing two or three men and several apprentices was growing slowly. When the Virginia Company was founded after the Civil War, opening up new markets for special goods for the new colonies, the brass-workers were able to meet the merchants' contracts as long as they could find enough raw brass. After 1666, when the outports became the working headquarters of many big merchant companies, the factors and merchants who had already built up good connections with metalworkers in the provinces found themselves very well placed.

There is no proof of internal patterns and routes, but it is reasonable to suppose that it was the merchants from Bristol who overcame the problem of Birmingham's inaccessibility. There is a 'Bristol Road' marked on eighteenth-century town maps of Birmingham, and if the merchants could not dispose of all the goods they bought to the trading companies there, then the road from Bristol to London was a relatively good one. Once the Bristol Brass Company began to supply Birmingham with brass, there were carriers' vans and carts making regular journeys to the forges to make the merchants' business links much easier.

Before the 1720s Birmingham was almost entirely reliant on shruff for supplementing the small quantities of foreign brass imported into the country. Most small articles and 'toys' were made of cast brass at that time. The forges were almost identical to a blacksmith's forge, except that they had a hollow or hearth in the centre of the forge which took the crucible in which the metal was melted down. Certain refinements in the regulation of draught produced a fiercer heat in the hearth than in an open blacksmith's forge.

The casting process is a very old one, and although the methods seem incredibly primitive, the same system is still used by small bronze-casting foundries today. A 'flask', an open wooden box in two halves without a lid or base, is partially filled with a special kind of sand, mixed with loam, calves' hair or horse-manure, which binds and holds well when it is wet. The master copy of the object to be cast is impressed into the bottom half of the box, and the sand rammed down as tightly as possible all

round it, leaving half the master copy standing proud. The surface of the sand is then dusted with a fine layer of charcoal, bean flour or burnt red brick-dust to prevent it from sticking. The empty frame of the top half is then fitted on, and in turn filled with the sand mixture and well tamped down. Moulding boards forming the base and lid of the box are then put into place, and when the sand is judged tightly enough packed round the article the two halves are separated again. The master copy is carefully removed and the sand dried to an almost cement-like hardness. The two halves are then firmly clamped together and molten metal is poured into the mould through a small channel at one end. When the molten metal is cool and hard, the moulding boards are removed and the finished cast is 'tapped out' and finished by hand.

In 1693 John Lofting, a London merchant, took out a patent for casting a large number of thimbles at one time. His patent shows that advanced casting methods had been used in Europe long before this date, for it states that thimbles 'in Germany and other forreigne parts whence they have been heretofore imported into this kingdome . . . are usually made by a certain engine or instrument hitherto unknown in our dominions'. The patent granted him 'the sole privilege of makeing and selling the said engine or instrument'.[4] Lofting and several Dutchmen set up a thimble factory near Islington – the first known instance of a brassworks specialising in casting one individual small item. Special sand from Highgate was used to make the moulds, and six gross of thimbles were turned out at one casting. Battery brass and shruff were melted down and poured into the moulds. When the castings were cold, they were separated with greasy shears and boys were employed to dig out the cores with pieces of pointed iron. The thimbles were tumbled in a barrel to remove the worst of the roughness, and then turned on a wheel and polished. The Islington works carried out anything up to six or seven castings a day, and one wonders where the daily output of over 5,000 thimbles could go. But they probably did not cast more than once a week, and they would certainly have taken as many castings as possible once the furnaces had been fired and the molten metal made ready. And one must remember that thimbles were not only used by ladies at their needlework, but by harness-makers, leather-workers, book-binders, hat-makers, cobblers, sailmakers and many other trades as well as tailors and dressmakers.

Patents for casting processes had been taken out before John Lofting's, but only for large things like bells and cannon, cauldrons and candlesticks. It can be assumed all the same that the foreign workers in Birmingham were using various methods of casting at the end of the seventeenth and beginning of the eighteenth centuries. Around this time, for instance, the candlestick-makers began to experiment with hollow-core castings, which allowed them to economise on the amount of brass they used, for casting was an extravagant process. The earliest proof that casting was generally being used for small articles is an indenture taken out in 1715 between Thomas Orme, toymaker of Birmingham, and Henry and Walter Tippen, brass-founders – the first documented evidence of co-operation between a toymaker and a brass-founder for casting small 'toys'.

Once the Cheadle Brass Company had opened and supplies of raw brass were easy to come by, the brass-workers of Birmingham began to increase both the quantity and variety of merchandise. The casting process meant that small numbers of identical articles could be made, such as furniture mounts, small ball-and-claw feet for clocks, tea-caddies and workboxes, doorknockers, bell-pulls, handbells, finials

and so on. And here the confusion between cast brass and bronze reappears. Brass made before 1750 may have traces of tin in it as well as zinc,[5] where bronze and brass were melted down together, but most of the things still classified by quite knowledgeable people today as gilt bronze are in fact gilt brass. The art of bronze-making may have been easier than brass-making, but casting bronze is far more difficult than casting brass. Bronze is hard to control in its molten state, being sluggish and slow to pour and quick to set. Very little bronze was made in Birmingham or any of the principal brass centres, and bronze casting was mainly confined to statues, busts, and bells – at least until Matthew Boulton's day. The sand used for making casts was said to be found only near Highgate near London, and once again difficulties of transport prohibited the carting of large loads for any distance until the roads and canals at last linked Birmingham to her major sources of supply for raw materials.

Birmingham, then, by the beginning of the eighteenth century had a growing reputation for brass as fine as any made on the Continent. During the lean years its main stock-in-trade was buckles, which had first been made in brass as early as 1685. There is a saying that the year 1688 was famous for 'William, Liberty and the Buckle'. Certainly by 1689 the fashion had caught on, and Birmingham took it up and made great quantities of buckles, from simple shoe-fastenings to highly ornate affairs which almost covered the entire shoe-front. They were still such an important part of the metal trade when shoelaces came in in 1800 that the Buckle Makers actually petitioned George III to continue wearing buckles so that the fashion would not die out. Merchants also had contracts with foreign buyers for Birmingham brass. In 1711, for instance, one saving grace to many a struggling brass-maker was a contract for making all the buttons for the entire Russian army,[6] and when a button manufactory was established in St Petersburg in 1725 it was a great blow to the English button-makers.

Rods and rings for the African market were a steady though uninteresting source of income. Also cast in Birmingham were 'manillas', a kind of specie money or trade token, used in the Spanish river settlements on the New and Old Calabar, and on the Bonny River in Africa. Some unscrupulous traders, cutting the cost of their manillas, had them cast in copper and lead, hardened with arsenic. They were aghast to discover that the natives could tell the difference with their teeth by the softness of the alloy. As well as manillas other specie money was also made: 'cock money', so called because of a chanticleer on one side, ring money, and specie money for the traders with China – coins with a square hole in the centre, surrounded by Chinese characters.

Birmingham began to grow. From 1659 to 1700 her population increased by nearly ten thousand to 15,032. These were the years which spanned the influx of Dissenters after the Acts of Uniformity and the flood of foreign workers driven out of Europe by the revocation of the Edict of Nantes. Between 1700 and 1731 another eight thousand people settled in Birmingham and the town itself added no less than twenty-five new streets to its size.[7] By this time the advantages of remaining a free city were far outweighed by the need for corporation services to administer its affairs. In 1716 Birmingham petitioned Parliament for a charter of incorporation, but unfortunately there was also a struggle for power being fought out in the local manorial courts. In London the petition was only seen as an extension of this private battle and was therefore refused. It made little difference to the people, who

continued to support the expense of running an orderly community voluntarily. Birmingham was at least as well governed as any other city in the country. Her high proportion of puritan-minded townsmen saw to it that the citizens of Birmingham lacked nothing it was in their power to give them. One of the greatest of the town's privileges was freedom from the dead hand of the old guild systems.

With the growth of the Empire, 'trade followed the flag' and the brass industry began to assume considerable importance. Parliament at last turned its attention to the abysmal state of the roads in and around Birmingham. Concern for the brass trade was probably not the only factor at work here, for by the end of the seventeenth century other things were being made in the vicinity which interested Parliament. By 1707 there were about four hundred people employed in making guns, many of them immigrants from Liège, internationally renowned for its gunsmiths.[8] In 1726 a commission was appointed to look into the whole condition of transport in and around the city. It found what many a travelling merchant had long known to his own cost – that the roads were in a ruinous condition. The deep ruts cut by the coal wagons made them completely impassable in many places, and though pack horses were used to carry some goods over roads too bad for carriers' vans, there were many things they could not take. A stage wagon called once a week to carry heavy goods to London, a journey which took several days. Otherwise, merchandise was taken to Bewdley and shipped out on barges down the Severn, or taken overland to Worcester to join the Severn there. The alternative was to send goods out to Castle Bromwich on the main road, where it could pick up a carrier going south to London or north to Chester, Liverpool and the overseas markets. Carriers' vans with instructions to collect or deliver knew this great hive of industry only as 'Birmingham, in Warwickshire. N.B. Turn at Coleshill'.[9]

Yet for all its activities Birmingham still had no commercial organisation of any kind. The first mercantile house to deal directly with foreign markets was not set up until 1750, and Birmingham did not get its own Assay Office until 1773. W. Hutton wrote in 1780:

The practice of the Birmingham manufacturer for perhaps a hundred generations was to keep within the warmth of his own forge. The foreign customer, therefore, applied to him for the execution of orders and regularly made his appearance twice a year; though this mode of business is not totally extinguished, yet a very different one is adopted. The merchant stands at the head of the manufacturer, purchases his produce, and travels the whole island to promote the sale; a practice which would have astounded our forefathers.[10]

The merchants from Birmingham were mainly responsible for building up the reputation of English brass, not only at home but abroad, for as Hutton says, 'The commercial spirit of the age has penetrated beyond the confines of Britain, and explored the whole Continent of Europe; nor does it stop there, for the West Indies and the American world are infinitely acquainted with the Birmingham Merchant; and nothing but the exclusive command of the East India Company over the Asiatic trade prevents our riders from treading upon the heels of each other in the streets of Calcutta.'[11]

The Parliamentary commission on the state of the roads was evidently taking its time. In fact it was a young aristocrat's traditional Grand Tour of Europe which changed the whole transport structure of the Midlands and industrial Britain.

Francis Egerton, Duke of Bridgewater, was extremely impressed by the canal-building he saw while he toured the Continent, and when he returned to his own estate, Worsley, he decided to build a canal to join his coalfields to Manchester, five miles south, thereby cutting the enormous cost of sending in coal by road. In 1759, wholly planned and financed by the Duke, work began on the first engineered waterway in England. The canal was opened in 1761, and linked the coalfields direct to Manchester – the first work of James Brindley, the eccentric architect and engineer. A few years later the Grand Trunk Canal was opened, running through Josiah Wedgwood's Potteries and linking the Trent with the Mersey.

In 1767 a meeting was held at the Swan Inn, Birmingham, where it was unanimously agreed to survey the possibilities of a canal to run from Birmingham to the Wolverhampton coalfields. James Brindley was contracted, and work began almost at once. The Birmingham Canal was opened in 1769, and at the same time a link was made with the Staffordshire and Worcestershire Canal which had been extended to join the Severn at Worcester. Like the last piece of an ice-cap melting, the Midlands were finally released from their enforced immobility, and goods of all kinds began to flow freely from pithead to furnace and mill, and from mill and factory to market. The barges nosed their way through the locks down to the coast and the ports; the costs of fuel came spiralling down, and the price of finished goods was never cheaper.

The rest of England was changing too, and not always for the better. As the industrial towns grew, the craft industries of the cottage and countryside shrank. Communications between small towns and villages were still appallingly bad, and in winter whole areas of the country were cut off completely from the outside world. From 1740 onwards, the Enclosure Acts dispossessed thousands of tenants and smallholders as rich agriculturalists enclosed more and more land in an agricultural revolution which fenced, hedged, drained, drilled and sowed land which had hitherto been cultivated in a rather haphazard way. There were also fortunes to be made in breeding sheep and cattle for the table. Up to this time the main, and indeed only consideration had been to breed sheep for their wool and cows for their milk. Farmers on the Continent had been breeding animals for slaughter for some time, and when new breeds of fatstock were brought over from the Low Countries, English farmers and landowners took the idea up with almost too much enthusiasm, evicting tenant farmers and leaving many small farmhouses to become derelict rather than outlay the cost of repairs and rebuilding.

This time the change was part of a far greater one which now began to alter the whole fabric of England. The provincial towns and cities, grown large with new mills, factories and businesses, could no longer support themselves – there were too many mouths to feed. Paradoxically, while their prosperity increased, their living standards actually fell. Food must now be bought from the farmers and breeders, and a new pattern began to emerge, with towns depending on country produce, and countrymen depending on the townsmen's money. Produce was no longer grown simply to feed the local community. It was taken away and sold. Butter and cheese, hens and geese, sheep and cattle, grain and vegetables went from the country to feed the towns. Fresh food was scarce in the villages and hamlets, and because carriage must be paid, it cost more in the cities. Moreover, wood was scarce and coal expensive in the industrial towns, and the poorer families were reduced to taking their Sunday joints round to the nearest bakery oven to have them cooked. For the

rest of the week they had to make do with one of the many cheap eating-houses which sprang up in the back streets. At the other end of the scale, plushy chop houses and steak houses catered for the wealthy industrialists, tradesmen and land-owners. Thin cheek by fat jowl, the people in the new industrial towns were divided.

The straitlaced men of Birmingham must have been shocked to hear how fashionable people behaved in London. There were more prostitutes than in any other city in the world, many of them girls of twelve and thirteen, come to London from the hard provincial world. Cock-fighting, bear-baiting, gambling, routs, masquerades and extravagances beyond their wildest imaginations amused a bored and beautiful society. But still, it was for these people that Birmingham was making her fine brass. The descendants of the Dissenters and the Huguenots, the Flemish and the Dutch did not hold with ostentation and vulgarity, and they tempered the demand for flamboyance with a certain purity of line and restraint of design which is perhaps the best and only hallmark of fine English brass.

Birmingham was a revelation to Mr Hutton. 'I was much surprised at the place, but more at the people. They were a species I had never seen; they possessed a vivacity I had never beheld; I had been among dreamers, but now I saw men awake . . . Every man seemed to know and prosecute his own affairs; the town was large, and full of inhabitants, and these inhabitants full of industry.'[12] Other industrial towns were low-lying, and by now already enveloped in familiar shrouds of fumes and smoke. But fresh winds blew cleanly through the streets of Birmingham, and Wenlock Edge and the Worcestershire gardens of England surrounded its western side. Its lofty setting may have been attractive, but it was also the reason why many of the iron and steel workers had already moved to Warrington and other places in the west Midlands. There was no water-power to drive the new machines.

Birmingham was entirely dependent on one small, inadequate flow of water at Hockley, which could only drive 'a feeble mill'. Small hand-operated or horse-driven machines were all that could be used. The problem seemed insuperable, yet it must be solved if Birmingham was to compete and survive. Insuperable too were the endless trials and tribulations of flooding in the Cornish mines, on which the brass industry still largely depended for the bulk of its copper. Working engines of magnificent inventiveness using air pressure had been constructed over the years to pump out the Cornish mines, and as early as 1702 Thomas Savery had put his first steam engine, 'The Miner's Friend', to work, but with only moderate success. However the Newcomen engine which developed out of Savery's prototype was remarkably efficient and reliable, and by 1765 there were no less than a hundred of them in operation, mostly in the Midlands coalfields. In 1768 a canal was cut which connected the collieries of Staffordshire with the furnaces of Birmingham and coal at last was cheap and plentiful – a fact which set many men's minds turning on the possibilities of using the coal-fired Newcomen steam engines for other things than pumping flooded mines. For, in the words of Samuel Timmins, 'very soon Birmingham men appear to have learnt that water power of so feeble and uncertain a kind as it is in their locality could be but little depended upon, and the first who seems practically to have obviated its use was a Mr Twigg who erected, in the year 1769, an infant steam or "fire engine" on the principle of Newcombe and Cawley . . . In all probability observations on the defective working of that engine led to [Boulton's] appreciation of the invention of James Watt, and eventually led to the partnership of these two celebrated men.'[13]

Matthew Boulton is a Victorian figure, despite his Georgian date. He was the first great 'Brass Baron' and the forerunner of all those later captains of industry who completed the industrial revolution begun so long ago at Keswick and Bristol with machines brought in from Germany. For Matthew Boulton 'bought brains': he had interests in mining, both in Cornwall for copper and tin and in the Midland coalfields, and when James Watt arrived in Birmingham after the hidebound guilds of Glasgow had refused to accept him as a scientific instrument maker, Boulton immediately took him up. He encouraged and financed his experiments with steam power, and in 1769 Watt took out his first patent, abruptly entitled 'Steam Engines etc.'. Boulton's great Soho Works were already producing all kinds of small objects of superb quality in copper, brass, and a variety of allied metals, in spite of the very limited power available. He took James Watt into partnership and together they gave Birmingham the engines to drive the new machines.

As more and more people wanted more and more of the same things, trades began to specialise, and by 1770 the *Tradesman's True Guide – an Universal Directory for the towns of Birmingham, Walsall etc.*, published by Sketchley and Adams, listed the specialised trades as follows: 'Three Brass Founders, Ten Braziers, Seven Candlestick Makers, Forty Three Buckle Makers and Eighty Three Button Makers . . . [who made] . . . an Infinite Variety . . . in both white, yellow, bath metal, pinchbeck, silver tuetinage and white, also of copper and steel'. The merchants could no longer carry samples of the ever-increasing range of Birmingham brass in their saddlebags, and by the time the new canal was opened in 1769 they had already resorted to carrying pattern cards and pattern books to show what they had to offer.

In 1781 the great Birmingham Brass Company was founded with Boulton and Watt as two of the principal shareholders. Steam-powered engines turned rolling mills, drove stamping machines, and industry teetered on the brink of mass production. But for the small master who made hand-finished articles of all sorts, the pattern remained the same for another forty or fifty years. He worked at his own hearth, using casts made by cast-makers, now greatly improved and made of iron or brass instead of wood. More often than not he specialised in a few designs which he turned out in small numbers, and he also made some individual articles on commission.

These small workshops were run by masters who each employed a handful of experienced metalworkers. They also took on apprentices, who became indentured to the master at fourteen years old for a period of seven years. In addition to teaching an apprentice his trade, the master also taught him the rudiments of reading, writing and arithmetic, and saw that he studied the Bible. Masters in many trades were often little better than slave-drivers, and apprentices frequently ran away from the long hours and appalling conditions. Brass-making was hard and dirty work, but in a city with a tradition of metalworking, so were all the trades to which a Birmingham boy might find himself apprenticed. And one gets the impression that though they were strict and hard-working, the Birmingham brass-masters were at least fair and honest.

Once the first steam-powered machines were installed, it was inevitable that the days of the small craftsmen were numbered. England was Great Britain now, with an Empire founded on trade. America was a continent and not a group of little settlements. The copper-mines and smelting works and zinc manufactories could produce unlimited raw material for the brass-foundries, and all manner of things

St. Thomas November 14th 1782 St^g.

Isaac Dorleon D^r to Merchandize in C^o w Ambrose Lloyd					
Brought forward		5. 14	1565	2	8

Handwritten ledger page; values not fully legible.

Item		£ s d	St^g		
2 d^z horn Lanthorns	24/	2. 8. —			
70 G^s Corks	1½	5. 5. —			
Puncheon		1. 2. —	14	9	—
1 Puncheon N^o 76 Containing the same as the above		" "	14	9	—
12 d^z Sailors bound Hats N^o 1	12/	7. 4. —			
11 d^z d^o 2	14/	7. 14. —			
6 d^z d^o 3	16/	4. 16. —			
Brush C^o Case 11/6		— 12 —	20 6		.
14 doz d^o N^o 1	12/	8. 8. —			
14 d^z d^o 2	14/	9. 16. —			
8 doz d^o 3	16/	6. 8. —			
Brush C^o Case 13/		" 13. 6	25.	5	6
15 d^z d^o N^o 1	12/	9. — —			
15 doz d^o 2	14/	10. 10. —			
7 d^z d^o 3	16/	5. 12. —			
Brush C^o Case 13/		" 13. 6	25.	15	6
4 Nests hair Trunks, Brass mounted & matted	3/	7	7.	12	—
5 Bundles cont^g the same N^o 78. 79. 80. 81. 82. ea 7 n^s			38.	—	—
4 Nests Gilt red leather Trunks matted	20/		4.	—	—
3 Bundles N^o 84 Cont^g the same as the above 85. 86. 87. 88 ea 4			20	.	"
28 d^z plain Wine Glasses	3/	4. 4. —			
12 d^z flint Mason d^o	4/6	2. 14. —			
18 d^z half pint Tumblers W^t 95lb	1/	4. 15. —			
18 d^z gill d^o	3/6	3. 3. —			
18 d^z ½ gill d^o	2/6	2. 5. —			
3 d^z plain ½ pint Tumer Glasses	9/	1. 7. —			
a Puncheon		1. 2. —	19	10	—
28 d^z doub^l flint Bumper Wine Glasses	4/6	6. 6. —			
12 d^z best plain Wine Glasses	4/6	2. 14. —			
19 d^z half pint Tumblers 9^t 100lb w^t	1/	5. — —			
19 d^z gill d^o	1/	5. — —			
10 d^z ½ gill d^o	3/6	3. 6. 6			
3 d^z plain ½ pint Tumer Glasses	9/	1. 7. —			
a Puncheon		1. 2. —	21	"	6
Carried Forward £			1775.	10.	2

A page, dated November 1782, from the Lloyd-Vaux account book of trade carried on between England and America via the Virgin Islands. The preliminary treaty of peace to end the Wars of Independence was signed on 30 November 1782, and the definitive treaty on 3 February 1783. Lloyd and Vaux were Philadelphia merchants who ordered a large range of goods from England and Ireland, transferred them on neutral soil (in this case St Thomas, Virgin Islands, at that time a Danish possession), and shipped them on from there in American bottoms to Baltimore, Wilmington and Philadelphia. *Winterthur Museum.*

which had traditionally been made of iron and steel began to be made of brass. It was cheap, it was lasting, it was versatile, and it did not rust. Once the stamping process was brought in it was possible to produce elegant brass fittings of all kinds, indistinguishable from expensive cast brass, at a quarter of the cost. The solid middle classes could have the gentle sheen of silver and the bright glint of gold without dipping too deep into their purses and pockets. There was silvered brass and gilt brass above stairs and plain elegant functional brass in the kitchens and stables and outhouses. Cabinet-makers now decorated their furniture with elegant brass handles and escutcheons for ordinary households, as well as for the rich and noble.

Two more inventions at the end of the eighteenth century were finally responsible for tipping the brass industry wholesale into the age of mass production. In 1781 James Emerson of Gloucestershire, Brass and Spelter Maker, took out a patent for making brass by direct fusion,[14] the principles of which still underlie all brass-making today. It is interesting to see how old traditions persist: Sir John Pettus in his first description of brass-making notes that '8 pots or pipkins are set out and filled . . .' and a hundred years later, James Emerson was still using eight pots for his measurements.

Direct fusion of zinc and copper meant that brass could now be produced of completely controlled and even quality, without variation in colour or malleability. It was a great advance for the industrial face of brass, which had now begun to produce piping, valves and stopcocks for machines. But a little bit more of the individuality of decorative brass was peeled away; the imperceptible differences in colour vanished, and a master craftsman could no longer tell whether the brass he was working came from Birmingham, Bristol, Cheadle or Wales. Brass became a little more impersonal.

The last important innovation was patented in 1783 by Henry Cort, not from Birmingham or Bristol, but from Tichfield, not far from Steere's pirate brassworks at Chilworth. His foundry, the Funtley Iron Mills, produced iron fittings for the docks and shipyards of Southampton, and it was he who finally harnessed steam power to the rolling mills on a commercial scale.[15] His machines were adapted to the brass trade, and soon it was possible for a multitude of objects to be cut, stamped, impressed and decorated without a man's hand touching them. But for all that, the articles made in the early years of mass-production still had a certain quality of line and finish which distinguished them as English brass of fine ancestry and tradition. It was the Victorians who ultimately dealt the fatal blow to English brass, bringing it into such low repute that much fine early brass has since been judged in the same breath as the shoddy tasteless mass of later years.

Notes

1 The weavers and clothiers agitated frequently against the wool 'broggers', but even after the Civil War Parliament refused to intervene, on the grounds that the wool grower should be able to sell his wool 'to any chapman he might think fit to deal with'.

2 Quoted in Dorothy Hartley and Margaret Elliot, *Life and Work of the People of England*.

3 S.P.D. James I. xciv. 8. Calendar 1611–18, p. 493.

4 Patent Office. Patent No. 319.

5 Analysis of many early 'bronze' and 'brass' objects shows that the alloys frequently contain both tin and zinc. The term 'brass-bronze' is sometimes used by purists.

6 House of Commons Committee Reports, x, p. 162.

7 W. Hutton, *History of Birmingham*, 1781.

8 *The Resources, Products and Industrial History of Birmingham* . . .

9 *Birmingham Gazette*, 6 February and 28 May 1744. See also W. T. Jackman, *The Development of Transportation in Modern England*.

10 W. Hutton, *History of Birmingham*.

11 *History of Birmingham*.

12 *History of Birmingham*.

13 This statement of Timmins is a curious one, since there is no trace of Mr Twigg in the subsequent unscrupulous race between the Cornish inventors – Trevithick amongst them – and Boulton's protégé James Watt, to harness steam power, though there is mention of an engineering company called Charles Twigg and Company in contemporary records. In all probability Matthew Boulton bought him out, since James Watt's penalising patent which (or so he thought) gave him a monopoly on the application of steam power for no less than twenty-five years, is dated that same year, 1769. The first Watt engines were installed in 1774 at Wheal Busy, near Chacewater, and at the Ting Tang mine near Redruth.

14 Patent Office. Patent No. 1297.

15 Patent Office. Patent No. 1351.

8
Patterns and Pattern Books

The position of the brass trade between 1689 and 1760 was that of making only – it had not reached the dignity of manufacturing. The then industry of Birmingham was, as has been well said, 'of a staid and steady character', while the fame of the brass articles produced had, even in those days of imperfect roads and limited means of transit, reached many of the larger towns of the empire; the manufacturers remained at home and let the orders come to them; customers did come, and brought with them, not three or six months' acceptance to pay for their purchases, but produced the cash from their saddle bags, paid for what they had, and took their limited purchases away in the same receptacle or, if too bulky, had them forwarded by the first carriers' van, drawn by four horses. The era of travellers and blue bags had not then arrived. Oak brass-bound boxes, filled with pattern cards, on which are displayed samples of the articles made by the houses represented, had not then been called into existence; and of pattern books, folio in size, with representations of the articles, there were none.[1]

The smug Victorian overtones of Samuel Timmins's report on the industrial history of Birmingham, and his characteristic idolisation of mass-production methods, are all too evident in this description of the brass trade. But the tone is too disparaging of Birmingham's fine brass, for already a prodigious quantity of articles was being produced, from everyday objects like hooks and hinges, buttons and buckles, to all kinds of small objects of exquisite beauty. Many of the brass workshops were Alladin's caves of intriguing, tempting 'toys', and many a brass-founder was making a fortune out of his trade. Hutton tells of one John Taylor, living in Birmingham around the 1750s:

To this uncommon genius we owe the gilt button, the japanned and gilt snuff boxes with the numerous race of enamels ... In his shop were weekly manufactured buttons to the amount of £800 exclusive of other valuable products. One of the present nobility, of distinguished taste, examining the work with the master, purchased some of the articles, among others a toy of 80 guineas value, and while paying for them observed with a smile 'he plainly saw he could not reside in Birmingham for less than £200 a day'.

John Taylor, adds Hutton, died worth £200,000.[2]

It is quite obvious that even if there had been no tradition of pattern books and design books the Birmingham merchants would have had to invent them. By the 1770s the craftsmen were producing such an enormous range of merchandise that it was no longer possible for a factor or merchant to carry representative samples around with him to show to his wholesale and private customers. However there was already a long tradition of books or collections of drawings and sketches for designs engraved on gold, silver and other metals, as well as designs for jewellery. The goldsmiths and silversmiths of Genoa and Venice used pattern books of this

kind as early as the fifteenth century. In particular the makers of weapons illustrated their designs for poignards and sword-hilts, either engraved, inlaid, damascened or studded with precious stones. By the seventeenth century many other craftsmen in Europe were producing sheets of designs, bound together in loose book form.

In France, Jean Bérain, architect, designer and engraver, was employed by Louis XIV to design the scenery and costumes for court masques and fêtes, and printed many sheets of engravings showing his fantastic, grotesque creations, among them the monkeys which became so popular and which influenced not only court fashions but humble faience in regions a long way from Paris and Versailles. In England a book of Adam van Vianen's work was published by his son Christian van Vianen, who came to London in 1635 to be court silversmith to Charles I and II. The book was widely circulated among designers and makers of fashionable tableware and considerably influenced the style of the day as a result. The French goldsmith and ornamentist Meissonier also published designs for elegant silverware, many of which were eventually made in porcelain and not silver. Books of designs were also published in Germany in the early eighteenth century by Paul Decker and Johann Leonhard Eysler, intended to be used by craftsmen carrying out their work.

In England pattern books as such did not make their appearance until the middle of the eighteenth century, coinciding with the burst of creative talent and the expansive, elegant way of life of the landed gentry and rich professional classes. This was the age of the country seat and the house in Town. The provinces flowered with spas and watering-places, graceful crescents and terraces. The countryside was adorned with superb country houses with landscaped gardens and parklands, and everywhere there breathed an air of peace and prosperity. Country estates became fashionable as roads and carriages improved, and the landed gentry now decided to live on the estates they had neglected for so long. The legacy of Queen Anne and Georgian architecture speaks for itself in almost every county in England. Often carpenters, joiners, plasterers and cabinet-makers were brought from the towns to work with the architect and designer entrusted with the building and furnishing of a grand new country seat, for many local craftsmen had already left their homes, forced out of the villages by lack of work. Perhaps this is why early English pattern books illustrate entire suites of furniture with all the details and all the fittings. The most influential of these, Thomas Chippendale's *The Gentleman and Cabinet Maker's Directory* published in 1754, is too great a work to be demeaned by the title 'pattern book'. It shows how comprehensive the early English books of design were, illustrating furniture of all kinds as well as fittings and embellishments, even including drapes for beds and windows. In this respect Thomas Chippendale's book bridges the gap between the design books, whose function was to show the buyer and to guide the craftsman, and the pattern books of articles actually available from the manufacturers.

The brass-makers' pattern books, show the incredible versatility and universal use of brass. In many cases they illustrate such a humble range of ordinary things, so taken for granted today, that it is delightful to think they were once an exciting novelty. Brass, after all, was a newcomer. Iron and steel eventually rusted, especially in the damp English climate. Brass was durable as well as decorative, and a million and one improvements took place in every branch of making and manufacturing, as well as in ornament and design.

The bulk of many pattern books, as may be seen from the large collection at the

Victoria and Albert Museum, is taken up with strictly utilitarian ranges of hardware and 'ironmongery'. Hooks, hinges, castors, fancy nails and patterae for upholsterers, escutcheons, drawer knobs and handles, all of the plainest, most functional kind. There were window catches and door catches, coach fittings, harness fittings, locks, cogs and wheels, taps and chains and all the humdrum bits and pieces of metalwork that are so commonplace today as to go unnoticed. There are plain buckles and ornamental buckles, brass buttons for livery, for regiments, for engraving with coats of arms or monograms, and buttons so beautifully worked that they are miniature works of art. There were cloak and hat pins, purse mounts and chatelaines, needlecases, patch-boxes, snuff-boxes, watch stands, clock faces and finials, scroll-work and ormolu mounts for furniture, picture frames, mirror frames, medallions, walking-stick and umbrella handles, scissors, knives, seals and watch cases – all of them 'toys' of the most exquisite workmanship and design. But 'the fashion of today is thrown into the casting pot tomorrow', as Hutton briskly says, and all too often not even the pattern books are left to testify to the skill and craftsmanship of the eighteenth-century brass-maker. Like the objects themselves, the designs went out of fashion and few people considered old trade catalogues worth preserving.

The largest items found in pattern books are candlesticks, wall brackets, wax or taper jacks, tea bells, house bells and an occasional rarity like a range of beautifully elegant brass dog collars. Unlike design books, the brass-founders' catalogues illustrate every item 'actual size'. Some of them even reproduce a range of standard screws from the smallest to the largest with painstaking accuracy. If the object was too big to fit the page, there was no question of scaling down the drawing. The page was simply made larger and folded to fit inside the covers.

Many pattern books are fine examples of the art of engraving, notably the Sheffield plate books which began to appear around the 1780s. Sometimes, though, and often in the case of the brass-founders' books, the illustrations are a little crude and scratchy, because the engravings were done in the brass-founders' workshops by their own engravers, who, though highly skilled in engraving on metal, were not familiar with copper-plate techniques for the printer. No doubt the brass-founders of Birmingham were thrifty, but they were also very jealous of their designs. In a trade which depended so much on the fickle wave of fashion, designs could be pirated, and it was a needless risk to put drawings out to an engraver in a town where every third man was a metalworker. This was particularly the case with cast brass, when the brass-founder would already have paid good money to a cast-maker for a few precious casts for his special designs.

Although ostensibly these pattern books were intended to tell the buyer all he needed to know about a manufacturer's range of items, embellishments and finishes, they were curiously secretive in many respects. None of them has a title page or a maker's name, and none of them is dated. Almost all of them have pages numbered out of sequence and seem to be bound at random. The reason for their anonymity is simple. Pattern books were used by factors, the equivalents of commercial travellers, or by merchants, who negotiated contracts with trading companies for overseas markets. Neither of them wanted to disclose the source of their merchandise, particularly once communications improved and travelling became easier. Contacts between merchants, factors and craftsmen had been built up painstakingly over the years, when roads were almost impassable and sources of fine brass were jealously guarded. Now, with new roads and regular stagecoaches, if the cabinet-maker or

wholesaler discovered the source of supply, there was nothing to prevent him from going to Birmingham himself and placing his order direct. For the same reason, retailers who sold to individuals, or perhaps supplied an entire country estate, were more than happy to leave the manufacturer's name unknown.

The random numbering of pages is accounted for by the merchant changing his range from time to time, adding something new or dropping something no longer in favour. Sometimes too merchants would tear out pages and give them to a potentially good customer or a favoured retailer in much the same way as books of wallpaper samples or swatches of cloth are treated today. The absence of any dating also has a simple explanation. No brass-founder or merchant wanted his goods to be pronounced out of date. Many things which went out of fashion in London after a short time would still be popular in the provinces and the overseas markets for many years to come. Many brass-makers relied on a range of functional things for the bulk of their business, and it was only the few fashionable objects which changed their design. It was far cheaper to substitute a few pages of these exclusive items than to have the whole pattern book reprinted and rebound.

For these reasons it is extremely difficult to date a pattern book accurately from this distance in time. One pattern book, for instance, has several pages illustrating handles for furniture which were very much in fashion in the reign of George II, which one might assume to be the approximate period of the pattern book. But closer examination shows that the watermark on the paper dates it around 1794, over fifty years later. Only in very rare cases is it possible to date a pattern book at all accurately. One instance, in the hands of a private collector is a beautifully engraved book of designs for candlesticks, whose style places them not later than 1755–60. The watermark on the paper confirms that this was about the date that the book was printed.

Early pattern books illustrated both cast and stamped brass, but towards the end of the eighteenth century many more small brass articles were stamped. Candlesticks were almost the only exception. Until about 1670 they had almost always been cast in solid metal; around that time the principle changed to casting in two halves with a hollow core, and this remained the practice until after the 1770s, when core-casting in one piece for all but the most ambitious designs was finally mastered by the English brass-makers. The great brass-makers of Dinant were core-casting in the fifteenth century, and there are some fine examples of French brass using this technique, but English craftsmen did not succeed in perfecting their working of brass until well after 1770. Cast candlesticks with ornamentation were often cast twice – the rough cast was taken first, decoration was added to the cast with wax or pipeclay, and a second casting was then taken. After that it was hand-finished, polished and lacquered. Candlesticks were often turned and spun, particularly up to the beginning of the eighteenth century. The rough cast was turned on a lathe so that ring-decoration could be added, the metal cleaned off and polished and the thickness of the base pared down to economise on metal. Squared bases were roughly gouged to cut away any surplus metal from the underside.

Candlestick-makers sometimes used both casting and stamping processes to make a single stick, particularly in the case of chambersticks and push-up ejector sticks. The bases of chambersticks and their drip-pans were stamped out, the stems were cast and the two pieces were either screwed or brazed together. Push-up sticks often had sheet metal stems and cast bases, or stamped, lathe-finished bases. When

brass-making became more commercial towards the end of the eighteenth century, the English brass-makers were still having difficulty in casting highly ornamented items in one piece, and in 1781 William Parker took out a patent for casting candlesticks and many other items which stood on bases or pedestals in several pieces joined together by an iron rod down the middle.[3] Although this method is found in earlier pieces, the date of the patent indicates that it was by now being used to an extent which merited protection for William Parker's particular construction. The method was not as successful as single casting, at which the French were adept, but it was one which was used frequently with brass-mounted porcelain, particularly during the great neo-classical revival.

Good stamped brass in its early years was of such excellent quality that it was virtually indistinguishable from cast brass, except by its weight and slightly softer definition in the moulding. To all intents and purposes, the rich gold appearance of cast brass could now be achieved at far less cost and with far less labour by stamping and lacquering. From the 1770s onwards many items, small and large, were stamped out of sheet metal, instead of being extravagantly cast in solid brass.

Lacquering is not, as many people suppose, a recent innovation; nor is its purpose simply to prevent tarnishing. From the earliest times, brass was finished in a variety of ways – by gilding, silvering, tinning, whitening or lacquering. (Gilding, incidentally, was bitterly opposed by goldsmiths in the Middle Ages and laws were passed forbidding the gilding of brass in order to protect their trade.) It is a sad comment on the poor reputation of brass, and the lack of general knowledge about this much-neglected metal, that many experts in decorative art still resolutely refer to gilt brass as 'gilt bronze'. Some of the finest eighteenth-century metalwork is in fact gilt brass – in particular much of the work by French craftsmen, who could work brass like butter. There are a few examples of gilt brass from the late eighteenth century, but by then the laborious and expensive techniques of gold-leaf and fire gilding had been more or less totally abandoned in favour of lacquering.

There were several reasons for varnishing or lacquering brass. First, it protected the surface of the metal from the elements and prevented it from tarnishing. Secondly, it softened the hard metallic appearance of brass and gave it the indefinable rich look of gold itself. And thirdly, as Stephen Bedford of Birmingham had discovered in 1759, the lacquer itself could be impressed with decoration to imitate engraving at a fraction of the cost.[4] It is highly unlikely that any examples of this delicate technique have survived, however, for lacquer wears off, leaving no trace of the ephemeral decoration.

There were a large variety of lacquers and varnishes of different colours and thicknesses. The base was either spirits of wine, in which seed lacquer was dissolved, or spirits of turpentine and amber. Plain lacquer looked like pale French brandy; gamboge, turmeric, sandalwood or dragon's blood was added to produce the right colouring. Some fine brass which survived into the nineteenth century was relacquered by the Victorians, for fumes from gas-lights corroded brass to such an extent that brass picture-wire, for instance, was frequently quite eaten away, with disastrous results. The relacquering was done with a heavy hand, and often fine detail was puddled with dark brown viscous lumps which completely obscured the quality of the craftsmanship it was protecting. Lacquering was an optional extra, according to prices quoted in some pattern books, and it applied right through the entire range, down to screws which could be supplied with lacquered heads, presumably for coach

fittings, door fittings, lamps, lanterns and anything which had to stand up to the elements.

By the second half of the eighteenth century England had built up a huge trade empire with markets for her goods all over the world. Ironically, by far the most important European customer for English brass was Holland, who for centuries past had supplied England. Declining as a world power, once more a battleground, and lacking the enormous advantages of England's newly discovered techniques of manufacture, Holland also had a rich merchant class who were eager to buy the elegant furniture mounts and fittings made in England. The Dutch market was so important that England's manufacturers made a special range exclusively for Holland. Some pattern books of this period illustrate designs made specially for Dutch cabinet-makers which were far too ornate and Rococo for the English taste. Brass ring handles framing large circular medallions of coloured Bilston or Battersea enamel, for example, were very popular for Dutch commodes in the Louis XV and XVI styles, but they are most uncommon on English furniture of the period. There are also pattern books with French and Italian texts, showing that in spite of the political situation both countries continued to buy English goods.

America and the Plantations were another large market for manufactured goods of all kinds from England. Ever since 1699 it had been England's mercantile policy not to allow her colonies to establish manufacturing industries of their own, nor to trade with each other. The policy was laid down to protect England's profitable and delicately-balanced trading system. Simple finished goods, such as woven cotton and cloth, brass wire, rods and rings, were exchanged for gold and slaves on the west coast of Africa. The slaves were then shipped to the sugar plantations in the West Indies and the tobacco and cotton plantations in Carolina and Virginia. In exchange for these cargoes of 'black gold', English ships filled their holds with raw cotton, rum and tobacco, sugar, molasses and pig-iron which were shipped back across the Atlantic into Bristol and Liverpool to provide the raw materials for the growing industrial towns of England. Sometimes things went wrong and ships returned to Bristol with their holds full of slaves: but then they lay offshore and their 'above board' cargoes were discharged by lighters, so that no one should know what lay under the hatches.

Apart from a few small braziers and coppersmiths who made basic hollow ware and simple domestic utensils, no brass was made in America in any quantities until after the War of Independence. Everything had to be imported from England, right down to pins for the Governor's lady. Among the few metal goods manufactured in America were andirons or firedogs, which were made from iron and brass in local foundries. By the mid-eighteenth century most houses in England burned coal in grates, and firedogs were becoming a rarity. It seems that English manufacturers did not consider it worthwhile to make such heavy objects specially for the American market – practically everything shipped out to America was identical to that made for sale at home. There were a few isolated exceptions: one item which was made in great quantities for America was the jamb-hook or 'chimney huck' – a fireplace fitting never used in England. Chimney hooks were fixed either side of the fireplace to hold the large fire tools neatly upright, away from the fierce heat of an open log fire, and there is one pattern book from the late eighteenth century with a whole page of these most practical fittings, made for the American market.

There is an interesting overlap here, as elsewhere in American and English habits

and customs. Very few brass andirons were ever made in England because of the lack of brass and the ability to work it satisfactorily. By the time both these problems were overcome England was mainly a coal-burning society and andirons were no longer needed. In America, however, coal was scarce, and well into the nineteenth century all but the grandest houses still burned wood in open hearths. Jamb-hooks and andirons were still essential in America long after they had been superseded by the cast-iron grate and the coalscuttle in England.

Apart from these few exceptions, American craftsmen and cabinet-makers seem to have used the same fittings and mounts as their English counterparts. There is enterprise in every trade, however, and one brass-founder at the turn of the century capitalised on national events by making a whole range of commemorative furniture mounts. Among these were some commode handles bearing the profile of George Washington, and some with the early national emblem of the American eagle and the original 'Old Thirteen' states – the first to be united.

Tools of all kinds were also exported for many small crafts and trades, since many tools were made of brass, and therefore not possible to make in America. At the beginning of the nineteenth century some large industrial companies in England amalgamated with iron and brass founders, and some pattern books of this period show a wide range of hoes, matchets, pruners and other edge-tools for use by workers in the plantations. None of the tools seems to have been especially designed for using in cotton, tobacco or sugar plantations; again they were simply the same as those made and used in England.

And still, in spite of the craftsmen, the specialists, the groups of artisans and the extremely fine articles which were being made in England, the tradition of leaving finished objects unmarked went on. In all its history, the brass trade still had not evolved or had imposed upon it a trade guild to oversee its workers. No one obliged them to mark items with symbols of their trade or assay-marks of quality. The ancient Founders' Company accepted masters in casting all base metals, and a few brass-makers joined them, but on the whole the Founders' Company was principally concerned with bells and cannon, weights and measures. The Armourers and Braziers had a right to oversee brass made in the City of London from 1714 onwards, and small groups of trades within the brass industry like the pin-makers and the button-makers formed themselves into companies or guilds, but none of them had an official stamp or seal. Occasionally large merchant houses would stamp goods passing through their hands, but this was no guide to their date, as objects made many years before the merchant house acquired them would be stamped at the same time as mint-new objects. Brass-makers fulfilling contracts for merchants likewise may have stamped the goods contracted for, before sending them out to stock-rooms for collection. Even pattern books are no help in identifying the makers. It is possible to match actual objects with their illustrations from time to time, but as the pattern books themselves give no more clue as to their source, the maker remains staunchly anonymous. Occasionally brass which was destined to be silvered has a mock hallmark on it, but more often the silversmith probably considered it beneath his dignity to mark a base metal with his own stamp or cypher.

The most common markings on brass are those of large landowners, who made inventories of the entire contents of their houses and marked every item listed. But unless a small individualistic brass-founder decided to mark his goods in order to distinguish them from those produced by larger manufacturers, it was extremely rare

for makers' markings of any kind to be used on English brass. There must have been a very strict trade understanding or agreement, for not even Matthew Boulton's finest pieces are marked, and his Soho factory and craftsmen were among the most famous makers of brass in Europe.

American brass, on the other hand, may carry the mark of a maker, though this is by no means a general rule. Early brass-founders in Pennsylvania, Virginia, Boston and New York produced andirons and skillets marked with their names, and once the taxes and duties levied by England became almost prohibitive many other small items began to be made in small local foundries to avoid paying the exorbitant prices for imported brass. Often the men who made these things had emigrated from Birmingham, and there are several instances of well-known names such as Richard Wittingham,[5] Thomas Dowler, Joseph Baker and James Emerson setting up as experienced brass-founders in the new States. During the War of Independence there were no imports from England of any kind, and when at last a brass industry was established in America many brass-founders marked or stamped the articles they made in order to distinguish them from British imported goods.

Although there was almost certainly a strong antipathy to all things English after the War of Independence, manufacturing industries are not started overnight, and America relied on outside sources long after the war had ended. English imports, as often as not, came through 'neutral' European countries such as Holland, or by way of other colonies, and so the visible conscience of America was clear. There were no British Bills of Lading. Those days of roundabout trade must have provided another good reason for the British brass manufacturers wanting to remain anonymous, and for their goods remaining unmarked.

Notes

1 *The Resources, Products and Industrial History of Birmingham.*

2 W. Hutton, *History of Birmingham.*

3 Patent Office. Patent No. 1287.

4 Patent Office. Patent No. 737.

5 William Rollinson Wittingham emigrated to America in 1791 and established his business in Paterson, New Jersey. After three years he moved to New York City. His son Richard took over in 1806 – William Rollinson retired in 1808 and died in 1821.

9

The Borrowed Lines of Brass

Brass has never really achieved an identity of its own, as silver, Sheffield plate and even pewter and copper have done. Throughout its long history on the Continent and its slow development in England, brass was an imitative metal. When it was scarce, it was used as a substitute for gold. When it was made in any quantity, fine brass tended to follow the lines of its grander relation silver. Much of it was disguised by gilding and silvering, so that brass itself was seldom appreciated as a decorative metal in its own right, even when the excellence of the brass-makers' skill reached its peak.

The many setbacks in the manufacturing side of the English brass industry had their repercussions on the decorative use of brass: the greatest ages of Continental brass have no equivalent in England. And even the first flowering of English brass during the Restoration was not entirely due to the talents of English brass-workers alone. Much of the work of that period may have been done in London, Birmingham, Bristol and the other brass centres, but French, Dutch and Flemish genius was at the root of the whole development of the English decorative brass trade, and not until after the 1720s can a true and native gift for decorative brass be wholeheartedly recognised.

Fine brass made by the first great influx of European brass-workers into England during the Thirty Years' War was practically all destroyed during the Civil War. So too were earlier objects, such as the highly decorated bowls and dishes used to grace the sideboards and side-tables of wealthy households during the sixteenth and seventeenth centuries. Most of these beautiful, impractical dishes, with designs in high relief, were made on the Continent where the fashion for display originated, and very occasionally a rare survivor will turn up, often as part of church plate, when an offertory dish is found to be early Dutch, Flemish or French brass. But they are few and far between.

Very little remains to show the exuberant resurgence of the extravagant taste of an English society rebelling against the austere fashions of the Protectorate, when English brass began to come into its own. Brass, after all, is a base metal of little intrinsic value, and particularly during those years, when the raw metal was scarce, many objects which were no longer fashionable were handed in to the brass-makers as shruff in exchange for the new designs which came to England from Europe when Charles II was restored to the throne. So many of these pretty little things were ephemera: 'toys' made to amuse and delight and then be discarded, little nick-nacks and gewgaws which were carried round in the pocket, like penknives and chatelaines, spectacle cases, snuff-boxes, miniature mirrors, corkscrews, and a

hundred and one other little things which quickly went out of fashion and were easily replaceable.

It is tragic to think of the beautiful 'toys' and ornaments which have completely vanished in England, though collections in France and on the Continent give an idea of the remarkable quality of craftsmanship which has been irretrievably lost. When Charles II was restored to the throne of England in 1660 he brought with him many court customs from his exile in Europe, and the metalworkers of England excelled themselves in order to meet the new fashions. All manner of fantasies, exquisitely made, decorated the royal banqueting-rooms, and since there was no functional use for them, the craftsmen could give full rein to their talents and imagination. The 'nef' is perhaps the best known example of these exquisite table decorations: although they are French and date from long before the Restoration – they were a traditional feature of all high tables long before court fashions reached their heights of extravagance – the few which have survived give some idea of the greatness of the loss of many other table decorations and ornaments.

At banquets gigantic confections were made by the court kitchens and decorated with populations of delicate animals and people to illustrate the theme of the banquet. Originally these figures were made of sugar paste but later porcelain and other more durable figures took the place of edible ones. The famous Kändler monkeys were originally made specially for the court kitchens of Louis XV to decorate their elaborate creations. Ingenious and delightful automata and clockwork figures were built into the towering confectionery: swans glided over lakes of spun sugar, huntsmen hunted stags over mountains of marzipan, mock battles were fought on snowy terrains of icing-sugar. Court table-decoration was naturally made of gold or silver, but as the fashion spread, and the rich merchants and bourgeoisie copied the royal customs, brass – often gilded or silvered – was commonly used to allow craftsmen to come as near as possible to the court fantasies on something like the same scale at a fraction of the cost. But when the silver or gilt had worn away and only the base metal remained, nobody wanted them, however fine the craftsmanship, and they were melted down or thrown away. The fashion passed, and brass was expendable.

On the functional side of brass in its early years there was little that could be called design. The most convenient, most easily made battery ware was sometimes pleasing to the eye, and sometimes no more than a crude container whose shape was dictated by the battery workers' ability to work the metal. The sixteenth-century 'kettles' or containers for holding water which were discovered at Novaya Zembla in 1870[1] have a certain rough charm, but they are nothing more than cylinders of beaten copper or brass latten held together with rivets and joined to a rounded bottom with a simple fold. Containers like these were made in all sizes, used till they could no longer be mended, and then melted down to make new ones. Their life was relatively short, and beyond their functional use there was no reason why design should have come into their production at all.

In fact English battery workers did not concern themselves with producing anything but the most basic hollow ware, since right up to the Civil War finished articles of every kind came into England in great profusion from France, Germany and the Low Countries. Cauldrons, skillets, trivets, jugs and ewers changed very little over the years, and the occasional adventurous worker who altered the basic functional shape was not likely to be either paid or thanked for his trouble. Primitive

methods of manufacture and the erratic quality of raw brass did nothing to encourage the makers of domestic utensils to experiment beyond very limited variations on traditional patterns. When trade with France was prohibited in 1688, however, both sides of the brass industry at last began to come together. The makers of functional items improved their quality and design, and the craftsmen on the decorative side began to increase the numbers of articles they made. The cutlers and candlestick-makers were among the first to start using brass on anything like a commercial scale, and once the English brass-foundries began to smelt better-quality brass in greater quantities, other branches of the trade followed suit, as new methods of manufacture opened up all kinds of new possibilities.

In the damp climate of the British Isles steel rusted quickly, and much of the beautiful work done by the English steel-makers and iron-masters perished discouragingly fast. Brass was infinitely preferable, and gradually it began to replace iron and steel for a thousand and one different uses. It was far more pleasing to the eye, and in many cases it seems to have been the metal itself which encouraged the metalworkers to add a swirl or a curve to the basic functional shape, to pierce or engrave its invitingly golden surface. Sometimes the decoration was purely traditional – pierced hearts, leaves, animals, flowers – patterns which had been used by metalworkers in steel and iron. Sometimes, as in the case of tableware and candlesticks, it took its line from silver. Often it borrowed from pewter shapes in ordinary domestic items like plates and tankards. It is seldom possible to find a design which has been used and developed for brass alone, for brass was worked by metalworkers of all kinds, and by goldsmiths and silversmiths as well.

The one quality which distinguishes English brass from any other is its simplicity of design and purity of line. It seldom followed the swooping extravagances of silver when it took its line and shape from its richer relation. Even when it was destined to be gilded or silvered, the rich decoration was modified, the shape simplified and the ornament restrained. And in this simplicity and restraint it betrays its Protestant origins. Goldsmiths and silversmiths often learned their craft from France and Italy, where the taste was for the flamboyant and the ornate, but English brass-workers were taught their trade by generations of Protestant Dutch, Flemish and Huguenot craftsmen. Birmingham had received more than its fair share of emigrants over the years, and as late as the 1770s W. Hutton noted the interesting fact that out of a population of seventy thousand there were still only three hundred Catholics – and Low Church denominations of all kinds far outnumbered even the Anglicans.[2] A similar Protestant influence is discernible in silver, particularly during the last decades of the seventeenth century, when large numbers of Huguenot silversmiths came to England and greatly influenced the design of English silver.[3]

Brass was ubiquitous in England by the middle of the eighteenth century. The wealthy merchants, traders and early industrialists of England's solid middle classes were anxious to follow the fashions of the day set by high society, but not too ostentatiously or at too great an expense. Brass was the perfect emblem of respectable wealth. Such families probably owned several pieces of fine silver, which they complemented with brass – plainer in design, rich as gold in colour: the wall-sconces which lit the house, the trivet which glinted in the firelight, the candlesticks which lit their rooms, the chambersticks they carried to bed, the tobacco-box and inkstand on the desk – even perhaps the tray which held their calling-cards, silvered maybe, but good solid brass underneath. It was a humbler metal, well suited to its owners. And

in aristocratic houses, in halls and passages, brass replaced iron for hall lamps, wall-brackets, door fittings and countless other visible and invisible functional items. Brass enriched kitchens, pantries and still-rooms, added a glint to carriages and provided an outward reminder that these were the possessions of a man of substance.

Brass played a substitute rôle in every house in the land, though the level depended on the social standing of the family. In farmhouses pewter was used for plates and dishes, measuring-mugs, jugs and bowls. But there were brass candlesticks on the parlour table, and brass platters and dishes on the dresser or sideboard. Wrought or cast iron was used for many everyday tools, but in the richest households there were brass facings on the fireplace and the grate, brass in the kitchen and brass in the stables and outhouses. As travelling became easier on the better roads of the eighteenth century, brass took the place of coarse pottery in coaching-inns and post-houses, and many professional men replaced their glass and china travelling-accessories with bright, unbreakable brass.

One way or another, by the mid-eighteenth century brass was taking the place of pottery, porcelain, silver, steel, pewter, iron and tin. Sometimes worked by humble metalworkers, sometimes grandly by silversmiths, with every shade of design and skill evident in the middle ground between these two extremes, English brass took its line from almost every other decorative field, elaborating a simple base-metal design a little, subduing an ornate silver model slightly, imperceptibly adding its own individuality and yet never imposing a style of its own – and always remaining elusive, stubbornly refusing to be pinned down – to a date, or a place, or an individual craftsman or workshop.

Except for commemorative or personal items when the name or date is actually engraved on the object's brass face, there are very few cases where the date and origin of a piece of fine brass can be stated definitively, except when a design has without question been taken direct from a silver model. Here, it is possible to be precise, for there would have been no reason to make a piece of high-fashion tableware, for instance, once that particular style had been superseded by another. Moreover, in almost every case the design was destined to be silvered, and perhaps the reason that there are so few surviving examples is that once the silvering had worn it was better to replace the article with another of the current fashion rather than re-silver a design which was out of date. Apart from direct copies of silver models almost all fine brass designs were made over a number of years, for the taste of high society filtered slowly through to the provinces, which continued to buy designs long after London had discarded them in favour of the latest fashion. As for the origin of early fine brass, it is often virtually impossible to state definitely whether a piece is Dutch, English, Flemish, German or French, since identical articles were being made in several countries at the same period, frequently by foreign brass-makers living in England but working to designs being executed simultaneously in their native countries.

The way a piece of brass has been made can often be a broad guide, though here again it cannot be taken as definitive. Many people are adamant, for example, that cast candlesticks without seams cannot date from before the end of the eighteenth century. But this is to overlook the large numbers of candlesticks made in solid cast brass which date from before the technique of hollow-core casting in two halves was introduced. England was the last to adopt the core-cast method – both Holland and France were making seamless candlesticks long before the English metalworkers

mastered the art of core-casting in one piece. Nor can it be said with any certainty that there were no stamped brass articles being made before the 1770s, for John Pickering's patent of 1769 only shows that at this date the method was worth the protection of a patent, not that there had been no brass made by this method before that date. The same, in fact, holds true for all patents: they only serve as a rough guide and indicate that by their date the method was being used fairly generally.

There is such a thin line between the end of the rise of brass to its zenith and the beginning of its aesthetic decline that it is hard to say precisely just where the change occurred. Somewhere along the new production-lines fine brass objects being made in quantity gave way imperceptibly to increasingly poor-quality brass made *en masse*. When that happened, brass lost everything it had so painfully gained over five centuries of effort and setback, failure and success. The bright beauty of early fine brass was brought slowly into total disrepute by the brassy, badly finished articles which were turned out all through the Industrial Revolution. At the beginning of the era of mass-production the fine line and quality was still easily recognisable in English brass of all kinds. By the end of the nineteenth century it had vanished altogether. Some craftsmen hung on, making from old casts and dies for a small number of people of taste, usually in the country towns, away from the industrialised cities. But as wealth poured into the hands of the merchants and the middle classes, Sheffield plate and silver took the place of fine brass, and brass declined into a convenient metal for a million uses. The once-proud English brass-makers began to turn out those quantities of cheapjack novelties and badly finished domestic ornaments with which brass is generally associated today. Fine brass which had been treasured by families for generations was thrown out as the reputation of brass declined, and so much of the brass produced in England between 1680 and 1810 has been lost for ever on scrap-heaps and in melting-pots, considered until recently to be not worth keeping.

And so it has come about that until the last few decades eighteenth-century brass has been largely disregarded by collectors, always excepting candlesticks. Much of what did survive during the outcast years has already left England: a small number of discerning collectors, mostly in America, have salvaged pieces like those illustrated in this book, made in England at the height of elegance, when English brass was at its pinnacle of craftsmanship and design. Although it is too late to restore the lost heritage of brass, perhaps it is not yet too late to salvage its reputation.

Notes

1 See Plate 157.

2 *History of Birmingham.*

3 See John F. Hayward, *Huguenot Silver in England.*

Appendix I

Dates of Events Affecting the Development of the Brass Industry in England

1558	Loss of Calais, England's last French possession.	
1558	Accession of Queen Elizabeth I.	
1565		Patents granted to William Humphrey and Christopher Schutz for working calamine stone and making brass.
1568		Grant of Incorporation for the Company of the Mines Royal.
1568		Hochstetter begins work at Keswick.
1568		Grant of Incorporation for the Society of Mineral and Battery Works.
1568		Establishment of wire-drawing works at Tintern.
1588	Defeat of the Spanish Armada.	
1597		Import of foreign wool-cards into England forbidden.
1598	Edict of Nantes.	
1600	Foundation of East India Company.	
1603	Accession of James I.	
1607	Founding of the State of Virginia.	
1615	Acts passed forbidding the felling of timber.	
1618	Outbreak of Thirty Years' War.	Imports dwindle from France and Germany. Émigré metalworkers arrive in England.
1620	Sailing of the *Mayflower*.	
1625	Accession of Charles I.	
1632		Jorden's patent for smelting with 'sea cole'.
1636		Pin-makers of London form a Corporation.
1640		Sacking of Keswick.
1642	Civil War in England.	
1648	End of Thirty Years' War.	
1649	End of Civil War in England.	Dametrius and Monomia establish brassworks at Esher.
1649	Execution of Charles I.	
1649	Cromwell's campaign in Ireland.	

1652	Navigation Acts. England at war with Holland.	
1655	Capture of Jamaica.	
1658	Cromwell takes Dunkirk.	
1660	Restoration of Charles II.	
1662	Acts of Uniformity.	Prince Rupert recalled to England.
1662	Treaty of Dover.	
1663	Founding of N. and S. Carolina.	
1664	Mercantile war with Dutch.	
1665	Five-Mile Act.	Dissenters move to Birmingham and other non-corporate towns. Trade moves to outports.
1665	Plague of London.	
1666	Fire of London.	
1668		Mines Royal and Mineral and Battery Works amalgamated into United Societies. Prince Rupert appointed governor.
1681	Founding of Pennsylvania.	
1685	Accession of James II.	
1685	Revocation of Edict of Nantes.	Huguenot migration to England.
1688	Deposition of James II. Glorious Revolution.	
1688	Accession of William III. England at war with France.	All trade with France forbidden.
1689		Mines Royal Act passed, ending monopoly in mineral mining in England.
1693		Second act passed reinforcing Mines Royal Act.
1695		Patent granted to John Lofting for casting thimbles.
1699	Acts passed forbidding colonies to establish manufacturing industries.	
1701	Outbreak of War of Spanish Succession.	
1702	Accession of Queen Anne.	Thomas Savery develops his steam engine for pumping called 'The Miner's Friend'.
1703	The Methuen Treaty.	
1704	Marlborough at Blenheim.	Abraham Darby opens Baptist Mills Brassworks at Bristol.
1707	Act of Union with Scotland.	
1710		United Societies finally dissolved.
1713	End of War of Spanish Succession.	
1714	Accession of George I.	
1714	England captures Baltic ports.	All imports of copper and brass from Sweden cease.

1719		Thomas Patten establishes Cheadle Brassworks.
1720	South Sea Bubble.	
1727	Accession of George II.	
1728		John Payne's patent for rolling metals.
1738		William Champion discovers distillation of pure zinc metal.
1740	Outbreak of War of Austrian Succession.	
1745	Jacobite Rebellion.	
1750		First mercantile house opens in Birmingham.
1754		Smelting works open at Hayle, Cornwall.
1754		Publication of Thomas Chippendale's *Directory*.
1759	Capture of Quebec.	
1760	Accession of George III.	
1768		Parys Mine opens in Anglesey.
1769		Mr. Twigg's 'steam engine' at Birmingham.
1769		Patent granted to John Pickering for stamping metals.
1769		Patent granted to Richard Ford for stamping and rolling.
1769		James Watt granted patent for steam engine.
1769		Opening of Birmingham Canal.
1773		Assay Office established at Birmingham.
1775	Outbreak of American War of Independence.	
1776	Declaration of Independence.	
1779		William Bell's patent for ribbon stamping.
1781		Patent granted to James Emerson for direct fusion method of brass-making.
1782/3	End of American War of Independence.	
1783		Patent for Henry Cort's rolling-mills.
1789	French Revolution.	
1792	First Napoleonic War.	
1797		Copper coins minted at Boulton and Watt's Soho factory.
1800		Birmingham is the world's largest consumer of copper – out of a world total production of 10,000 tons, Birmingham's consumption is 2,000 tons.

Appendix II

Marks and Signatures Found on Brass in Great Britain

Marks of any kind are rare on brass, and extensive research does little to explain why this metal remained uncontrolled or checked throughout its history, except to bear out the theory that because it was an industrial and a decorative metal it escaped the controls of both sides. The Founders' Company mark is found on weights and measures and on bells, but in the case of weights and measures the mark was applied as a check against fraud and cheat, and was originally implemented to control the large numbers of 'straungerz' setting up foundries and making fraudulent weights. Attempts were made by both the Founders' Company and the Armourers and Braziers to bring all brass-making under one guild or 'closed company' but the brass-workers also worked in copper, iron, steel and a variety of other metals and persistently evaded any single overall control.

It was only in the nineteenth century that large merchant houses began to mark goods in their stockrooms, and as the descriptions of articles marked show, they impressed their stockroom stamp on all goods passing through their hands, regardless of date or origin. With the exception of commemorative articles and goods made on special commission these are the only marks to be found on brass apart from inventory numbers of large estates, and practically none of the articles in regular everyday use have survived. There is only documentary evidence that marking was a common practice. From delving back into the history of brass, it becomes apparent that so many controls and restrictions were placed on imported raw brass which were

Signatures found on brass in Great Britain, documented by
Douglas Ladd, antique dealer and brass-collector.

almost certainly violated by many an independently-minded brass-worker, that it was unwise to mark finished articles over long periods, when restrictions were in force banning the use of imported foreign metal. No overseer could prove conclusively that 'shruff' had not been used, and the continued practice of melting down and remaking did little to help any attempts at controlling the diverse activities and products of the brass trade in England.

Appendix III

Metals and Alloys Sympathetic with Brass

Content of Brass Metal

Until the end of the eighteenth century brass was made by the cementation process. Lapis calaminaris (natural carbonate of zinc) was mixed with charcoal in an average ratio 3 parts calamine, 3 parts copper and 2 parts charcoal. This mixture was fired in a 'pot' or crucible until the mass had melted and fused. As zinc is an ore of variable richness, the colour of the resulting brass varied considerably.

In 1781 James Emerson discovered how to make brass by the direct fusion method, by introducing pure metallic zinc directly into molten copper. This discovery was made possible by William Champion's method of distilling pure zinc from zinc ore, and the setting up of a zinc manufactory in 1738. But for some time after that there was still considerable difficulty in making brass because no way had been found of 'fixing' zinc, whose melting-point is much below that of copper. Much of the zinc was burnt off before fusing with the copper.

The colour of brass could be varied according to the percentages of the two metals:

1–8%	zinc	copper colour
14%	zinc	reddish-gold (Tombac or 'red brass')
17%	zinc	pure golden colour
30%	zinc	pale golden colour (*cuivre poli*)
40%	zinc	pinchbeck
53%	zinc	reddish-white colour
56%	zinc	yellowish-white colour
67%	zinc	blue-white colour
70%	zinc	lead colour
80%	zinc	zinc colour

The qualities and properties of the various alloys so produced differed considerably, getting more brittle as the zinc content was increased, and behaving in a molten state more like bronze when very little zinc was added. Molten brass of the 3:3 alloy is smooth and of a thinner consistency than bronze. The melting-point of brass is 850°C.

ARGENTAN Also known as Argentane or Argentine
The name given by Dr E. A. Geitner, a chemical manufacturer, to an alloy of excellent colour and quality which he produced in 1828. It was an alloy of copper, zinc and nickel, and was the forerunner of German Silver.

BATH METAL Also called Prince's Metal
An alloy of 16 parts copper and 4½ parts zinc. (See Prince's Metal.)

BELL METAL
An alloy for making bells, as its name implies. There are varying proportions, but

generally speaking it is composed of 80 parts copper and 20 parts tin. Small quantities of other metals were sometimes added. (See Gunmetal.)

BRITANNIA METAL

An alloy similar to pewter, of Dutch origin, consisting of tin, antimony, copper and bismuth, but no lead. The proportions used by Hancock and Jessop in 1770 when they began making it in quantity were 90 parts tin, 8 parts antimony and 2 parts copper. It is sometimes called hard pewter.

BRONZE

An alloy of copper and tin, probably the first alloy to be made by man. In colour it is reddish rather than yellow. The proportions are usually 90 parts copper to 10 parts tin. It is friable, cannot be worked in sheet and can only be cast.

CALAMINE

Lapis calaminaris – natural carbonate of zinc. (See Zinc.)

COPPER

Copper-mining in Britain goes back to the Romans, who apparently worked the Amlwch Mine near Holyhead in Wales. The famous Parys Mine in Anglesey was discovered in 1768 and by 1784 was producing some 3,000 tons annually. The Romans also mined copper in Cornwall, Lancashire and on the site of the Mines Royal colony at Keswick, in Cumberland.

DUTCH METAL

See Pinchbeck.

GERMAN SILVER

An alloy of copper, zinc and nickel in variable proportions. Generally there are 3 or 4 parts copper, 1 to 2 parts zinc and 1 part nickel. In the late eighteenth century it was known that Paktong contained nickel, but it was not possible to imitate it until 1804, when Richter of Baden in Germany first produced nickel in a chemically pure state, and then only in small quantities. It was very difficult to fuse with other metals until a way was found to alloy it with zinc, after which it was possible to alloy it with other metals, thus enabling copper, zinc and nickel to be alloyed together in controlled ratios: the elusive German Silver was finally produced around the late 1820s.

GUNMETAL

Almost the same as Bell Metal, but it takes its name from the cannon originally made from this alloy.

LAPIS CALAMINARIS

See Zinc.

LATTEN

Brass in sheets, probably owing its name to the French *laiton*; the term 'latten' was originally used to describe the form in which brass was first imported into England. It has also been applied to other metals in sheet form, such as iron tinned over (Bailey 1761) and tin plate, which were referred to by Dr Watson in 1789 as 'fer blanc': Sir John Pettus says that they were 'with us vulgarly called "latten", tho' that word more usually I think denoted brass'. Sometimes known as 'metal prepared',

latten was the name used to distinguish thin sheets of brass which had been hand-hammered from cast plates of brass.

NICKEL

First discovered in Europe by German miners on the site of silver-mines in Saxony, it was named 'nickel' as an ore bewitched by the German equivalent of 'Old Nick' because when the miners smelted the ore, instead of silver all that was obtained was a dirty whitish metal which disintegrated into dust in the crucible. Used in various nineteenth-century alloys (see German Silver, Paktong) and, later, for electroplating.

ORMOLU

Gilded bronze, brass, or sometimes copper. From *or moulu*, an amalgam of gold and quicksilver mixed to a paste, applied to the metal and then heated until the mercury was driven off as vapour, leaving the gold which was then burnished. Mercurial poisoning was common among workers.

PAKTONG Chinese Metal

An alloy of copper, zinc and some nickel, made in China and supposed to have excellent sonorous qualities for bells, gongs, etc. Its exportation was strictly forbidden, though small quantities found their way into Europe in the 1700s in billet form. Engestrom analysed a specimen in 1776 and found it to be 43.750 copper, 40.625 zinc and 15.625 nickel. Dr Fyfe of Edinburgh analysed a further sample in 1820 and found it to be 40.4 copper, 25.4 zinc and 31.9 nickel. It was made in great secrecy in a manufactory at Luhl from material obtained from old abandoned mines, consisting of slag left from smelting copper ore. The slag, according to Brandes, was composed of 8.75 nickel, 88.0 copper, 0.75 sulphur and antimony and 1.75 iron and earth matter. Paktong was more commonly called 'Tutenag' but this is a misnomer because Tutenag is an old word for zinc, probably derived from the Sanskrit *tuttha*, an oxide of zinc. The confusion almost certainly occurred because billets of Paktong arrived in the same shipments as billets of zinc. Paktong was used for making all kinds of domestic items because of its great similarity in colour to silver. It was mainly used for candlesticks, some of which even bore imitation hallmarks, but it declined in use from about 1770 with the advent of Sheffield plate. The last use of Paktong was in the 1820s, after which it was superseded by German Silver.

PEWTER

An alloy which has been used for many centuries both in England and on the Continent. Its constituents are basically tin, lead, and small quantities of antimony and copper. There were three sorts in common use in the late eighteenth century, namely, plate, trifle and ley pewter. Plate was the hardest and was used for plates and dishes. It contained up to 2% copper and would take a high polish. Trifle was used for beer-drinking vessels, and ley for wine and spirit measures. The last two contained no copper, and ley often had a high percentage of lead. Pewter articles were marked by their makers from as early as the fifteenth century, and markings were made compulsory in the sixteenth century. They were known as 'touch marks' and were instigated to control the amount of lead for eating and drinking utensils. The Pewterers were incorporated in 1482, their motto being 'In God is All My Trust'. (See also Britannia Metal.)

PINCHBECK

An alloy of 5 parts copper to 1 part zinc. This was slightly variable, as in the case of watch-cases and jewellery, when the proportions were probably nearer to 4 parts copper to 3 parts zinc. It takes its name from Christopher Pinchbeck (1670–1732), the inventor of the alloy, who was a famous London clock and watch maker. Pinchbeck was extensively used for watches and jewellery because of its resemblance to gold.

PRINCE'S METAL Also called Rupert's Metal or Bath Metal

An alloy composed of 6 parts copper to 2 parts zinc with a beautiful golden colour. It was originally invented in the 1670s by Prince Rupert, cousin of Charles II and Governor of the United Societies. The alloy was heated until slightly red and then pickled in diluted spirit of vitriol (sulphuric acid) to clean the surface. When the scale of dirt had been washed off it was dipped for a few moments in aqua fortis, then burnished with an agate or bloodstone. It was most frequently used in button-making.

RUPERT'S METAL

See Prince's Metal, Bath Metal.

SHEFFIELD PLATE

Copper plated with silver by a method first discovered by Thomas Bolsover of Sheffield in 1742. A man called Hoyland, also of Sheffield, was the first to use it for making candlesticks. Bolsover only used it for small articles such as buttons and snuff-boxes. Sheffield plate is made in plates or sheets: a thin plate of silver is laid over a thicker one of copper, and the two are heated together with a little borax between them; when heated, the borax melts and melts with it the surface of the silver next to the copper; the silver-plated copper is then rolled under steel rollers until it reaches the required thickness and the silver covers the whole surface. Sheffield plate, or 'Old Sheffield', as it is known in America, is not to be confused with 'plated' silver, which is achieved by electroplating. Electroplating, or the depositing of silver on to copper by means of an electric current, was first demonstrated by Dr Smee in 1840, and first used on a small commercial scale by Messrs Prime & Co. of Birmingham, using a magnetic electroplating machine invented by John Stephen Woolrich of Birmingham. The difference in colour between Sheffield plate and silver electroplate is due to the borax, which causes minute alloying between the two surfaces of silver and copper; in electroplating the colour is that of the pure silver which is deposited in minute particles on the surface of the copper. The electroplating method was also used for nickel-plating.

SPECULUM METAL

An alloy of about 2 parts copper to 1 part tin. It has a brilliant blue-white colour and can be highly polished. It was used for the mirrors in reflecting telescopes.

SPELTER

The English name for distilled zinc metal.

TIN

A metal which in its pure state has the colour of silver. It is not very hard — somewhere between gold and lead. It is very malleable and has the peculiar quality that on being bent it makes a crackling sound called 'the creaking of tin'. The

importance of tin throughout the centuries lay in its use for making bronze. Tin was mined in England over a very long period, particularly in Cornwall, where the Phoenicians came to buy it before the birth of Christ; they traded Cornish tin to Egypt, Greece, and other countries of the Middle East for bronze-making. Tin was also essential for all domestic hollow ware made in copper and brass, both of which tainted food and corroded if not covered with a protective layer of tin. (See Tinning.)

TOMBAC Also known as red brass

An alloy of copper and zinc, of Eastern origin. It has a very high proportion of copper, usually not less than 80%. When made in the proportions of 80% copper, 17% zinc and 3% tin it formed an alloy of a beautiful golden colour which was used in France to make sword-hilts.

WHITE TOMBAC

In *The Panorama of Science & Art* published in 1815 by J. Smith, he states: 'Tombac has still more copper and is of a deeper red than Pinchbeck. Copper combined with 5/6 Arsenic [forms] a white hard and brittle alloy which is called White Tombac and is much used in the manufacture of buttons.'

TUTANIA

An alloy of 8 parts brass, 32 parts antimony and 7 parts tin. It is named after William Tutin, its inventor, a well-known buckle-maker in Birmingham. First produced there in 1770, it was used for the manufacture of buttons, buckles and also spoons.

TUTENAG

This is the name under which Paktong was imported into England during the eighteenth century, thus producing the misconception that Paktong was a form of zinc. (See Paktong.)

YELLOW METAL

First produced by James Keir in 1779 and having the property of being able to be forged or wrought when either red hot or cold. More suitable for making bolts, nails, and sheathing ships. It was composed of 100 parts copper, 75 parts zinc and 10 parts iron, the copper and iron being first mixed with charcoal and pounded glass, and afterwards fused with the zinc.

ZINC Zink or Zinch

The metal obtained from calamine or lapis calaminaris – natural carbonate of zinc. The ore in its natural form contains up to 52% zinc. Used as crushed ore until 1738 when William Champion discovered a method of distilling pure zinc metal. The first English zinc manufactory was established by him at Bristol in 1743. The first Continental zinc manufactory was not established until 1807, at Liège.

Appendix IV

Processes and Materials Used in Working, Decorating and Finishing Brass

AQUA FORTIS
Nitric acid, somewhat diluted, was so called by the alchemists on account of its strong solvent and corrosive action on many mineral, vegetable and animal substances. It is still used under the commercial name of nitric acid. It is most useful for testing metals which appear to be gold. The surface of the item to be tested is scratched, and the acid is applied. If it is gold or contains a high percentage of gold, the scratch will remain bright and unchanged. If the item is of a base-metal alloy containing copper, the scratch will become green, the intensity of the colour varying with the copper content.

AQUA REGIS
The name given by alchemists to the mixture of nitric and muriatic* acids which is best fitted to dissolve gold. The best proportions of these are about 1 volume of strong nitric acid to 3 volumes of hydrochloric acid.

BRIGHT-CUT ENGRAVING
A form of engraving, popular at the end of the eighteenth century, whereby the metal is removed leaving a V-shaped or bevelled cut, the effect being jewel-like. Much used on small objects, especially shoe buckles and buttons.

CHASING
A method of decorating the surface with raised designs by the use of punches, chisels and hammers. It is also used for the finish given to *repoussé* work and to casting.

CLOSE PLATING
A method of silvering, especially items of iron or steel, e.g. scissor handles, knife blades, spoons, spurs, etc. It came into common use in the seventeenth century, but was generally discarded with the advent of Sheffield plating (see SHEFFIELD PLATE) but came back into fashion in the early 1800s until the mid-century for silvering small steel domestic tools such as sewing paraphernalia. The process is as follows: having first smoothed and thoroughly cleaned the metal, the item is dipped in sal-ammoniac which, as well as providing additional cleaning, also acts as a flux. It is then dipped in molten tin. The area to be silvered is then overlaid with a sheet of foil silver to fit as evenly and closely as possible. It is then pressed down and a heated soldering iron is lightly passed over the surface. The tin melts and forms a solder between the steel and silver covering, and the surface is then carefully smoothed again all over with a heated soldering iron and the surplus edges of the silver are cut away. The item is then burnished. This method is still the only practical method of silvering iron and steel.

*A solution of hydrochloric acid in water is the muriatic acid or spirits of salts of today – anciently called marine acid.

ENGRAVING

A method of decorating the surface by incising lines with a cutting tool. This is the normal manner in which inscriptions and coats of arms are rendered. It is sometimes used in conjunction with flat chasing.

FLAT CHASING

Similar to chasing, but effected in low relief. It was popular in the early eighteenth century combined with engraving.

GILDING

The most reliable method of gilding is fire gilding, which has been used since ancient times. The procedure is to liquefy the gold by dissolving it in mercury, forming a wet amalgam. This is then brushed or painted on to the metal which has been previously cleaned and wetted with aqua fortis. The metal is then heated by stoving. The mercury is volatilised, leaving the gold firmly adhering to the surface of the metal. The effect is dull: it can either be left matt, or burnished, usually with a stone such as agate. The process is dangerous because mercury fumes are very toxic. The second method of gilding is by laying gold leaf on to the metal surface which has first been cleaned and polished. Gold leaf can be applied to brass, copper, iron and steel. The metal is heated strongly and the first coat of leaf gold is applied and pressed down gently with a burnisher. The metal is then exposed to a gentle heat. Several leaves, either single or double, are applied in succession, and the last layer is burnished down cold.

PLATING

See Sheffield Plate, Close Plating.

REPOUSSÉ WORK

Relief decoration to sheet metal effected by punches and hammers used on the reverse side of the metal. A block of pitch was used as an anvil. This work was often finished by chasing to sharpen the detail.

SAL-AMMONIAC

The importance of this 'salt' in the arts was in its use as a flux, especially in tinning. There were several ways of making sal-ammoniac: basically two gaseous solutions, namely hydrochloric acid and ammonia, were brought together by burning animal excreta or manure. When the fire or kiln had cooled fine crystals of sal-ammoniac were left deposited on the inside of the container.

SILVERING

There are three methods of silvering, the first two being similar to fire gilding, but the final result is not as even, or as effective. The third method is to dissolve fine silver in aqua fortis and then by heating it evaporate the acid. Water is then added to dissolve the dry calx, after which it is again heated to evaporate the water. This is repeated several times to clean away the calx, which is finally left as a dry white powder. This residue is mixed with common salt and crystal, or tartar, in equal quantities. The metal to be silvered is wetted with clean water and the mixture is rubbed on. The more applications, the better the effect. The object is finally washed, dried and polished. Silvering should not be confused with plating.

TINNING

The surface of the metal to be tinned is scrupulously cleaned, and a flux of

sal-ammoniac is applied. Tin in powdered form is then used to cover the surface. The metal is then stoved to melt the tin, and while it is hot, brushed to remove the excess. In the case of hollow ware, the vessel is swilled around so that the molten tin covers all the interior surface, and the excess is then poured off. Tinning is the cheapest method of finishing, but new applications must be made, because the tin wears off quickly with use.

WHITENING

This method was used on small objects to imitate silvering, and is described in *Elements of Science and Art* by John Imison, published in 1822: 'To whiten Brass or Copper by boiling. Put the Brass or Copper into a pipkin with some white tartar, alum and grain-tin, and then boil them together. The articles will soon become covered with a coating of tin which, when polished, will look like silver. It is in this manner that pins and many sorts of buttons are whitened.'

WRIGGLEWORK

A form of surface decoration usually associated with pewter but found occasionally on brass, often used in conjunction with *repoussé* work and engraving from the late fifteenth century. It is made by cutting a zig-zag line with a blunt chisel-like tool which is used with a rocking or walking movement.

VARNISHING, LACQUERING

Brass was lacquered to protect the surface of the metal against the elements, and to stop it tarnishing or deteriorating. It was also used to dull the hard colour of brass and make it look more like gold. A large variety of lacquers were used, but the basic ingredients were either spirits of wine or spirits of turpentine, in which seed lacquer was dissolved. Various colourings were added: turmeric, gamboge, amber or dragon's blood, depending on the final effect required. As well as being used extensively on brass lacquers were also used on gilded metals. The effect was more lasting if the lacquers were applied warm on a slightly heated surface.

Glossary

ANNEAL, NEAL
To strengthen metal by means of slowly diminishing heat.

BATTERY
The method of flattening a cast 'plate' or bar of copper or brass into sheet by hammering with huge water-driven hammering machines. Also the term applied to beating pots, pans, kettles and cauldrons into shape with similar machines, or beating by hand.

BRAZING
The method of joining sheet metal under great heat, using copper mixed with a flux. Braziers were the men who originally joined pieces of armour – the term was later extended to cover workers in sheet metal generally, and is still used today.

CASTING
The term used for making large or small objects by pouring metal into a prepared cast. Brass was cast in 'plates' and then hammered into sheet. Small objects were cast from a mould prepared from a master design of the object.

CORE-CASTING
A method of casting brass and other metals with a hollow centre, principally to economise on the amount of metal used. In France, core-casting was common from the days of the Dinant metalworkers of the fourteenth century, but in England brass-workers could not achieve a single core-cast, and until the end of the seventeenth century objects such as candlesticks were cast in two halves and then brazed together.

FOUNDING
The term loosely applied to the process of casting, usually in the case of large items such as 'plate', ingot, cannon, bells, etc. The term 'brass-founders' originally denoted the makers of cast objects, but was later used as a generic form for brass-makers making a wide variety of objects with different methods of manufacture.

PLANISHING
To make smooth the surface of sheet metal, and to remove the marks of the heavy battery hammers with hand-hammering using a dish-shaped, polished and slightly convex-headed hammer. Planishing was not part of the manufacturing process, but part of the finishing process of removing marks and dents from the surface of the metal.

PLATING
See Sheffield Plate.

RAISING
Method of making dishes and dish-based hollow ware in one piece by beating discs of sheet metal over a 'stake' or 'stump' – a round-headed anvil used by battery workers.

ROLLING
The process of reducing the thickness of a piece of metal by rolling it between two heavy cylinders, adapted by Henry Cort in 1781. Sheet brass was, after this date,

made by casting it in a bar which was rolled cold to prevent it from cracking. It was then heated to red heat and dipped in dilute sulphuric acid to clean the surface of oxides. The method was pioneered by John Payne in 1728 and was used for small quantities of sheet metal, particularly by the makers of Sheffield plate. But not until Henry Cort's patent did the brass-makers adopt the method of rolling on any commercial scale: brass sheet was made by hammering 'plate' and ingot with heavy battery-hammers.

SMELTING
The extraction of pure metals from crude ore in large furnaces.

SOLDERING
The method of joining sheet metal using an alloy of tin with a flux. The great difference between this method and brazing is that much less heat is required, and the join is therefore less strong.

STAMPING
First used to impress a pattern on sheet metal, when the brass was laid on a die or raised model of the design to be impressed, and then hammered with a drop-hammer. This method was used by 'smalls' makers such as button-makers. It was first adapted to cutting and raising patterns simultaneously by Richard Ford in 1769; he extended John Pickering's methods of stamping out small articles such as cabinet and coffin handles to a far wider range of goods, including basins, scale pans, etc.

Bibliography

A. C. BOUQUET *Church Brasses* London, Batsford, 1956

R. A. BUCHANAN *Industrial Archaeology in Britain* Harmondsworth, Penguin, 1972

SIR WINSTON CHURCHILL *History of the English Speaking Peoples* 4 volumes, London, Cassell, 1956–8

G. R. ELTON *England under the Tudors* London, Methuen, 1955

CHARLES FFOULKES *The Gun-Founders of England* London, Arms and Armour Press, 2nd edition 1969

NICHOLAS GOODISON *Ormolu: the Work of Matthew Boulton* London, Phaidon, 1974

HANS ULRICH HAEDEKE *Metalwork* (translated by Vivienne Menkes) New York, Universe Books, 1970

HENRY HAMILTON *The English Brass and Copper Industries to 1800* London, 2nd edition Frank Cass 1967

ROGER HART *English Life in the Eighteenth Century* London, Wayland, 1970

DOROTHY HARTLEY AND MARGARET ELLIOT *Life and Work of the People of England* London, Batsford, 6 volumes 1925–31

E. BARRINGTON HAYNES *Glass through the Ages* Harmondsworth, Penguin, revised edition 1959

J. F. HAYWARD *Huguenot Silver in England 1688–1727* London, Faber, 1959

W. CAREW HAZLITT *The Livery Companies of the City of London* London, 1892

SIR AMBROSE HEAL *The London Goldsmiths 1200–1800* Cambridge, Cambridge University Press, 1935

WILLIAM T. JACKMAN *The Development of Transportation in Modern England* Cambridge, 1916

HENRY J. KAUFFMAN *American Copper and Brass*

J. SEYMOUR LINDSAY *Iron and Brass Implements of the English House* London, Alec Tiranti, revised edition 1964

E. LIPSON *Economic History of England* London, volume I 11th edition, volume II 6th edition, Black, 1956

E. LIPSON *A Short History of Wool and Its Manufacture* London, Heinemann, 1953

GEOFFREY MARTIN *The Town*, London, Vista Books, 1961

PETER PADFIELD *Guns at Sea* London, Hugh Evelyn, 1973

GUY PARSLOE (ed.) *Wardens' Accounts of the Founders' Company, 1497–1681* London, University of London, The Athlone Press, 1964

PHILIPPA PULLAR *Consuming Passions: a History of English Food and Appetite* London, Hamish Hamilton, 1971

RUDOLF ROBERT *Chartered Companies and Their Role in the Development of Overseas Trade* London, Bell, 1969

ERNEST SAMHABER *Merchants Make History* (translated by E. Osers) London, Harrap, 1963

GEORGE SAVAGE *A Concise History of Interior Decoration* London, Thames and Hudson, 1966

G. M. TREVELYAN *English Social History* London, Longmans, 3rd edition 1946

H. V. WILLIAMS *Cornwall's Old Mines* Truro, Tor Mark Press, 1969

Index

(referring to main text and introduction to plates)
References in italics are to plate numbers

The Illustrations

Introduction

Candlelight

The simplest form of man-made light was the fire, which provided heat for warmth and cooking and light to see by. Indeed, the fir tree owes its name to its use as a torch – 'firr' or 'fire' tree. In Russia and northern central Asia the vast caravans of traders lit their way through the dark forests by setting fire to whole 'fire' trees at intervals down the route. Less extravagantly, the wood of long-fallen fir trees which had lain buried in bogs was split and used as candles – a common practice in Scotland. In central and northern Europe the oil lamp preceded the candle, as the Dutch harvested the whale in the dangerous northern seas. In England oil lamps were used, but infrequently, until 1704, when the candle tax came in, and the use of oil for lighting was forbidden, except in lowly houses in small coastal villages where crude fish-oil was sometimes the only method of lighting. The most usual way of lighting was by candle, rushlight or taper; flaming torches and flambeaux were carried by link-boys in the vast corridors of draughty castles and manor houses, or set in cressets or sockets outside the house or in the streets.

Candles made of tallow, animal fat or beeswax were still few and far between in sixteenth-century England. Spermaceti was not brought into England in any quantity until the middle of the eighteenth century. Up till then it was expensive and reserved for the rich and the church. The flaming fire in the hearth, the flambeaux which flared down the long passages, and dim, flickering rushlights were all that lit the hours after dark in most houses. Outdoors there were small lanterns, sometimes made of latten, more often of iron. And in churches and great houses there were candelabra and more elaborate wrought-iron hanging lanterns. For the most part activities were confined to daylight hours, and unless there was a very solemn or important occasion, even the Church grudged the expense of lighting places of worship – the last service of a winter's day was usually held at three o'clock in the afternoon. The brass candlestands and candlesticks in the churches were all brought in from the Continent, for none were made in England except for such rarities as the Gloucester candlestick – and even its country of origin is in some doubt. Almost without exception, early English candlestands, beams and sticks were made of iron, or occasionally pewter or pottery.

Up to the end of the sixteenth century most households made their own candles from mutton fat, beef dripping, 'sweet suet' or beeswax, dipping long wicks repeatedly in melted wax or fat until the candles were thick enough. With the exception of those made of beeswax, these candles smelled disgusting, smoked a lot and dripped and guttered constantly. These noxious lights were set on pricket sticks, with a large dish or grease-pan below the spike to catch the melted fat. By the end of the sixteenth century, however, when the Merchant Adventurers were trading

regularly with Russia, tallow was imported in considerable quantities and candles greatly improved. Moulded candles began to be made: the melted wax or fat was poured into iron moulds, and four or six were made at a time. The resulting candle was of a more regular size and far finer quality. It dripped less and shed more light, and so, as tallow became more easily available and more moulded candles were made, the pricket stick gave way to the nozzle stick. Poorer households went on making their own candles, however, and prickets were still in regular use right up to the end of the eighteenth century.

The 'trumpet' candlestick of the mid-1600s[1] was the first purely English design to be made: the few survivals are more common in brass than they are in silver. Base-metal candlesticks of that date were usually little more than tubes of sheet iron or pewter crudely fixed to a flat base. Candlesticks made of brass in England before this date were indistinguishable from those brought in from France and the Low Countries, and the purely native 'trumpet' shape must have been developed just before the Civil Wars when some brass was still in circulation. Its ancestral roots go back to a European Gothic strain, but its shape is simpler than the more bell-footed model from which it is directly descended. It was a socket candlestick, with the drip-pan still low, as with the grease-pans of pricket sticks.

There was obviously great optimism and enthusiasm about the new tallow candles, for the drip-pan was almost completely phased out in the designs which followed the widespread introduction of moulded tallow candles in the second half of the seventeenth century. However, at the beginning of the eighteenth century the drip-pan reappears, directly under the nozzle of the candlestick, as it was sadly found that although the candles were greatly improved, they still dripped. One problem was that the wicks still burned more slowly than the tallow; wick-trimmers, douters and snuffers[2] were essential equipment throughout most of the eighteenth century. The slow-burning wick problem was finally solved towards the end of the eighteenth century when a tight piece of thread was incorporated into the plaited wick which pulled it towards the edge of the flame so that it was burned away.

Around 1730 the detachable drip-pan and nozzle, or *bobèche*, made its appearance, but this was a functional change rather than a development in design. In some cases the drip-pan was cast in a single piece with the nozzle, and as this new variation gained in popularity brass was often used in conjunction with turned wood, with the socket and drip-pan fitting on to the main wooden stem.[3] In essence, although the outline, decoration and ornamentation changed many times, the straight stem with nozzle and drip-pan combined is the theme which runs right through the design of candlesticks from the 1680s to the present day. Towards the end of the seventeenth century a slightly different variation in the functional characteristics made its appearance in the push-up candlestick,[4] which with some modifications was made in considerable quantities right through the eighteenth century. Push-ups had a hollow stem, cast and brazed together, and an adjustable screw, so that the candle could be used right down to the smallest stub. Their popularity was probably due to the candle tax, a theory which is borne out by the fact that nearly all push-up candlesticks were made of base metal. Presumably those who could afford silver could also afford to leave the last inch or so of stub unburned.

Wall brackets and wall sconces developed out of a need to replace the old flambeaux. In England wall brackets were made of wrought iron until the end of the seventeenth century; in the late seventeenth and early eighteenth centuries most

brass wall sconces were still being imported from the Low Countries. The brass back-plates acted as reflectors and greatly increased the amount of light from the candles.[5] Later wall fittings developed this idea by using mirrored glass and lustres to reflect and multiply the light of the candles mounted in front of them. Glass was incorporated into many light fittings as it became more available – the beautifully proportioned hall lanterns[6] of the mid-eighteenth century, for instance, used glass as a shield to prevent candles blowing out in a draught. They took the place of hanging chandeliers which must frequently have deposited large lumps of hot wax on new arrivals every time the great hall doors were opened.

The Rococo style for candlesticks,[7] wall-brackets[8] and light fittings as well as for doors, furniture and mirror frames, first becomes apparent in the early 1740s. The genesis of Rococo took place in France during the last years of the reign of Louis XIV between 1695 and 1715 and it was through French design that it came to England in the 1730s. The word 'Rococo' was unknown in England in the eighteenth century. It was first used in France in the latter part of the eighteenth century by the followers of the neo-classical school. In England the Rococo style was at first referred to as 'The French Fashion' or 'The New Fashion'. In English brass, Rococo forms were mainly reflected in only one type of domestic article, light fittings – candlesticks and wall lights. With both of these, the brass-workers tried with partial success to emulate their French counterparts, but they lacked that essential ingredient found in all French Rococo of the period – namely asymmetry, as epitomised by the work of Juste-Aurèle Meissonier (1693–1750), the French master-silversmith and designer. The English translation of Rococo was almost always symmetrical, but the few examples which survive have a charm all of their own.

In England neo-classical forms, especially in candlesticks and wall lights, came to the fore in the 1780s, but demand for Rococo was not totally eclipsed.[9] In the early 1800s there was a revival of the Rococo style both in metal and in porcelain which continued tenuously throughout the nineteenth century, but getting heavier and more ornate and losing a great deal of its original charm and fluidity. It is ironic that the greatest exponent of neo-classical metal in England, Matthew Boulton, never achieved the acclaim which he certainly merited during his lifetime.

Chandeliers were, of course, in general use in churches, public buildings, great halls and country houses by the end of the seventeenth century, and their ancestor the 'candel-beam' is of far greater antiquity. Candle-beams were made of two shafts of wood or iron, fixed together in the shape of a cross. They hung from a central shaft, with a candle socket at the end of each arm. Another form of early hanging light was the 'corona', an iron ring suspended from the ceiling by chains, with a ring of candles set around it. There is evidence, though, that brass chandeliers were being used in England as early as the fourteenth century, for acts passed by Henry IV and Richard III banned the importation of 'hanging candel stickes'. They probably came from Flanders, the centre of chandelier-making until the beginning of the eighteenth century. Brass was the obvious material for light fittings, since it reflected the candle-light and lent itself to curves and structural designs of great elegance. The two- and three-tiered chandeliers threw out great pools of light and were most beautiful sunbursts of splendour. But English brass did not follow the flamboyance and extravagance of baroque and Rococo so prevalent in France in the late seventeenth and early eighteenth centuries. Thus the bursting, blossoming

chandeliers which suited the glittery taste of the Continent were only echoed in England in a very simplified form.

Many examples of eighteenth-century chandeliers and, in rare instances, some late seventeenth-century ones, are still to be found in churches today, though they are not necessarily the original ones commissioned by the parish.[10] It is possible to trace these few pieces of brass almost exactly, because church-wardens' accounts and records detail the bequest or donor, the maker and even the extra cost of hanging the 'branches' in their church. But many church chandeliers were disposed of in the early nineteenth century when gas-light took the place of candles. The Gothic Revival in the 1820s also made their style inappropriate, and many of them found their way into private houses, only to be re-dedicated perhaps a hundred years later to a church in a different locality.

The three main centres in England for chandeliers in the eighteenth century were London, Bristol and Chester. London-made chandeliers do not have any particular identifying characteristics to the modern eye, except perhaps for their quality, which was the finest. London was, however, the centre of fashion and if it were possible to identify dates and makers it would probably be found that new styles originated in London and were later copied in the provinces. Bristol's distinguishing mark is a 'smooth unfeathered dove' or stylised tongues of flame which were frequently used as finials.[11] Chester chandeliers alone are easily recognisable by a small, almost Gothic fleur-de-lis motif in the shaped arms which is not found elsewhere.[12] Chandeliers also have the distinction of being occasionally signed by the makers – but as they were made on commission, and usually for churches, this identification was more for the church records than for the brass-maker's benefit. Birmingham came late to chandelier-making – the first recorded Birmingham chandelier-maker was Joseph Walker, in 1766, and Birmingham chandeliers do not appear to have any particular distinguishing mark.

Unlike the French, whose chandeliers became progressively more ornate through the eighteenth century, English chandelier-makers kept in step with the Dutch and continued to make the traditional chandelier with central globe and simple scrolling arms. But, sadly, the very fact that all chandelier arms were always of cast solid brass was the main reason for the disappearance of nearly all the later examples. Neither gas-pipes nor electric wire could be accommodated or hidden, and because they could not be converted, hundreds of candle branches from churches and private houses were jettisoned at the beginning of this century. Occasionally a light fitting turns up which has been made from the remnants of a once-noble centrepiece of magnificent scale, but except for the small number which still hang in churches today there are pitifully few chandeliers left to show their development and their ultimate splendour.

Notes

1 Plates 1–5.

2 Plates 77–88.

3 Plate 62.

4 Plates 22, 23, 35.

5 Plates 89–94.

6 Plates 109–12.

7 Plates 20, 21, 28, 63.

8 Plates 98–105.

9 Plate 106.

10 Plates 114–26.

11 Plates 116, 125.

12 Plate 118.

Hearth and Home

Both warmth and light were provided by burning wood, peat, turf or 'sea-cole'. Wood was the most common fuel in England until the mid-seventeenth century in both town and country. Great attention was paid to the variety of logs which were burned: apple smelled sweetest, elm burned fastest, oak gave a good heart to the fire, alder lasted longest. 'Sea-cole' came into more common use at about the time of the Restoration, particularly in London, where it arrived in colliers down the east coast from Newcastle. During the Plague Year of 1665, huge quantities of coal were burned in 'sanitary fires' believed by physicians to destroy pestilential germs, and this may well explain the change-over from wood to coal in the towns during and after that time. In the embryo industrial cities too, coal became more commonplace as the iron, brass and steel works began to use it in quantity. Coal at that time was burned in 'dog-grates' – rectangular wrought-iron baskets with ornamented uprights. But in the country, wood continued to provide fuel for open fireplaces almost through until the beginning of the nineteenth century. Only occasionally were brass andirons or finials seen in the seventeenth century – wrought or cast iron was the rule unless brass was imported from the Continent.

Firedogs or andirons were used to support the length of the logs, sometimes with a single smaller firedog or 'creeper' in the centre of exceptionally big open fireplaces to allow more air to get to the heart of the fire. In some more sophisticated houses, a basket was hung between the two firedogs to raise the fire off its bed of ash; plain cast-iron firebacks protected the brickwork behind them from damage by fire. In grander houses, these firebacks were often emblazoned with a family coat of arms. The hearth was the centre of the house, even a big house, and where better to display one's family crest or shield?

As open hearths gave way to fireplaces which were ornamental features in their own right, firebacks were decorated with all manner of birds and beasts, flowers and mythical animals. In front of such splendour firedogs could not remain plain. More elaborate designs were called for to match the grandeur of the fireplaces and firebacks. But if brass embellishment was needed, the firedogs had to be imported from the Continent, because the English brass-founders were still unable to produce them. There were, of course, exceptions, among them the famous and enigmatic

Surrey enamels[1] of the mid-seventeenth century. The remarkable casting technique used for these pieces is sometimes attributed to Jacob Monomia and Daniel Dametrius, though on the fairly flimsy evidence that their brassworks at Esher was founded at about the same time as the Surrey enamels began to appear. The method of manufacture was in fact a crude form of *cloisonné*, very similar to that used by makers of Russian icons of the same period. Cast brass with shallow cavities filled with coloured vitreous enamels is found nowhere else in England, and knowing the record of the Dametrius/Monomia brassworks in some detail, it is strange indeed that no mention is made of the fact anywhere in existing documents. Perhaps this particular technique was introduced as part of a commission for the Russia Company, operating out of the Port of London, or perhaps there were 'straungerz' from farther afield working in England at that time.

By the 1720s, when the brass-founders had at last mastered the art of making firedogs with a considerable degree of skill, and there was a good supply of English raw brass, firedogs were no longer in general use. Basket grates had begun to evolve from the simple dog-grate or firedog-and-basket combination, and some of them were beautifully ornate, often decorated with lattice or brass medallions and scroll-work fixed to the cast-iron or wrought-iron frames.[2] But these were only used in houses of some substance. Lesser households, inns and minor public meeting-houses still had open fires with cast or wrought iron andirons to support large logs for a goodly blaze, though they may have had a simple form of built-in duck-grate in the kitchen where the heat of the fire and its proportions needed to be limited and controlled.

America was almost entirely a wood-burning country, and coal was not used domestically on any scale until after 1800, because of the imposed ban on industrial development of any kind. Andirons were common, often made locally, and their own particular American style is easily identifiable. Fire-grates were also used in America, but only in the very grandest of private establishments, in such fashionable places as Boston, New York and Philadelphia. These grates were almost certainly sent over from England and not made locally. After the War of Independence when small foundries were at last set up brass andirons were made in increasing quantities, and many of them survive bearing their maker's name. But except in the case of a very few grand houses, the European tradition of magnificently designed fireplaces was not transplanted to the new colonies. In England jamb-hooks[3] would have spoiled the line and decoration of the moulding, but in plain-faced American fireplaces they were a practical necessity.

Notes

1 Plate 131 and caption.

2 Plates 134 and 137.

3 Plates 143–6.

Kitchen and Parlour

The development of the kitchen as a separate room varies in date depending on the size and nature of the household. In the vast Elizabethan mansions, with estates which provide for all the needs of the whole household, the kitchen was a huge affair with still-rooms, larders, pantries and subsidiary rooms for all the many activities connected with preparing, preserving and cooking food. But in the smaller manor houses and farmhouses of the same period, cooking was largely carried on in the main parlour of the house, and was an integral part of the main hearth. In the towns it was the practice of many professional households to live, eat and sleep in the same room, right up to the end of the seventeenth century. This social pattern persisted right through to the end of the eighteenth and beginning of the nineteenth century, with the kitchen separating off from the main room as the social standing of the household demanded, depending to a certain extent on whether the house was in town or country. But whether the kitchen hearth was part of the parlour or separated in the servants' quarters, the methods of cooking were, up to the seventeenth century, much the same.

There were two basic methods of cooking: on a spit, or in a cauldron. The kitchen hearth was quite wide and deep, and the fire would be kept in for twenty-four hours, probably banked up at night with sods of peat or turf. Cauldrons were placed on the hearth, or hung by a chain from a hook in the chimney. English cauldrons[1] were slightly different from Continental ones – they tended to be more squashed and sack-shaped than the tubby round ones from Germany and France. Always practical in their approach, the English designed cauldrons which were less likely to be overturned. Although cauldrons went out of fashion with the French and Germans around the sixteenth century as their culinary skills and equipment became more sophisticated, England continued to use them in every hearth and home for at least another century. Once the kitchen became distinct from the main room in the house and cooking became a more specialised affair, the three-legged cauldron, used for standing in or near the fire, gradually gave way to the more open, handled pan. But long after this recognisable saucepan shape had developed the traditional three legs survived, although shrunk to vestigial stumps. The transitional skillet[2] – halfway between a cauldron and a saucepan – was usually cast in iron or bronze to withstand the direct heat of the fire. Cauldrons and saucepans, which did not come into direct contact with the coals themselves, were made from sheet metal in the battery works. There were also jugs made on the three-legged principle, sometimes spouted, but usually with no more than a grooved lip to make pouring easier. As spiced wine and mulled beer were a favourite of the English, high and low, one can presume that broth was not the only hot drink which filled them.

Other kitchen utensils were slowly evolving as cooking became a separate function, and an art rather than a necessity. Skimmers, colanders, strainers, sieves, ladles and spoons, up till now made only of wood, iron, horn or heavy pottery, were all made in brass by the end of the seventeenth century. But it was still an expensive material and larger kitchen equipment was usually made of copper, tinned to prevent the tainting of food. Neither English kitchens nor English cooking developed in the same way that the French did, however. One practical factor was the absence of olive oil for all kinds of refinements which crude animal fat did not allow; but the main

cause was the Puritan influence on the English table, for just as all kinds of culinary delights were making their appearance in Continental cuisine, England was forced by Parliamentary decree back into the Dark Ages of gastronomy. All the traditional feast-day fare was banned, and new innovations such as sauces were declared wicked and Romish. England went back to plain food, boiled, stewed or roasted; many regional dishes were lost, and English cuisine suffered a setback from which it is only just recovering. English kitchens never had the huge free-standing braziers festooned with game so common at that time on the Continent. No English silversmith was ever called upon to make an entire suite of silver spoons, ladles and kitchen equipment such as was used by the royal kitchens in France.

Without the free-standing braziers, roasting meat in open hearths was a primitive affair. The meat was skewered on long iron rods which ran from side to side in front of the hearth, supported on spit-dogs and turned by a spit-boy or a dog in a cage. Joints were still hung on hooks over the hottest part of the fire; the trivet originated as a metal stand to hold the pan which caught the fat as it dripped from roasting joints. By the end of the seventeenth century the spit engine and jack-rack[3] had made their appearance in the kitchen, winding and unwinding and constantly rotating the smoking joints of meat. Iron was usually used to make hooks, chains and spits for open-fire cookery, since nobody bothered to clean the smoky, greasy equipment. But as brass became more common, many kitchens in mid-eighteenth century houses gleamed and shone with tools and implements, many of them just for show, which the poor spit-boys and kitchen maids burnished for grubby hours with wet sand.

At the table in larger houses, whose kitchens were often a considerable distance from the banqueting-rooms, hall or parlour, there was a constant problem of keeping food hot while dozens of courses, entremets and syllabubs were consumed. Many plate-warmers and dish-warmers[4] served a double purpose, either keeping hot dishes in front of the fire until they were needed and served, or for bringing them straight to the table. In the mid-eighteenth century, when such beverages as tea and coffee were fashionable, kettle stands[5] for hot water evolved from the practice of keeping a plain copper kettle on a trivet by the fire.

Drinking-accessories in brass, except for wine cisterns, are few and far between. Wine cisterns,[6] in japanned tin, brass or silver, were in use over a long period: in spite of the lack of facilities in the seventeenth and eighteenth centuries, in many ways more attention was paid then to the refinements of dining and drinking than today. Glasses were cooled for hock and warmed for claret – the Englishman more than the Frenchman was responsible for the discriminating wine-bibber's palate, consuming quantities of imported wines from France, Germany, Spain and Portugal. Little bowls of clear water were always on the table in elegant society for dipping greasy fingers during the meal, and every beverage and food had its own individually designed plate, dish, bowl or jug.

When a household had reached the point of refinement which demanded better materials than horn or thick glass for drinking-vessels, they had usually arrived at a point of prosperity which allowed them silver. Brass tarnishes quickly, and is not very pleasant to drink from. More particularly, it corrodes and discolours in contact with acid foods and drinks, unless either silvered or tinned. But there must have been a brief time when people longed for expensive porcelain or fine glass and could not afford it, for there are jugs for the table, tankards and an occasional

loving-cup and goblet, not all of them disguised by silvering or gilding, which have survived to suggest that many more must have been made.

But the kitchen was the province of brass embellishment *par excellence*, where many humble tools and devices were raised from their lowly state by the brass-workers' instinct for using the bright golden metal to its very best advantage. And gradually English kitchens began to recover from the Puritan insistence that eating was a necessity and not a pleasure. The agricultural revolution brought fatstock into England, and gone at last were the days of pickling meat and slaughtering all but breeding animals in the autumn. Gone the weary months of salted, highly spiced greening meat which had not kept so well into January and February. Pickling and preserving developed as a refinement, now that animals were bred and killed for the table. In England particularly, with its plain cooking and lack of sauces to disguise the last pre-Lenten mutton, the relief of fresh meat after Christmas must have been a blessing.

Kitchens began to be more civilised and less primitive: the old baking oven was brought forward into the chimney breast and enclosed with a cast-iron door so that roasting could be done in a more controlled, less haphazard way. In the last quarter of the eighteenth century grates were built which enclosed the fire, and these new cast-iron cooking-stoves began to look like the new steam engines, with brass plates bearing the founder's name, and knobs, swirls and barley-sugar ribbons of brass across their workaday faces. Cast iron and brass set each other off to perfection, and the brasswork on some of these kitchen ranges is a pure delight.

Notes

1 Plate 159.

2 Plates 160, 161, 163.

3 Plates 164, 165.

4 Plates 190, 191, 195.

5 Plates 198–207.

6 Plates 233–7.

Accessory and Ornament

The enormous diversity of things made in brass during the period covered by this book has made it difficult to confine and categorise its many uses. One of the most immediate associations of brass in a domestic context is with brass beds. Whole books have been written about these fabulous pieces of furniture, but regrettably brass bedsteads do not come within our period. Experiments with brass-covered iron rails were made in 1782, but owing to the difficulty of the process met with little

success. By 1803 a few brass-covered rails were in evidence, mostly used for decorating shop-fronts and for exterior ornament;[1] but the era of the brass bed did not begin until 1811 when a satisfactory method was found for covering iron with brass, and then for making brass tube.

Nor do architectural embellishments come within the province of this book: curtain rods and finials, swags, drapes, crossed arrows and so on must therefore be excluded. The objects which do come within the range of the period 1680–1810 are small, and strictly the accessories of a comfortable life. Eating, drinking, smoking, writing, travelling – the personal, everyday occupations of the average gentleman and his lady, were all greatly enhanced by brass, which seems to epitomise the solidity and respectability of the times.

The only exceptions to this rule are the forerunners of many later applications of brass in small intricate work. Locks were some of the very first objects to be made in brass in England, when locksmiths began to use small quantities of brass with steel. English locksmiths had a long tradition of highly skilled metalwork, dating back to the eleventh century, and by the end of the seventeenth century locks of considerable mechanical sophistication as well as beauty were being made in the neighbouring towns of Wolverhampton and Birmingham. Locksmiths began to use latten for the cover-plates of rim locks, engraving and chasing elaborate designs, and often marrying brass and steel together purely for their appearance. Curiously, one can detect a similarity in the complicated figures and dials of English seventeenth-century locks[2] to the work of German clock and watch makers: here English locksmiths had a perfect opportunity to indulge their delight in toy-making and ingenuity.

The tobacco habit was well established by the middle of the seventeenth century, both in England and, more particularly, in Holland. Pipes, tinder-pistols, tobacco-boxes and ember-tongs were all made in England, though many smoking accessories were imported until the eighteenth century. The greatest range of accessories were made for the snuff-taker, since snuff was a more fashionable addiction than pipe-smoking, which was considered a little coarse for a gentleman to indulge in. Snuff-taking in England became enormously popular during the first year of Queen Anne's reign, when the English fleet captured a large number of Spanish ships loaded with snuff at Vigo Bay in 1703, and a whole ritual grew up under the reign of Beau Brummel's predecessors who set the fashions in the salons of London. Snuff or 'rapée' was far more coarsely ground than today's fine powder, and was frequently sold in a plug or 'carrot' which was grated into a coarse powder on a rasp. Snuff plug could also be chewed, a habit prevalent among the richer citizens of London during the Plague, when it was thought to ward off infection. The correct way to take snuff was to spread a small pinch in the crook of the bottom thumb-joint of the left hand, inhale lengthily through first one nostril and then the other, and complete the ceremony by flourishing a voluminous silk handkerchief over ruffles and lapels after first dabbing delicately at the nose. It was extremely bad form to sneeze.

The gentleman on his travels, either up and down the potholed, rutted roads of England or on the smoother highways of the Continent on his Grand Tour, needed to be well-equipped against boredom, footpads, highwaymen and daylight robbery from unscrupulous landlords in coaching houses and inns. An old rhyme helped the memory:

Purse, dagger, cloke, nightcap, kerchief, shoehorn, boget and shoes,
Spear, male, hode, halter, saddlecloth, spurs, hat and horse-comb,
Bows, arrows, sword, buckler, horne, leash, globes, string and thy bracer.
Pen, paper, ink, parchmente, reed, wax, pommes, bokes thou remember.
Penknife, comb, thimble, needle, thread, pointe, lest thy girthe breake,
Bodkin, knife, lyngel, give thy horse meate, see he be shod well,
Make merry, sing and thou can, take heed to thy gear that thou lose none.[3]

The rhyme is too early to remind him that he would also need soap, sponge, coin scales, padlock and tinder-pistol – to say nothing of side-arms.

Most businessmen who handled the coin of the realm with any frequency would most certainly have owned a pair of scales,[4] for the practice of 'paring' coin was rife in the eighteenth century. It was normal practice when receiving payment to check that coins were the correct weight, and never considered an insult to either party. In some professions specialised scales were essential: jewellers and men in trades dealing with precious metals needed them, and of course a physician would never have been without his little set of apothecaries' weights and measures. The lady of the house would have had her set of scales and weights in the provision room, still-room or kitchen, so that she or her housekeeper could keep an eye on the tradesmen, who frequently gave short measure, and on the servants, who were in the habit of taking provisions out by the back way.

Servants were summoned by bells from the depths of the servants' quarters to the front of the house. Little handbells stood on tables in most rooms, and only the English had a special, slightly larger design called a tea-bell – to bring the guests to the drawing-room from their leisurely afternoon pursuits in the garden or around the house. By the end of the eighteenth century large houses were wired with bells which rang on a board in the pantry passage when the tapestry or embroidered bell-pull was touched.

Eighteenth-century ladies and gentlemen needed more than a quill pen to write their letters and keep their journals and accounts. There was an inkpot, for writing-ink made from oak-gall, copperas and a little gum arabic. Pounce pots[5] held the fine powder made of gum sandaric (dried resin from juniper trees whose name has resulted in the popular misconception that sand was sprinkled on the paper) with which they dusted the paper to give it a good writing surface. Sealing-wax was only used for important documents and sealing-wafers were the everyday method of securing the folds of a letter. Wafers were rather like batter in consistency, made with flour, white of egg, isinglass and a little yeast: the mixture was rolled out, dried, and then cut and sometimes coloured. If sealing-wax was to be used, then a wax or taper jack, with its long coiled snake of wax taper, would be needed. These little pots and containers stood on a tray on the desk known as an ink-stand-dish, or inkstandish; many of these, as befitted items on permanent show, were made of silver. Inkstandishes made of brass were in common use, but do not seem to have been made in England or Holland at all. They were imported, curiously enough, mostly from Spain. Pounce pots made of glass with brass perforated tops were certainly made, because they are illustrated in some pattern books,[6] but why the complete inkstandish was not made in brass in England remains a mystery.

To a large extent, once brass was freely available, so were other materials until recently out of reach of the middle classes. The chief silver substitute was Sheffield plate, first made by Thomas Bolsover in 1745 and produced in great quantities in

Sheffield and elsewhere from about 1760 onwards. Brass to be silvered was usually cast, but Sheffield plate could be stamped and raised in one operation, and so brass relinquished its position as a silver substitute. Only a few clues are left after the middle of the eighteenth century to show that brass had its place in beautiful small things as well as in larger, more everyday objects in the elegant world of the wealthy man of the period.

Notes

1 *The Resources, Products and Industrial History of Birmingham* . . .

2 Plates 312–19.

3 Quoted in Dorothy Hartley and Margaret Elliot, *Life and Work of the People of England*.

4 Plates 337–9, 341.

5 Plates 267–9.

6 Plate 74.

Brass and the Hereafter

As in life, so brass in death had its part to play. Coffin furniture certainly deserves a place in the history of brass, if only because John Pickering first took out his patent for stamping metals in order to make coffin plates and handles. In the seventeenth century, funerals with all the trappings of horse-drawn hearse and nodding plumes, processions of mourners and mutes and funeral feasts, were all more or less reserved for the important families of local society. The last mortal remains of anyone of national importance were brought to London to be interred, and London was, quite naturally, the centre of the coffin-making trade.

Elsewhere, the local cabinet-maker or carpenter 'undertook' the formalities of relieving the bereft of their departed, and organising the ceremony and trappings of the funeral. This custom survives today: many businesses whose main trade is building, painting and decorating also incorporate an undertaker's parlour. Coffin fittings would appear to have been added to cabinet-fitting makers' ranges of brass in Birmingham in about 1760. There is an enchanting story told by Thomas Horne in his journals, concerning a certain Mr Mole who was the maker of coffin fittings in Birmingham at about that time. He was a clever workman and ambitious of bettering himself in the world, and he went with his patterns to London, hoping to capture the trade by supplying the London undertakers with his most excellent fittings. He persuaded the firm of Wagstaffe to give him an interview, but Mr Wagstaffe declared he would only consider the patterns if Mr Mole could lift both his heavy pattern-box and the porter who carried it, together. Mr Mole, a strapping fellow, proceeded to lift them both, set them on Mr Wagstaffe's trade counter – and promptly secured an order.[1]

Mr Mole would quickly have discovered that there were differences in taste between London undertakers and those in the provinces. They did not paint the name of the deceased on the lid of the coffin, but pricked it out with a punch on a metal plate. They abhorred back-plates to handles, and would never use a screw where a nail would serve. Their taste was severe, and they disliked the flowery, fancy ornaments which the provinces insisted upon. There were other regional differences too. The West of England preferred gilt metal fittings because they held a wake for the departed, and the coffin was placed on display for all to see. The Welsh traditionally used a combination of black and white metal, iron and tinned iron being most common. Lead was very often used, particularly where there was no metal industry in the neighbourhood, because it is very soft and easily worked. But in London, where the best were laid to rest, they used brass.

London coffins had handles and mounts[2] in much the same way as a chest of drawers or a commode, with the additional embellishment of a plate or plaque bearing the name of the occupant. During the rebuilding of the City of London, a certain amount of hitherto unknown evidence has come to light on the customs of burial. Old churchyards have been cleared, some of them originally damaged by bombing in World War II. Fortunately the sites have not been worked over before their contents have been examined and Church authorities and archaeological societies have been able to retrieve many things of interest.

Most of the coffins from which the fittings have been preserved are those which were kept in vaults, family mausoleums or chambers below the church, rather than those which were buried directly in an earth grave where damp, pressure and ground subsidence have damaged them. In these cases serious oxidisation has rendered the metal mounts unidentifiable or so corroded them that there is virtually nothing left.

Unknown vaults have come to light as a result of damage and decay of the foundation fabric of a church necessitating investigation and repair. One instance of this occurred recently at St Nicholas's Church, Perivale, to the west of London. Owing to the subsidence of a wall, a vault containing a coffin was discovered. The coffin was made of wood, covered with leather and studded with brass nails, very similar to the decoration on leather-covered trunks of the late seventeenth century. It was in a very good state of preservation, and before it was reinterred the mounts were removed and have been placed in a small museum attached to the church.

The most interesting point that emerges from the discovery of these early coffin fittings is that the design appears to have changed remarkably little over a long period. The plaques on coffins bearing dates of the late seventeenth century hardly differ at all from those used in the early nineteenth century.[3] But undertakers are conservative people and death, after all, is very permanent.

The wheel turns full circle: the original connection between brass and wool is repeated in the final chapter. As the wool industry fell on hard times, in an effort to increase the amount of woollen cloth used by his own subjects at a time when world markets were finding alternatives to English cloth, Charles II passed an act declaring that all dead bodies should be buried in shrouds of woollen cloth and no other material. The Flannel Act, as it was called, gave rise to the irreverent couplet by Arthur Young:

Since the living would not bear it
They should, when dead, be forc'd to wear it.

Certificates to this effect had to be produced, and no man, woman or child escaped wool's final, warm embrace.

Few coffins were remarkable enough to merit comment: there is one recorded instance, however, of a pair of solid brass coffins being commissioned and made, and although the event most probably took place after 1810, it surely deserves a place in this chapter. Two great African tribal chiefs bearing the grand titles of King I Am and Egbo Jack, commanded that their coffins should be made of brass, and of solid brass they were indeed duly made. Each one was 6 feet 10 inches long, 3 feet deep and 2 feet 3 inches wide at the widest part and weighed no less than 600 pounds. The chiefs insisted that the coffins should be completed before their deaths, so that they could see and admire them. The two brass coffins were polished, lacquered and richly decorated with cast ornaments, with a shield with emblazonings on the lid. But the most remarkable feature of these two coffins were four padlocks on each, two on the inside and two on the outside. The padlocks on the inside could only be locked from within. The explanation given was that the chiefs wished to use their coffins as oratories or private cells into which they could retire for devotional purposes, locking themselves in during their spiritual exercises! It is far more likely that the chiefs used them as treasure chests – but the explanation still does not explain the two inside padlocks.[4]

Nothing so exotic was ever commissioned for use in England, though undertaking had its ghoulish side. Interest in anatomy and medicine was fast gaining ground by the end of the eighteenth century, and body-snatching became a gruesome problem: so much so that Gabriel Aughtie of Cheapside invented a special coffin, one 'so secure as to render it impracticable either to break, cut, or otherwise open the same and consequently prevent the stealing, removing or taking away the body or bodies contained therein'.[5]

The main feature of coffin design for plates, handles and embellishments was the use of winged cherubs' heads and flowers, a motif which one associates with Carolean design, and which certainly originated at that time. The same motif is also found on little clasps, pins, and rings – mourning jewellery – and also on some mirror and picture frames, substitutions perhaps for the more ornamental ones which were covered up or removed during the period of full mourning. The whole ritual of death was more and more widely observed during the eighteenth century, to such an extent that by the 1750s the pin-makers were producing black-lacquered pins in considerable quantities, and black silk crepe was being made in England and no longer imported from the Continent. But as far as can be ascertained, there was little or no change in coffin design until the early 1840s, when the Gothic Revival was at its peak. The influence of Augustus Pugin completely changed ecclesiastical architecture and church furnishings, and at least in the undertakers' world, Gothic has remained the basic theme for coffins and funerals ever since.

Notes

1 Quoted in *The Resources, Products and Industrial History of Birmingham ...*
2 Plate 356.
3 Plate 365.
4 *The Resources, Products and Industrial History of Birmingham ...*
5 Patent Office. Patent No. 2128.

The Plates

Unless otherwise stated, all the items illustrated are English, and made of brass. Except where another acknowledgment is given, all photographs were taken by Lyn Robins of Studio Wreford, Hungerford.

Pictures credited 'Winterthur Museum' are reproduced by courtesy of The Henry Francis du Pont Winterthur Museum.

Pictures credited 'Patent Office' are reproduced by courtesy of the Controller of H. M. Stationery Office.

Candlelight

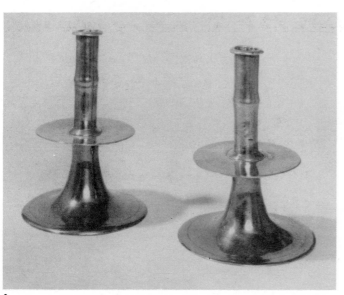

1

Candlesticks

1 A very good example of the 'trumpet' candlestick. Plain, with a small swelling above the mid drip-pan. Lathe-turned rings and decoration. The flatness of the base and absence of a foot are typical of early Commonwealth design.
7 inches high, c. 1640–50. Christopher Clarke.

2 Another 'trumpet' variation, but with the unusual feature of having the upper section of the stem tapering down to meet the mid drip-pan. Lathe-turned ring decoration to stem and base, which has a pronounced foot.
6 inches high, c. 1660.

3 Taller than normal, this one has the unusual feature of a stamped maker's mark on the top nozzle flange. It is too worn to be deciphered, but appears similar to marks found on latten spoons of the same period.
8 inches high, c. 1655–60. Clive Sherwood.

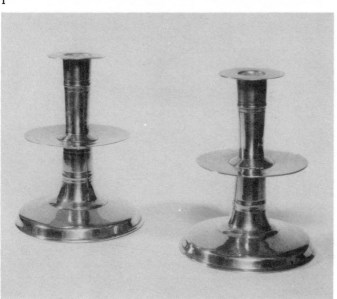

2

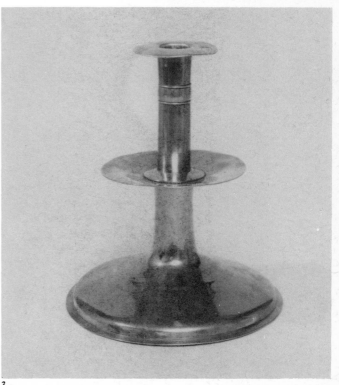

3

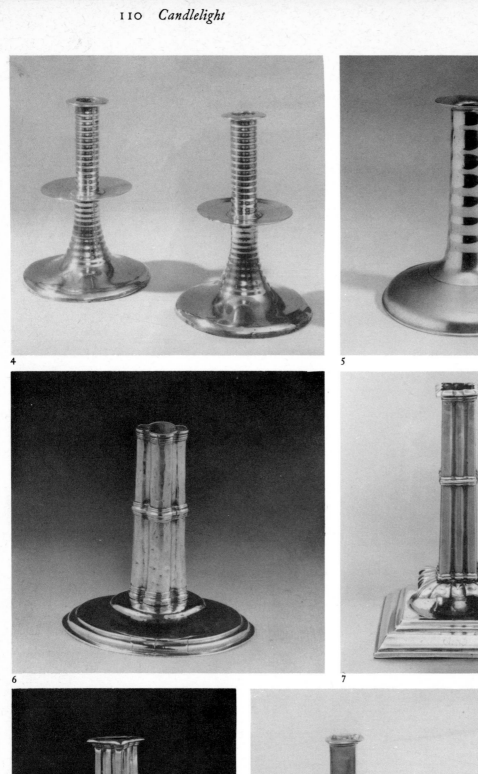

4

5

6

7

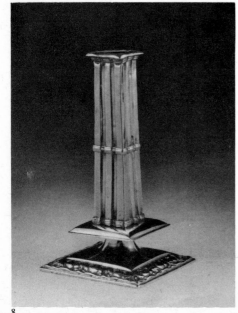

8

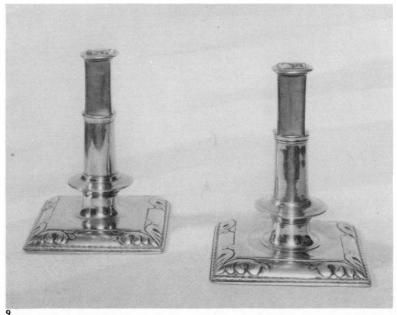

9

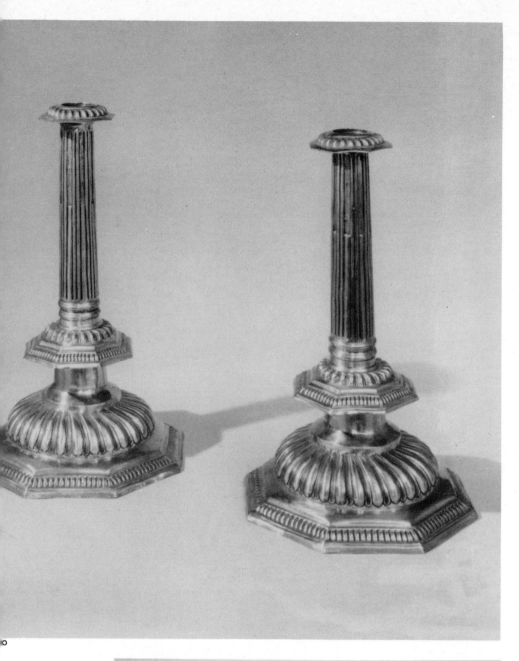

4 A basic 'trumpet' shape, but with ring or rib decoration on the upper stem which continues below the mid drip-pan and dies away into a plain base. This accentuated decoration probably came in after the Restoration as a reaction to Puritan severity.
7 inches high, c. 1660–5.

5 A rare variation of the previous model. A candlestick of this period looks strange without a mid drip-pan and the design may have been the result of over-optimism about the better-burning tallow of the period.
6⅜ inches high, c. 1660–70. Frank Dickinson.

6 A rare design in brass with a clustered column stem, similar to those cast in silver. An unusual example without drip-pan.
5⅞ inches high, c. 1670. Winterthur Museum.

7 The clustered stem has been squared and the drip-pan dropped to the base of the stem as a design feature rather than for practical use. A similar design is also found in French and Dutch silver.
7⅛ inches high, c. 1675. Colonial Williamsburg Foundation.

8 A variation of (7). The decorated cast metal is similar to French models of the period.
7¼ inches high, c. 1670–5. Winterthur Museum.

9 The upper section of the stem is square, becoming circular halfway down, with very small stylised drip-pan. The base has a cast and chased foliate design on each corner.
6⅜ inches high, c. 1680–5.

10, 10a A magnificent pair of candlesticks of rare design and construction, made in sheet brass, shaped and *repoussé*. The three sections have been numbered for assembly.
17½ inches high, Dutch or English, c. 1690.

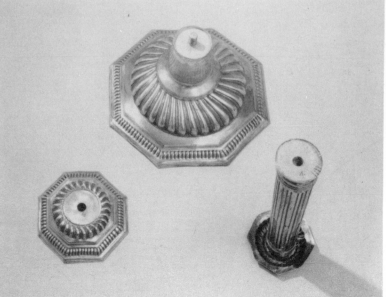

10a

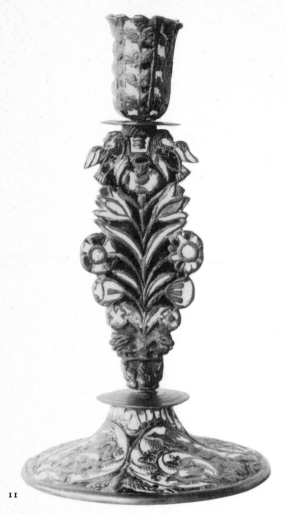

11

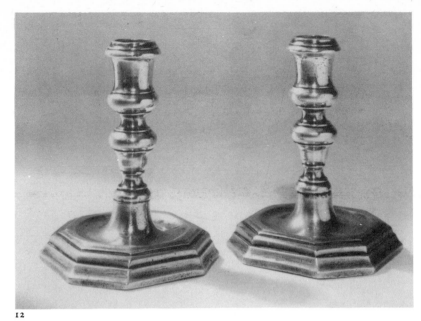

12

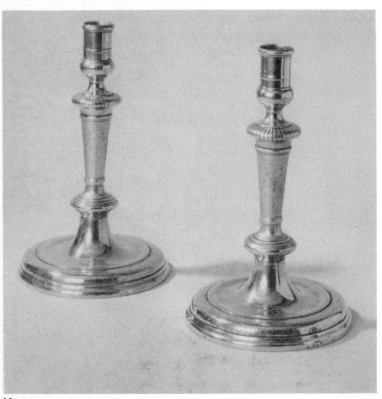

13

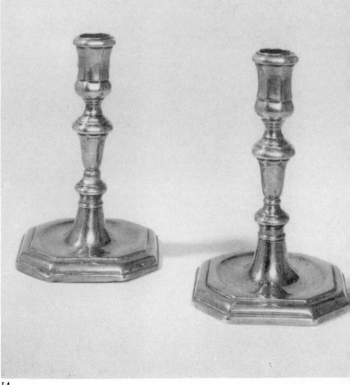

14

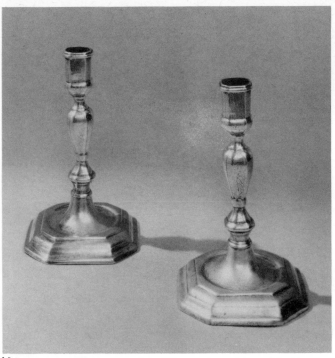

15

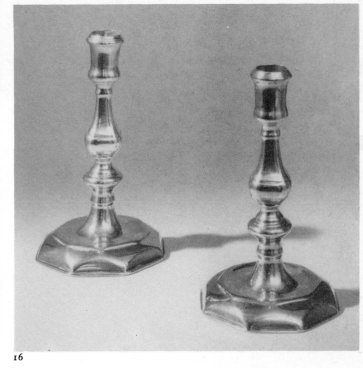

16

11 A 'Surrey Enamel' candlestick. Cast brass with shallow cavities filled with coloured vitreous enamels.
10 inches high, c. 1680. Victoria & Albert Museum.

12 The acorn design on the stem shows marked Huguenot influence. The stem is hollow-cast in two halves and then brazed together. This method of casting first appears about this period and continues up to the 1780s, when core-casting was generally adopted. The base is also cast and the two pieces screw together, a method of construction which is typical of virtually all base-metal candlesticks for the next hundred years.
5 inches high, c. 1690.

13 A most unusual model of heavy quality with cast and engraved decoration, with strong Huguenot influence reminiscent of the work of the London silversmith David Willaume.
8⅝ inches high, c. 1705.

14 The Huguenot influence is still in evidence, but the octagonal nozzle is an additional detail.
5 inches high, c. 1700–10. Christopher Clarke.

15 More additional detail on the basic Huguenot outline in the shape of the octagonal nozzle and engraved decoration on the stem.
5⅜ inches high, c. 1715.

16 The inverted baluster stem shows Continental influence. The stem and base of this candlestick are not screwed together but are joined by burring over the base of the column where it protrudes on the underside.
7½ inches high, c. 1715.

17 Normal baluster-shaped stem and octagonal base, rather inelegantly proportioned.
7⅜ inches high, c. 1715.

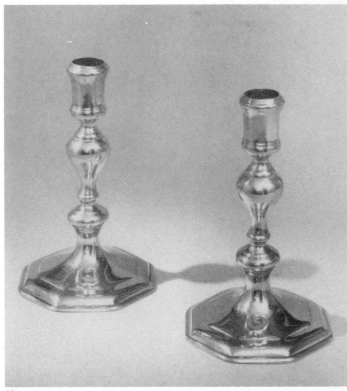

17

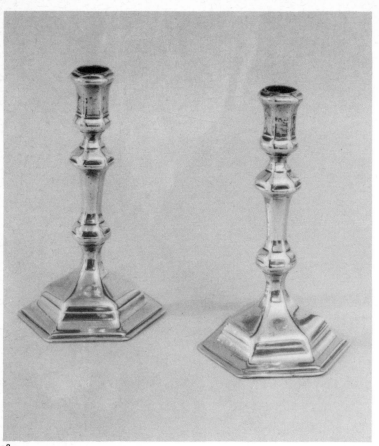

18

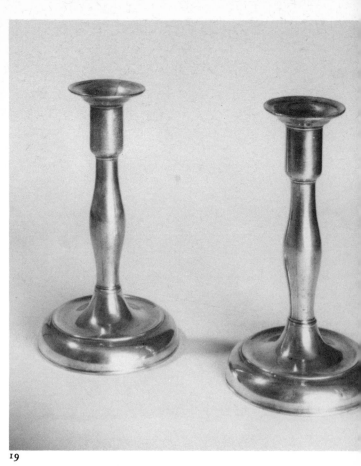

19

18 A well-known design in silver, very much in
fashion between 1710 and 1725. It has a
simplicity and angularity which is most
effective.
7 inches high, c. *1710–20.*

19 A most singular George I model with a
plain cylindrical stem which swells in the
middle. It is cast in two single vertical sections,
including the drip-pan. The circular base is of
bold form.
9 inches high, c. *1720.*

20 A most interesting candlestick, showing how
the Huguenot outline has been 'breached' with
cast and raised decoration with a definite Rococo
feel. Though simple, it is plainly visible in the
swirled gadrooning and acanthus leaf on the
underside of the nozzle. The candlestick has
been cast in three parts: nozzle, stem and base,
and the casting has been finished and gilded.
The decoration is against the flow of contem-
porary brass design and might certainly be
called a very early example of English ormolu.
7½ inches high, c. *1735.*

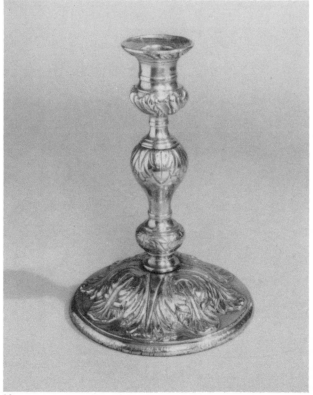

20

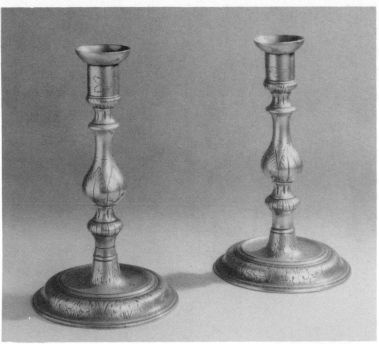

21

21a

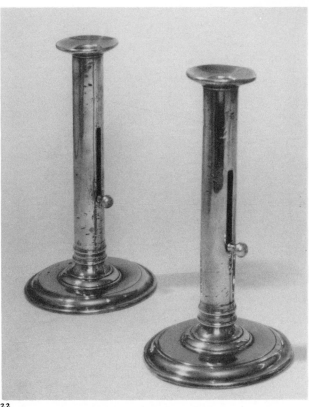

22

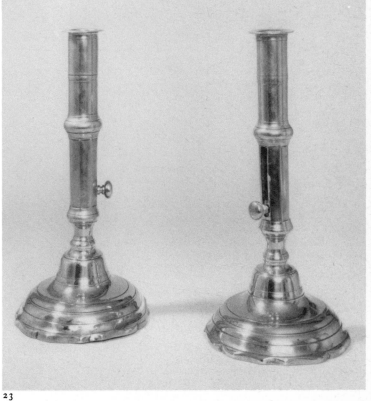

23

21, 21a A good example, though simpler than the previous one, with the same Huguenot profile. The decoration is engraved and the base is inscribed 'Skinners Company'. Owing to the importance attached to the fur trade, the Company of Skinners attained a prominent place in civil life at an early date and was among the first incorporated companies of the City, having received its first charter on 1 March 1327. It is sixth in number of the twelve great companies of London. The practice of marking company chattels was not all that uncommon, but it is a rare survival today.
7⅞ *inches high, c. 1710.*

22 A good example of the very simple push-up candlestick of the 'pig scraper' type. Also commonly made in iron, this design was made over a long period.
8½ *inches high, c. 1730.*

23 A fine example of the push-up candlestick, used right through the century in more humble households. Usually the stems were little more than a straight tube, but this pair has unusually fine detail. French influence can be seen in the base.
10⅛ *inches high, c. 1730.*

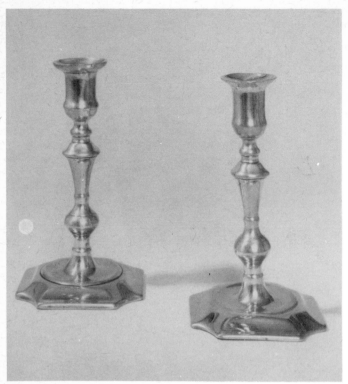

24

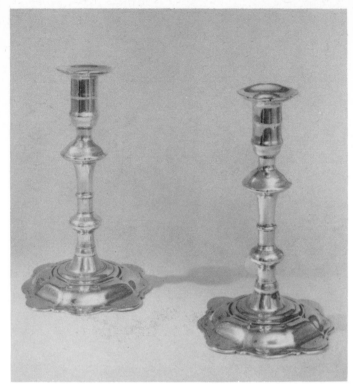

25

24a

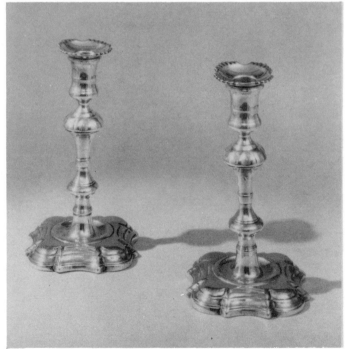

26

24, 24a A typical design which must have been made in some quantity, judging by the number still to be found. This pair has an engraved inscription on the base
 *Roy*l *High*s
 *Duke Cumb*d.
William Augustus, Duke of Cumberland, son of George II, was notorious for his cruel suppression of the Jacobites at the Battle of Culloden in 1746. These candlesticks were probably part of his campaign accoutrements.
6½ inches high, c.*1745.*

25 A sophisticated example of a simple shape. The drip-pan has been cast as an integral part of the stem, which is seamed. Only better-quality candlesticks of this period had a separate drip-pan or *bobèche.*
8 inches high, c.*1745.*

26 A fine pair, both in weight of metal and in detail. The separate pans are original.
8⅛ inches high, c.*1740–5.*

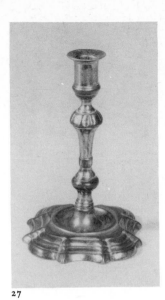

27

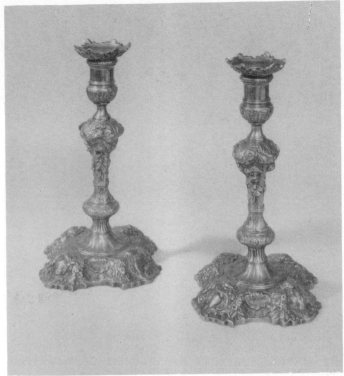

28

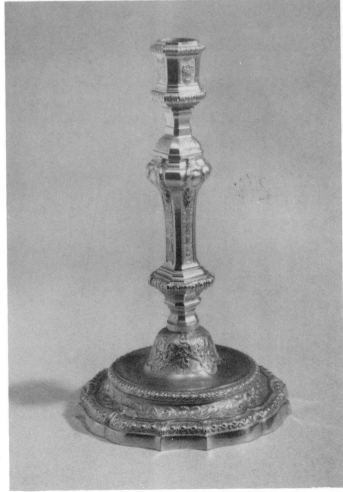

29

27 A taper stick, similar in design to (26). Used on a desk for softening sealing-wax, or for travelling. Taper sticks were sometimes made *en suite* with candlesticks.
3⅞ inches high, c.1740–5.

28 Rococo brass candlesticks are rare survivals. This pair is a fine example of the early period. The cast decoration is very rich, but the basic simple silhouette is clearly visible. The stems are hollow and seamed, but in spite of this they are very heavy. They have their original drip-pans and still bear traces of fire-gilding. They are reminiscent in style of work by the famous London silversmith Eliza Godfrey.
9¼ inches high, c.1745.

29 A good example of an early eighteenth-century French gilded brass candlestick. It is made in two parts – the cast and seamed stem and the cast and lathe-turned base. The chiselled and chased decoration is of fine quality and has been carried out after casting, unlike (30) whose decoration was left unfinished after being taken from the cast.
10 inches high, French c.1720–30.

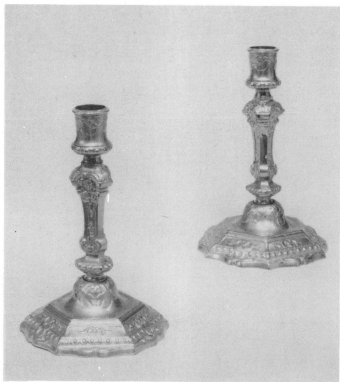

30

30a

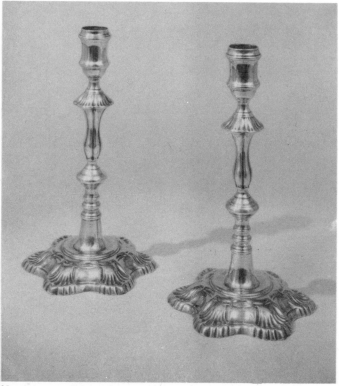

31

30, 30a A pair of very rare candlesticks with original fire-gilding. Their style is French Baroque: the stems are solid-cast and not seamed, and the base is also cast. Unlike their French counterparts, their decoration has not been chiselled or worked after casting, but in spite of this the effect is very rich. The cast detail of the base is most unusual and appears to be unique. Bases were normally turned or finished by hand to economise on metal.
7 inches high, c. *1745–55*.

31 A very good example of the shell base. A classic design of the mid-eighteenth century, also made in Bell Metal and Paktong.
8⅜ inches high, c. *1750–5*.

32 A more simplified version of the shell base, complete with detachable pan. The base lacks the step and decoration of (31).
10¼ inches high, Bell Metal, c. *1750–5. Charles Howard*.

33 An extraordinary pair of candlesticks, probably made for a private chapel. There is a great amount of fine detail in the stem, which is a little elongated. Original separate pans.
19 inches high, weight 7 lb each, c. *1755–60*.

34 This has the rare feature of a rod inside the stem which pushes up a base-plate in the nozzle when the stem is twisted, thus ejecting the candle-stub. Good detail in the stem modelling and well-shaped base.
8¾ inches high, c. *1750–5*.

35 An illustration from a mid-eighteenth-century brass candlestick-maker's pattern book which corresponds closely to (34) except that it has a push-up ejector.
c. *1755–60. Martin Orskey*.

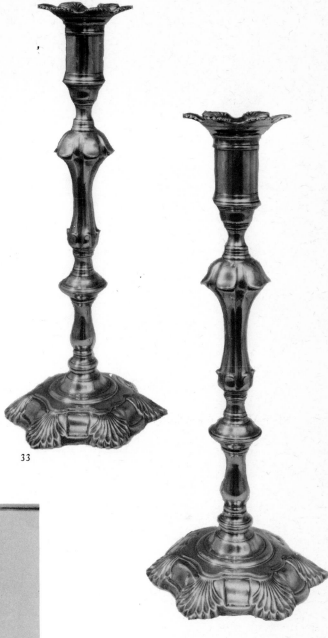

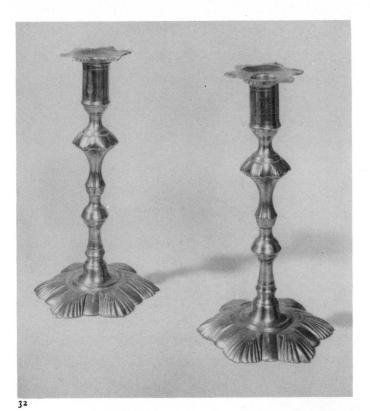

32

33

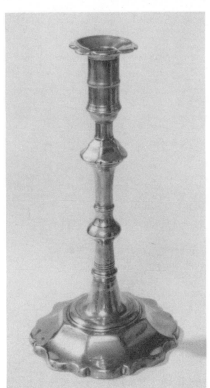

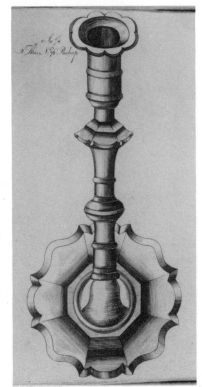

34

35

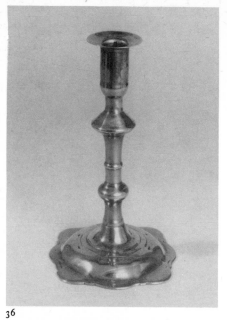

36

36a

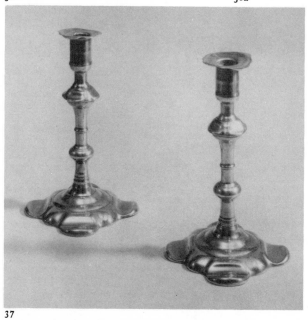

37

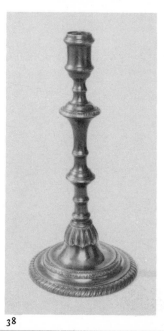

38

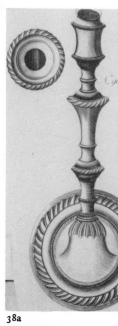

38a

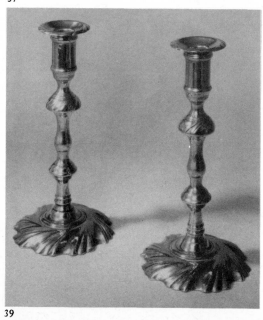

39

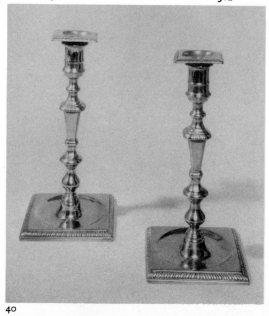

40

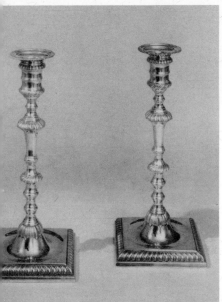

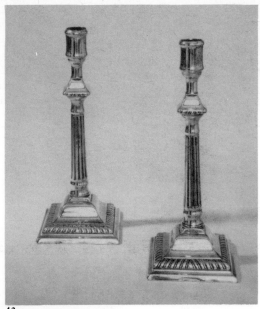

41

42

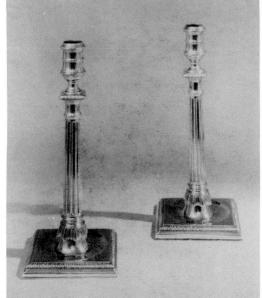

43

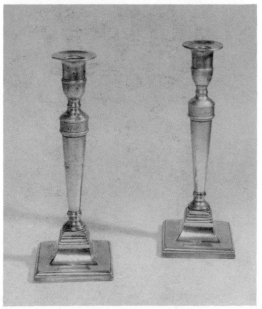

44

36, 36a A typical mid-eighteenth-century candlestick in shape and construction. The two marks stamped on the base are probably those of merchants or stock-rooms, and have undeniably nineteenth-century characteristics. George Grove is less well-known than Joseph Wood, whose stamp has been found on similar pairs of candlesticks.
7½ inches high, 4¾ inches diameter base, c.1755.

37 A pair of candlesticks of similar construction to (34). The undersides of the bases bear the stamp of George Grove.
8 inches high, c.1750–5.

38, 38a An interesting model found in both brass and Bell Metal. It has good detail on stem and base, and is virtually identical with the illustration in this mid-eighteenth-century pattern book.
10 inches high, Bell Metal, c.1755–60. Clifford Sandelson 38; Martin Orskey 38a.

39 This design is found in no other metal but brass. The outline is a familiar one, but the swirl base gives it an original effect.
8½ inches high, c.1755–60.

40 A well-known design in silver, most frequently associated with William Cafe, mid-eighteenth-century London silversmith.
10½ inches high, c.1755–65.

41 One of the finest examples of sophisticated brass. The detail is superb, and the quality of the brass excellent. The circular drip-pans are more pleasing than the square pans of (40).
10 inches high, c.1755–65.

42 The fluted stem heralds the advent of neo-classicism, and represents a complete break with previous designs. This model would appear to be a base-metal design only for it is found in brass and Bell Metal but not in silver. The separate drip-pans are missing.
11 inches high, Bell Metal, c.1755–60.

43 This pair is also in Bell Metal, used extensively from the mid-seventeenth century onwards owing to the lack of good raw brass. It dropped from favour as brass supplies improved, but was again a popular base metal from the 1760s to the end of the century. The base is reminiscent of (40) and (41).
9¾ inches high, Bell Metal, c.1760–5.

44 A pair of candlesticks in typical neo-classical taste, but each is engraved with the date 1769 on the stem, together with the name Amelia Scott. It is interesting that this model was being made at this date, showing that it was popular over the next twenty-five years.
9½ inches high, dated 1769.

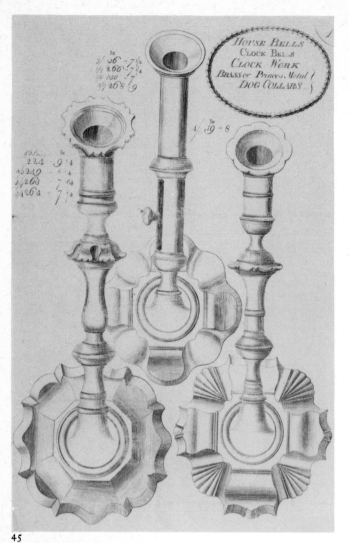

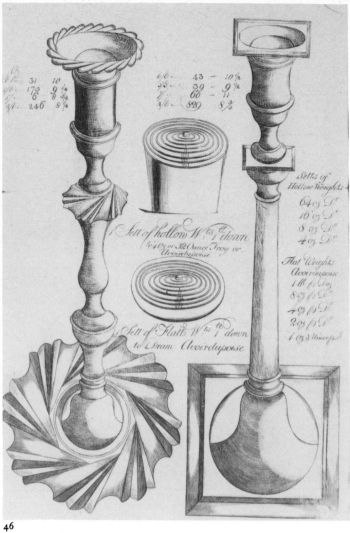

45

46

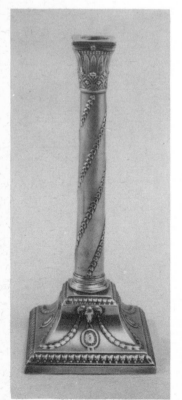

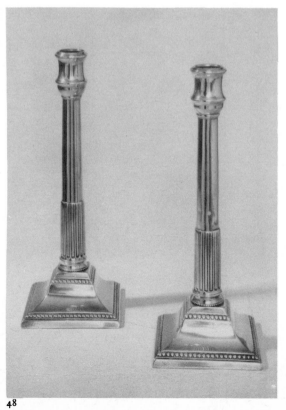

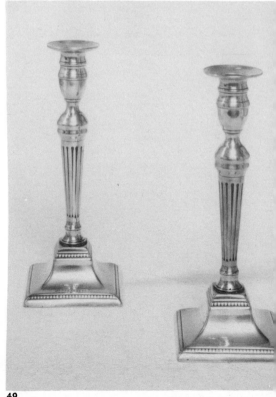

47

48

49

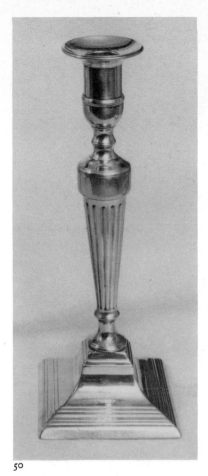

50

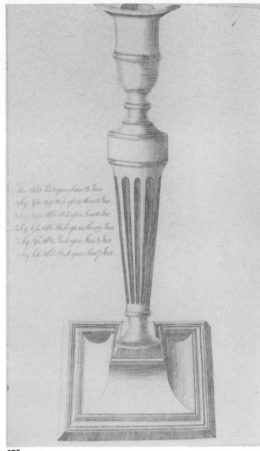

50a

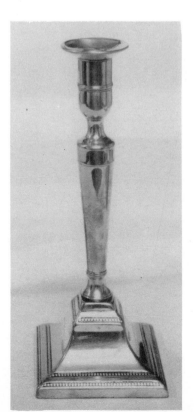

51

51a

45 The first page from a late eighteenth-century pattern book with the unusual feature of listing its wares in a decorative cartouche.
15 × 9½ *inches, c.1770. Winterthur Museum.*

46 Another page from the same pattern book showing two candlesticks and two sets of cup weights.
15 × 9½ *inches, c.1770. Winterthur Museum.*

47 One of a rare and interesting pair of late eighteenth-century candlesticks in pure neo-classical taste. They are not made in the conventional way, with cast base and core-cast stem, but in the same way as contemporary Sheffield plate. Several stamped sections have been brazed together and then pitch-filled to add weight. The colour of the metal is 'white' – it is probably Tutania, identical with Paktong but softer. Paktong was brittle and could not be stamped because it disintegrated under the hammer.
11¾ *inches high, c.1780.*

48 The development of neo-classicism is more marked in the fluted base of the stem. The beaded design on the base became very popular over the next twenty years.
11½ *inches high, c.1780.*

49 A variation on the basic shape with fluted stem. The nozzle is shaped and has more movement than (44).
8¼ *inches high, c.1780.*

50, 50a A very bold model of fine quality. The illustration from a contemporary pattern book states that this candlestick was made in heights from 7 inches to 12 inches.
11 *inches high, Bell Metal, c.1785. Mr & Mrs James B. Boone Jnr.*

51, 51a A typical neo-classical model without ornamentation. The cast inscription on the base reads 'Made of Spanish Cannon Destroyed at Gibraltar Sepr. 14 1782. T. Warner.' Admiral Howe relieved the siege of Gibraltar by the Spanish in that year. The Warners were bell-founders in the City of London.
9¾ *inches high, Bell Metal, c.1785. Arthur S. Vernay Inc.*

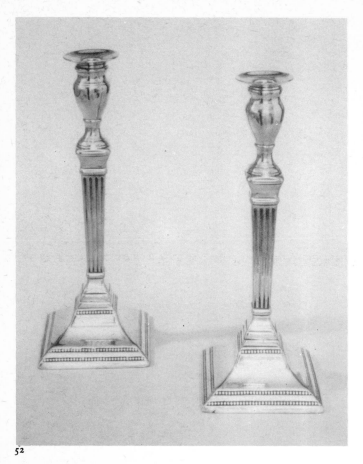

52

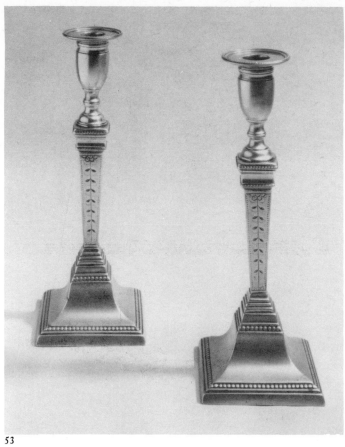

53

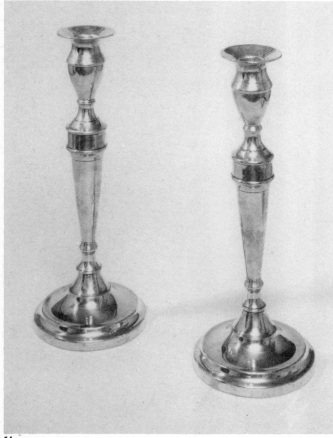

54

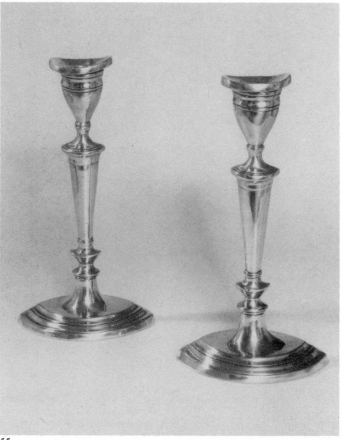

55

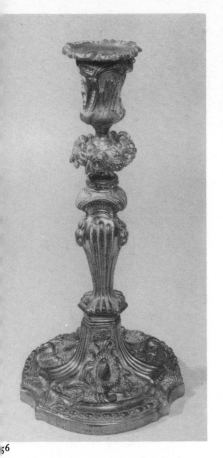

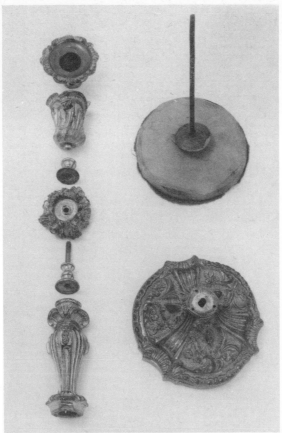

56 56a

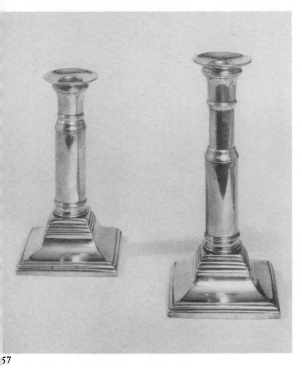

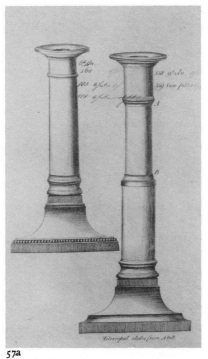

57 57a

52 Square fluted stem with popular beading decoration on the base. The nozzles are urn-shaped.
10¾ *inches high, Bell Metal,* c.*1785.*

53 An exceptionally fine pair of candlesticks with engraved decoration on the square stems. The beading decoration on the base is repeated at the top of the column and round the rims of the separate drip-pans.
11 *inches high, Bell Metal,* c.*1780.*

54 Another typical neo-classical design, with urn-shaped nozzle and elegant circular base.
11⅜ *inches high, Bell Metal,* c.*1785.*

55 This design is taken straight from silver and Sheffield plate patterns, and it is very rare to find it in brass. The cross-section is oval. Original detachable drip-pans.
11¼ *inches high,* c.*1780.*

56, 56a A rare Rococo model of important size. Unlike its French counterpart it has not been cast in one, but is made up of seven separately cast pieces held together internally by an iron rod. William Parker took out a patent in 1781 for this method, although it had been used much earlier in the century. The quality of the afterwork, or chiselling, is exceptional. Original gilding.
12½ *inches high,* c.*1755–60.*

57, 57a An extending or telescopic candlestick, not very elegant, but practical: an example of the ingenuity and inventiveness of the last decades of the eighteenth century. This pair corresponds very closely with the model illustrated in a contemporary pattern book.
6⅜ *inches high, 9½ inches extended,* c.*1800.*

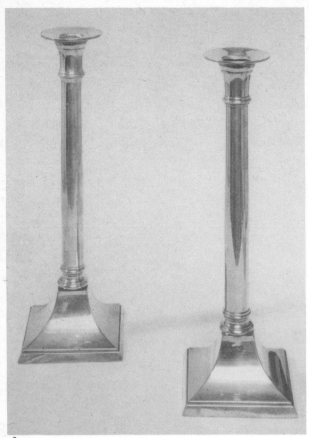

58

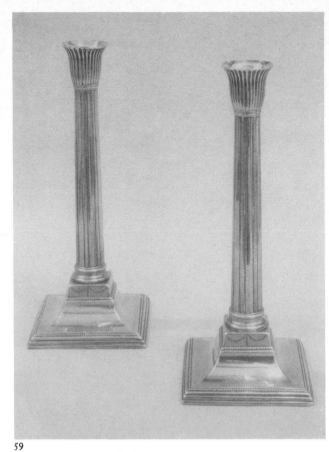

59

58 A good example of *trompe-l'oeil* proportions. The simplicity of line creates a feeling of elegance and stability which makes the height appear not disproportionate to the base. A rare model.
12¼ *inches high, Bell Metal, c. 1795.*

59 This pair is pure neo-classical in style, with fine beaded decoration and punched swags on the base. The column stem also has vestigial beading, terminating in a stylised lotus in the Egyptian manner.
12 *inches high, Bell Metal, c. 1795. Private collection.*

60 One of a pair of adjustable double candelabra with turned mahogany bases. Probably made for use on a desk in a library, or on a piano, harpsicord or spinet.
18½ *inches high, c. 1800.*

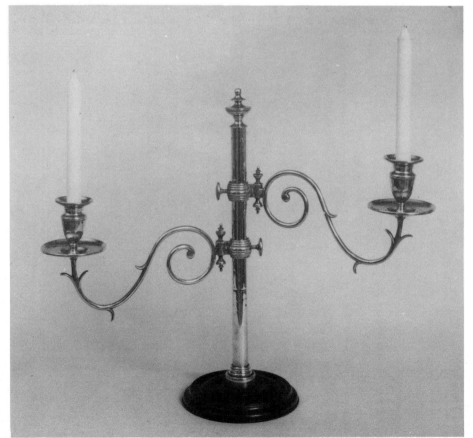

60

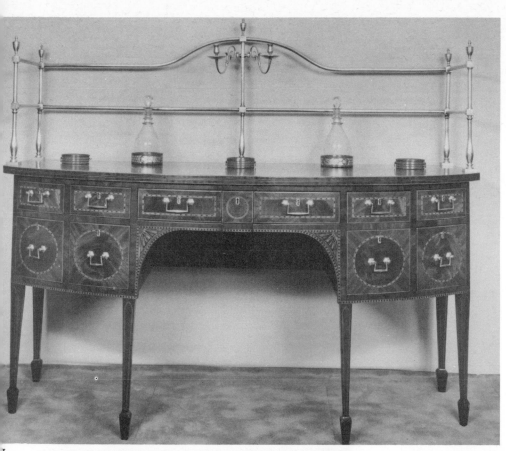

1

61 A similar design was also made for sideboards, the candelabra being an integral part of the brass frame which originally held splash-curtains.
c. *1800*.

62, 62a A pair of mahogany-stemmed candlesticks with reeded brass nozzles and drip-pans. These wooden candlesticks were popular from about 1760 until the early 1800s. This brass-founder's pattern book illustrates two different designs of nozzle.
10 *inches high*, c. *1785*.

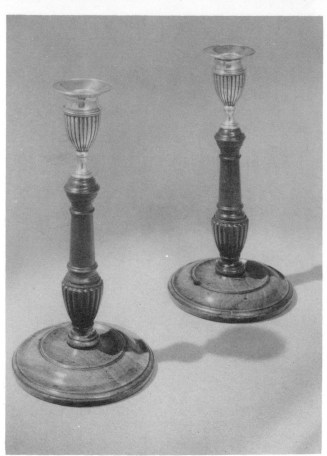

62

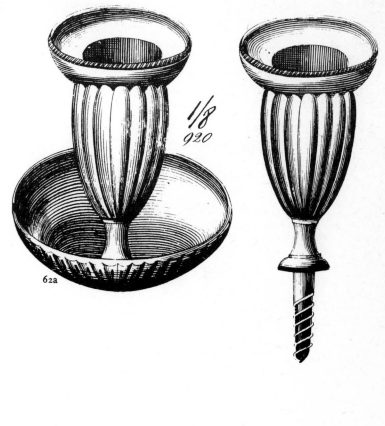

62a

Chambersticks

63 A rare Rococo chamberstick with a naturalistic theme. The handle is rustic and there is a caterpillar on the nozzle.
6½ inches long overall, c.1750–60.

64 A fine chamberstick with rather more detail than usual. The simplicity of its design suggests that it dates from the first quarter of the eighteenth century.
9¼ inches long, 2⅜ inches high, French or English, c.1725. Winterthur Museum.

65 A neat design with an unusual turned wooden handle. Cast brass with a plainness which dates it to the same period as the previous one.
7¾ inches long, French or English, c.1725. Winterthur Museum.

66 A more delicate chamberstick with detail on the ring handle and well-turned decoration on the nozzle and dish. Cast brass.
4¼ inches long, 2¼ inches high, c.1735. Charles Howard.

67 A plain, robust design of country simplicity. When not in use it was hung up by the ring in the long brass handle. Cast brass.
8 inches long overall, 2¼ inches high, c.1750. Christopher Clarke.

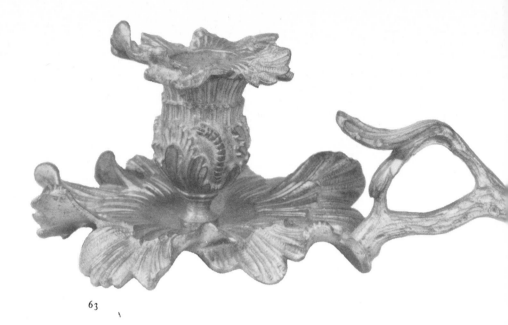

63

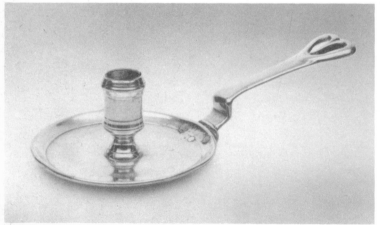

64

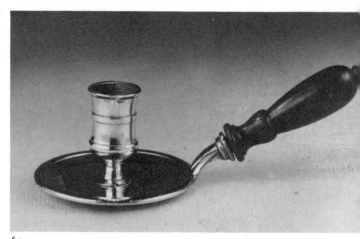

65

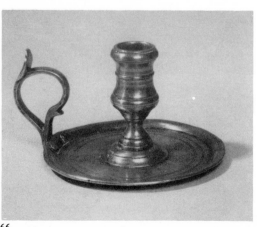

66

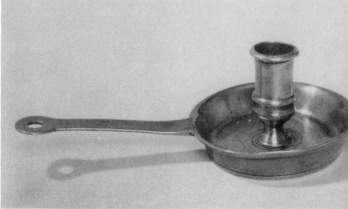

67

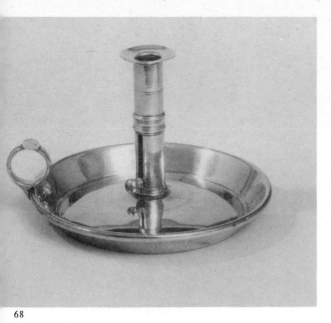

68

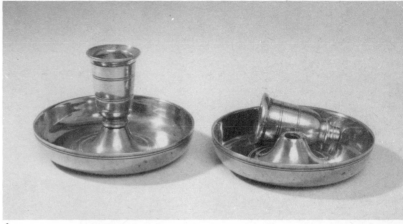

69

69a

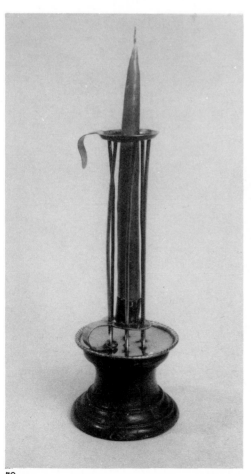

70

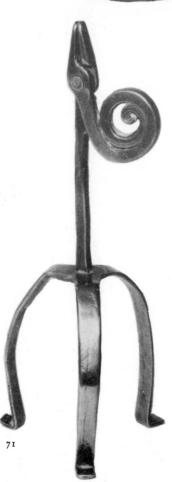

71

68 A typical late eighteenth-century model, but made of sheet metal and not cast. It is soundly made and has a push-up ejector.
5 inches high, 7½ inches diameter, c.1780.

69, 69a A pair of travelling chambersticks. When the two nozzles are unscrewed the two dishes fit tightly together. For all their simplicity they are well designed and made. Cast brass. Sometimes known as 'Brighton buns'.
3⅝ inches diameter, c.1790.

70 This portable candlestick, probably used in stables or haylofts, is commonly found in iron, but seldom in brass. The candle socket slides up the brass struts so that the candle can be raised as it burns down. The small lip-handle on the top drip-pan is for carrying. Turned wood base. Possibly Continental.
12½ inches high, 4¾ inches base diameter, c.1730–50. Roderick Butler.

71 A late eighteenth-century copper rushlight holder on a curved tripod base. This article was rarely made in any other metal than iron.
6¾ inches high, c.1770–1810.

Wax and Taper Jacks

72 An important wax jack, probably used in a business house because of the length of taper it holds. This design is also found in silver.
9 inches high, 7½ inches long, c.1680–1700. Victoria & Albert Museum.

73 A smaller domestic wax or taper jack. The base has a simple heart design.
5 inches high, c.1760–1800.

74 A page from a late eighteenth-century brass-founder's pattern book showing an almost identical design. The two perforated items are the tops of glass pounce pots. Watermark 1794.
Plate size 9½ × 6½ inches.

75 A domestic taper jack with its coiled 'snake' of wax, usually white, green or red.
6½ inches high, c.1760–1800.

76 A brass candle-box, hung on the wall in various rooms in the house to hold a supply of candles and tapers. Unusual in brass, and more often found in japanned iron or tin.
12½ inches wide, c.1750–1800. V. Chinnery.

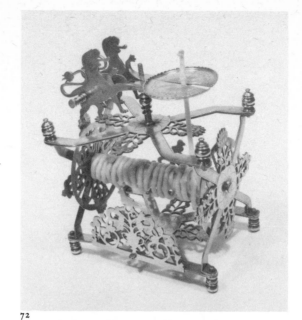

72

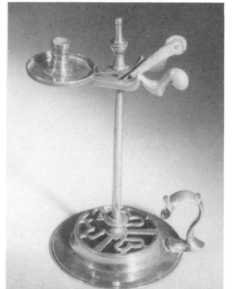

73

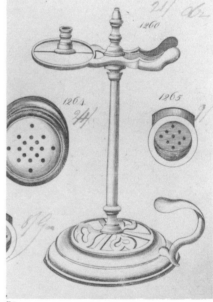

74

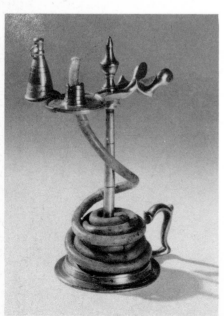

75

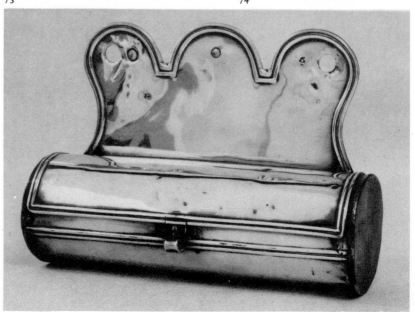

76

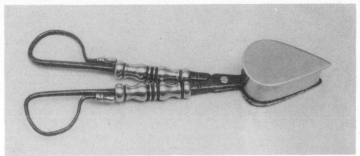

77

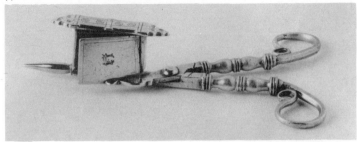

78

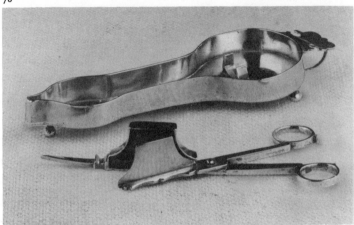

79

Snuffers and Douters

77 A late seventeenth-century candle-snuffer of rare form, which marks the beginning of a design change. The 'almond' or heart-shaped snuffer, which opened and cut like scissors, with a raised flange to hold the wick, was made for 150 years or more before this design, with a true box on the blades, made its appearance. *6½ inches long, c.1660–85.*

78 Late seventeenth-century scissor-shaped candle-snuffer with plate and box. The point on the end is common to all models, and was used for uncurling the burnt wick before cutting it, and for prodding the candle stub out of the nozzle. The tray is missing. *6⅝ inches long, 3 inches high, English or French, c.1670–90. Winterthur Museum.*

79 A silver design, rarely found in brass. Originally snuffers had a box on each blade, but later designs had a plate on one side so that the piece of trimmed wick could be trapped and held. *8½ inches long, c.1685. Winterthur Museum.*

80 The upright snuffer was introduced during the Restoration. There are a number of silver ones existing, but examples in brass are rare. This one dates from the first decade of the eighteenth century when snuffers were often made *en suite* with sets of candlesticks with the same base-design. *8¾ inches high, c.1705. Winterthur Museum.*

81 Similar in concept to the previous one, but without the small looped handle. The base is very similar in design to (24) and was made in the same period. *9¼ inches high, c.1745.*

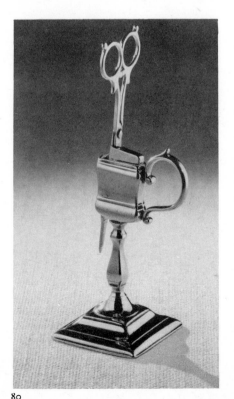

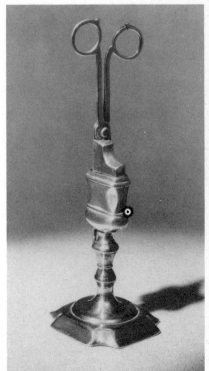

80 **81**

82

83

82 A snuffer tray with turned bun feet and an engraved crest. The cracking is perhaps an indication of the poor-quality brass of the period. A well-known Huguenot silver design. *6¼ inches long*, c. *1720–30. Victoria & Albert Museum.*

83 An example of the true douter, or 'out-quencher' as it was originally known, with two oval or circular blades to pinch out the flame. Original stand. *6¼ inches long overall*, c. *1720. Colonial Williamsburg.*

84 A slightly larger tray which, like the previous one, has lost its douter or snuffer. It has square peg feet. *7¼ inches long*, c. *1720–30.*

85 An unusual octagonal shape with an acorn motif on the handle. It probably held snuffers rather than douters. *7⅞ inches long, Bell Metal*, c. *1710.*

84

85

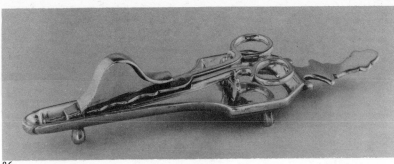

86

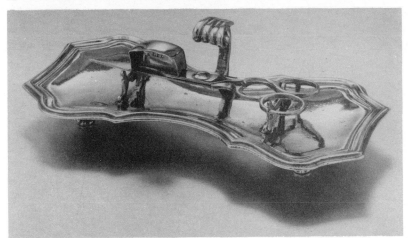

87

86 Snuffer and tray of heavy cast brass with curved box and plate.
9¼ inches long overall, c. 1720. Colonial Williamsburg Foundation.

87 A very boldly shaped tray with scrolled carrying-handle. Although the snuffers are the correct shape, it is doubtful if they are the original ones as they appear to be too small.
8⅛ inches long overall, tray probably French, c. 1740. Colonial Williamsburg Foundation.

88 A page of engravings from a late eighteenth-century brass founder's pattern book showing various models of snuffers and pans. The designs illustrated were in high fashion from 1730 to 1750 but this pattern book was produced some twenty-five years later, showing the continuing demand for popular designs.
Page size: 15 × 9½ inches, c. 1780. Winterthur Museum.

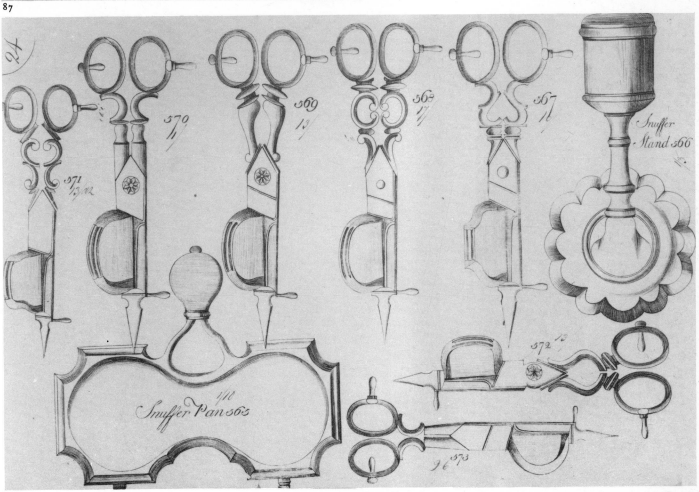

88

Wall Sconces

89 A fine example of English or Dutch *repoussé* brasswork. It is one of a pair, and they bear no trace of having been silvered. They are engraved 'Upholders Hall No. 11 and 12' and were originally part of a large set. The twin candle arms are later replacements. 15¾ *inches high*, c.*1690–1700. Benjamin Sonnenberg.*

90 A wall sconce of fine quality *repoussé* work, English made. Compared with (89) it does not have the same Continental overtones. The fluted base is similar to (92). The candle arm is missing. Traces of original silvering. 16¼ *inches high*, c.*1690.*

91 One of a set of six wall sconces at Windsor Castle. They are of the finest quality *repoussé* work, giving the impression that they are of cast metal. The open piercing is very unusual. The central cartouche has the royal crown and cypher of Charles II. 17 *inches high*, 12¼ *inches wide*, c.*1680. By gracious permission of Her Majesty the Queen.*

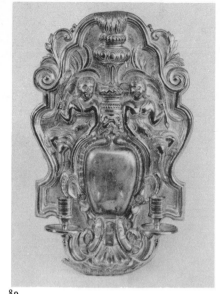

89

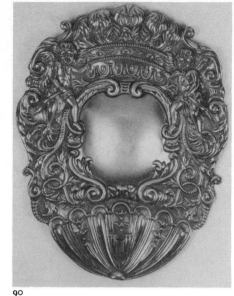

90

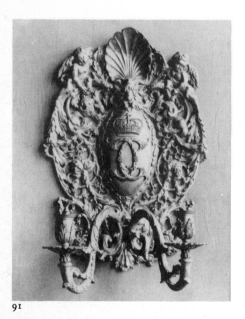

91

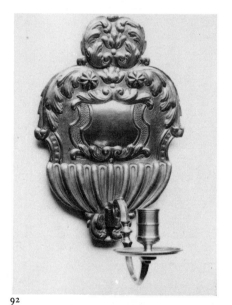

92

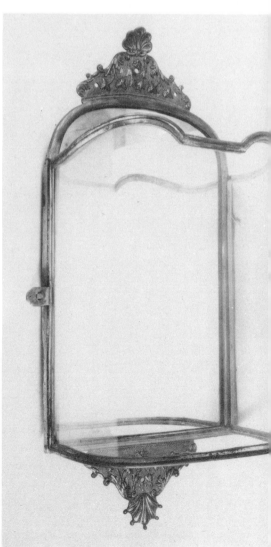

94

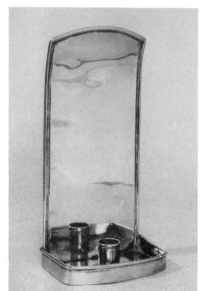

93

92 A finely designed *repoussé* wall sconce. The plain panel on the back-plate acted as a reflector. 'Edward Gore 1706' is engraved on the back. One of a pair. 9¼ *inches high*, c.*1700–10. Victoria & Albert Museum.*

93 A good example of a popular wall sconce for common use. The back-plate reflected considerable extra light. It could be either hung or stood on a table. 10¾ *inches high*, c.*1760–1800. Anthony Meyer.*

94 A wall or side lantern of known design, but made entirely of brass. The cartouches at the top and bottom are cast and chased, imitating the contemporary gilded gesso work usually found on mirrors. The mirrored back reflected the light of the single candle placed inside. 28½ *inches high*, c.*1720. Sotheby & Co.*

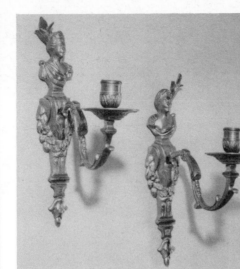

95

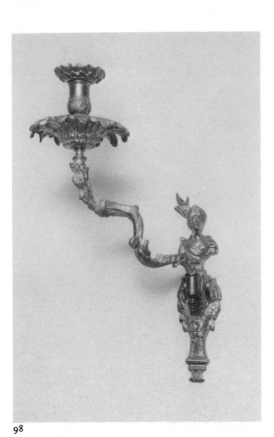

97

Wall Brackets

95 A wall bracket with three branches, made up of eleven sections. Its design is pure Louis XIV and it is a very rare survival. The branches are almost identical with those illustrated in (101) but bolder. Original lacquered finish.
10¼ inches high, c.*1735–40.*

96 Examples from Nicholas Pineau's book of designs. The engraving above indicates its influence on the design of the back-plate of (95).
c.*1720.*

97 A pair of early eighteenth-century wall lights in late Baroque taste – provincial in quality but nevertheless of good form.
11¼ inches high, French, c.*1730–5.*

98, 98a A pair of single-arm wall lights with back-plates almost identical with (97). The arms have a Rococo extravagance, but the sockets are Baroque. They may have been used on either side of a mirror – the arms swivel from both sides.
14 inches high overall, c.*1755.*

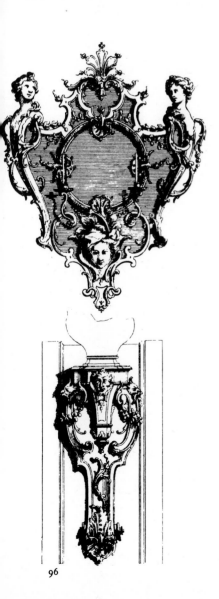

96

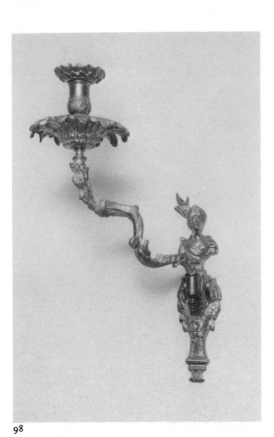

98

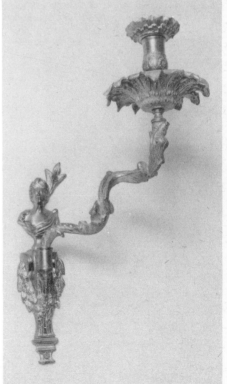

98a

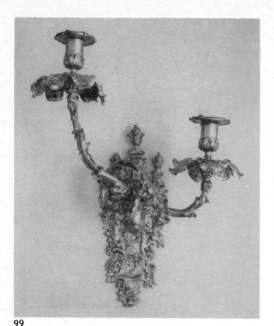

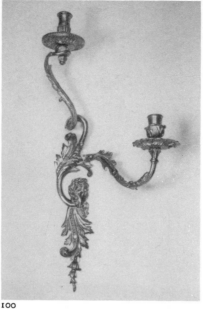

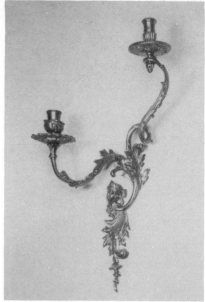

99

100

100a

99 A heavily ornamented asymmetric double
wall light, certainly one of a pair. In spite of its
rich decoration it was not gilded but lacquered,
and retains its original golden brilliance.
14½ *inches high overall*, c. *1755. Mr & Mrs
Richard Chester-Master.*

100, 100a A rare pair of gilt-brass wall lights in
full Rococo style, showing marked French
influence in their asymmetry. The arms,
drip-pans and sockets are different on each
one – even the nozzles are of different sizes, and
the heads on the wall-supports do not match.
Nevertheless the overall effect is balanced.
19 *inches high overall*, c. *1755.*

101 A page from a brass-founder's pattern
book, illustrating a variety of designs for
wall lights and brackets. One of them is very
similar to the arm of (98). On the left is an
example of furniture mounts in the *chinoiserie*
style.
Plate size: 19½ × 14 inches, c. *1775. Victoria &
Albert Museum.*

101

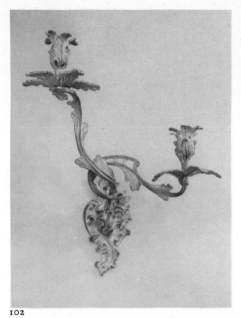

102

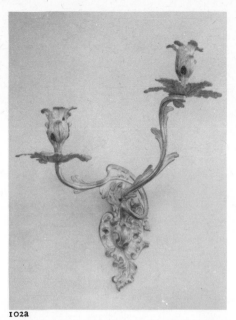

102a

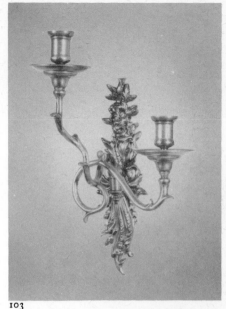

103

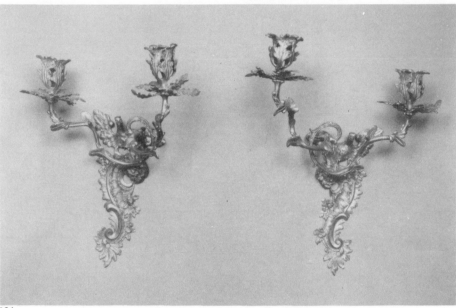

104

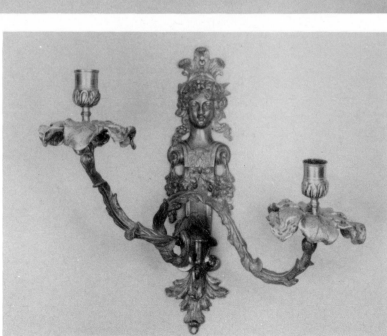

105

102, 102a A pair of wall lights in full English Rococo style. They consist of a back-plate, two branch-arms and two nozzles and drip-pans. Each piece is of cast metal. The back-plates are identical, but the arms are opposed. Original gilding.
14¾ inches high, c.1760–70.

103 The design of the arm is typical of a theme which ran concurrently with Rococo, and in this wall light both styles are brought together very satisfactorily.
12 inches high overall, c.1765. Winterthur Museum.

104 A pair of wall lights with similar nozzles and pans to (102) but the arms have better detail and the back-plates are symmetrically opposed with much more imaginative design.
12⅞ inches high, c.1765. Winterthur Museum.

105 A wall light of transitional design. The back-plate has the austerity of late Baroque in the form of the female caryatid. The double arm is in full Rococo style. The back-plate is cast metal and finely chased with traces of original gilding. A very rare example of English ormolu of superb quality.
12⅞ inches high, 11½-inch spread, c.1755–60.

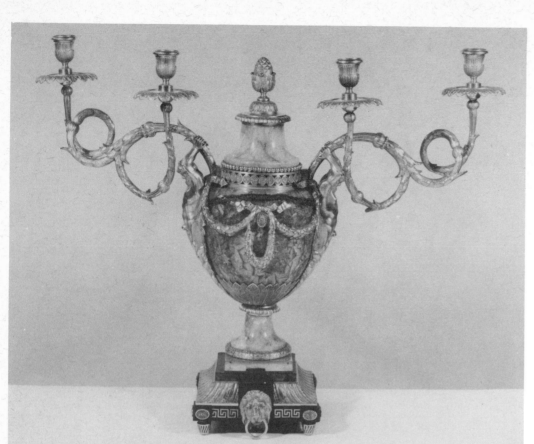

106

108

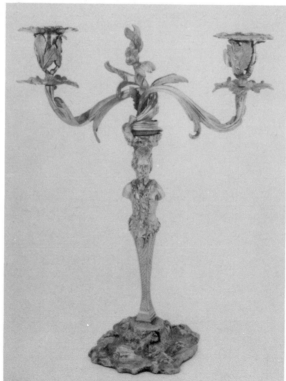

107

106 A candelabrum of Derbyshire fluorspar or Blue John, mounted in chased and gilded brass of the very finest quality – the work of Matthew Boulton. This *garniture de cheminée* epitomises the height of sophisticated design and quality attained by English craftsmen in eighteenth-century ormolu work. The design is in Matthew Boulton's pattern book at the Assay Office, Birmingham.
19 inches high, 22¼-inch spread, c. 1770. Ralph Dutton.

107 One of a set of four ormolu candelabra, each with two curving leafy branches with pierced foliate nozzles and Rococo-style drip-pans. When the branches are removed the bases form candlesticks with stems in the form of caryatids with baskets of fruit on their heads, standing on chiselled bases of rocks and leaves. Two of the candelabra are signed 'Frisbée fecit'. William Frisbée is recorded as having worked with Paul Storr at Cock Lane, London, in the early 1790s.
17 inches high, c. 1790. Sotheby & Co.

108 A table candelabrum with extending arms. Its purely functional design suggests that it was used in a library or office rather than in a drawing-room.
13 inches high, 20 inches overall with arms extended, c. 1790–1810. Bihler & Coger.

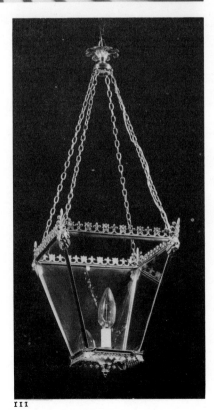

110

Hall Lights and Lanterns

109 An octagonal lantern which hangs in the Queen's Great Staircase at Hampton Court Palace. The sixteen candle arms attached to the inside of the lantern are most unusual – it is more common to find a separate candle-holder suspended inside the frame. The lantern was supplied by Benjamin Goodison in the early 1730s at a cost of £138.
48 inches high, 40 inches wide, c. 1730. By gracious permission of Her Majesty the Queen.

110 A fine late eighteenth- or early nineteenth-century hexagonal hanging lantern. It has applied cast decoration on the top and base. The candles were held inside the lantern by a grapple-shaped candle-holder with three or six arms which was suspended from the bar protruding down from the central boss.
31 inches high, c. 1795–1810. Metropolitan Museum of Art, Gift of James Walter Carter. 63.208.3.

111 A small early nineteenth-century lantern with tapered sides. It has unusually fine decoration incorporating an anthemion and fleur-de-lis, and curious masks on the four corners. It held a single candle only and may well have been a porch light.
32 inches high overall, 12 inches wide, c. 1810.

112 A rather unusual hanging lamp in which oil was used rather than candles. The rams' heads are typical of Robert Adam's work, of which this is a fine example. The design can be found in *Works in Architecture 1775* and the lamp is from a staircase at Osterley Park.
36 inches high, c. 1775. Victoria & Albert Museum.

113 One of a pair of elegant hanging lights. The two curved candle arms are attached to a central boss or covered bowl. These lights could either be suspended from the ceiling or hung from small wall brackets.
14½ inches wide, 8½ inches high, c. 1810. Private collection.

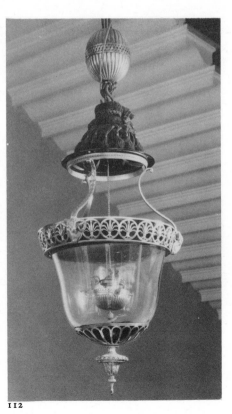

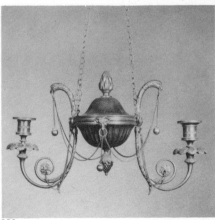

111

112

113

Chandeliers

114 Late seventeenth-century chandelier of a design similar to (115), but with three tiers. The branches follow the same simple S-shape, and there is additional scroll decoration on the stem. It has the royal crown as a surmount, and hangs in the King's Grand Chamber at Hampton Court Palace.
54 inches high, 42-inch spread, c.1690.
By gracious permission of Her Majesty the Queen.

115 This chandelier, in St Andrew's Church, Sonning, Berkshire, is the earliest-known English-made chandelier surviving, and well illustrates the typical Continental design from which early English models were made. The central stem is in several hollow-cast sections, held together by a central iron rod, and incorporating two large balls or globes. The solid cast arms radiate out in tiers from the stem which terminates in a top finial or hook by which the chandelier was hung. It is dated 1675 and has a large winged cherub's head, representing immortality, as a surmount. The cherub's head emblem was used on chandeliers until the early 1700s.
33 inches high, dated 1675.

116 An early eighteenth-century chandelier in St Mary's Church, Langley Marish, Buckinghamshire, very similar to the one at Sonning, with additional scroll decoration on the stem. It has a dove, representing the Holy Spirit, as a surmount – another popular device.
42 inches high. dated 1709. R. J. Sherlock.

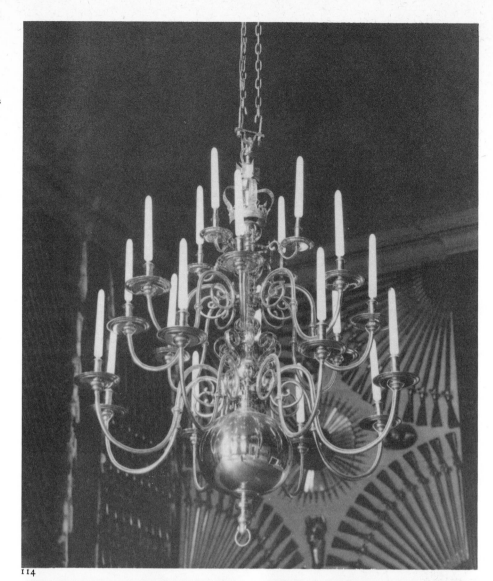

114

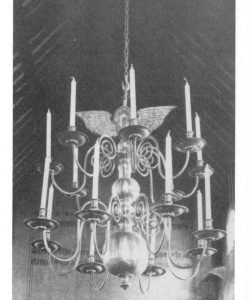

115

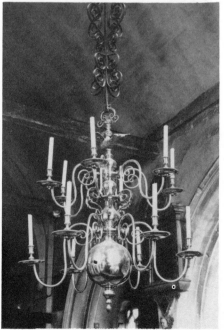

116

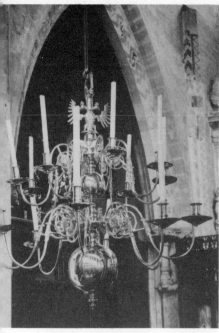

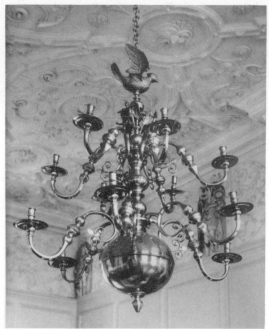

117 118

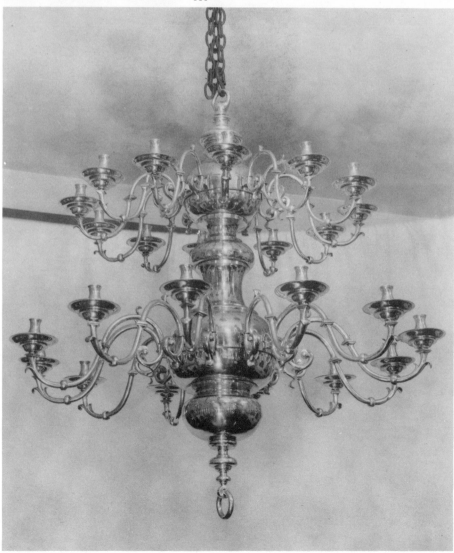

119

117 One of a pair of chandeliers in the church of St John the Baptist, Cirencester, Gloucestershire. The design is an excellent example of contemporary Dutch taste, and although the chandeliers were provided in 1701 by John Spooner, a brass-founder in Bristol, it is very likely that they were imported rather than made by him. The double eagle surmount is most un-English, and the scrolls of the branches where they join the stem are far too elaborate for an English maker of the period. Engraved 'Thomas Stevens and William Hill. Church Wardens. 1701'.
45 inches high. R. J. Sherlock.

118 One of a pair of chandeliers now hanging at Aston Hall, Birmingham, but originally made for the church at Malpas, near Chester. The unusually moulded branches end in the typical Chester feature of a fleur-de-lis scroll. Inscribed 'Ambrose Johnson and Robert Caudwell, Wardens. 1726'. As in the previous four examples, the branches are hooked into holes in a tray which is incorporated in the stem – a method not used after about 1740 in England and found only on Continental chandeliers after that date.
48 inches high, 44-inch spread, dated 1726. Birmingham City Art Gallery.

119 A very fine model with two tiers of branches, known as the Cheltenham Chandelier and important as much for its construction as for its design. The branches are attached by bolts or pins to the inside of a ring which is incorporated in the globe, a completely English innovation which appears around 1740 and is not found on any Continental chandeliers. The Cheltenham Chandelier was originally given to the Church of St Mary, Cheltenham, Gloucestershire, and is inscribed 'Edm. Smith, Surgeon, gave this to ye Church of Cheltenham ano: Dom: 1738'. It was probably made by John Giles, Master of the Founders' Company from 1740 to 1741.
39 inches high, dated 1738. Messrs Pratt & Burgess.

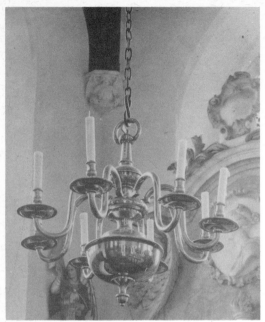

120

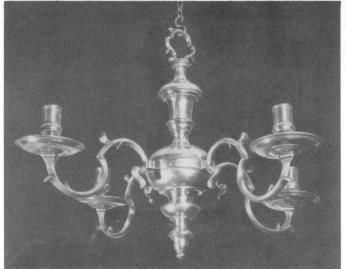

121

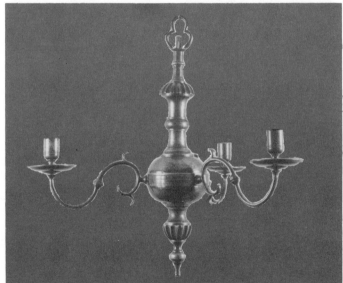

122

120 A small gallery chandelier in Hatfield
Church, Hertfordshire, which is a striking
example of design sacrificed to technique. The
stem is cast in two vertical halves and brazed
together – a very rare feature. The arms are
made in the same way, and consequently have
none of the detail and elegance which typifies
most English chandelier arms.
22 inches high, donated 1733. R. J. Sherlock.

121 A very small chandelier of compact design.
The normal S-scroll of the four branches has
been 'kinked' to a rather more elaborate shape.
12 inches high, c. 1760–5.

122 A very simple basic form with a rather
elongated stem. The detail is fine, and it has the
unusual feature of having only three arms –
perhaps one of several used in a passage or
gallery where only minimal lighting was
required.
19 inches high, c. 1750–65.

123 A chandelier of twelve branches in a single
tier. The central stem is elegantly simple and the
branches are of conventional pattern. The
drip-pans, however, have a strong Rococo
flavour. The surmount is a swirling flambeau,
repeated in a smaller version on the base.
*33 inches high, 36-inch spread, c. 1755–70. Pratt
& Burgess.*

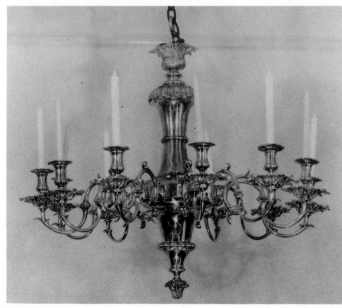

123

126

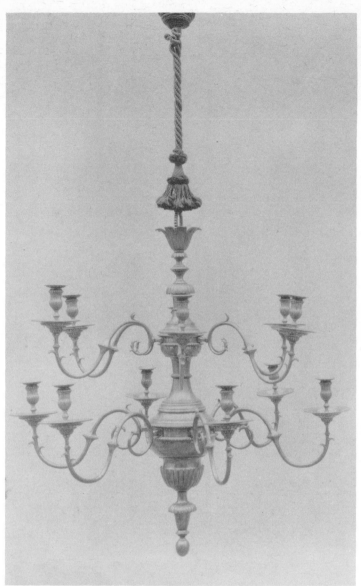

124

125

124 One of a fine pair of chandeliers with twelve branches arranged in two tiers. The overall design is particularly elegant and light, and the excellent detail on the stem is repeated on the candle nozzles and drip-pans.
37 inches high, 39-inch spread, c. 1765–75. Metropolitan Museum of Art, Rogers Fund. 24. 68. 1-. 2.

125 A late eighteenth-century twelve-branched chandelier of lighter design. The stem has a softer neo-classical line, and the acorn finial and terminal are correspondingly plain. The dove surmount shows that it was made for a church. It is engraved with a shield and monogram, too worn to decipher.
30 inches high, 36-inch spread, dated 1788. Bihler & Coger.

126 An eagle with outstretched wings in cast brass. Not a chandelier surmount which has become detached, but a chandelier-hanging. The upper side of the body and wings are worked as well as the underparts, indicating that it was used in the well of a staircase where it would have been seen from above and below.
23-inch wingspan, c. 1760.

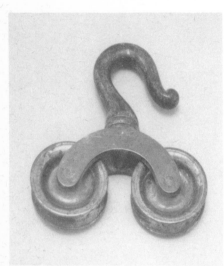

127

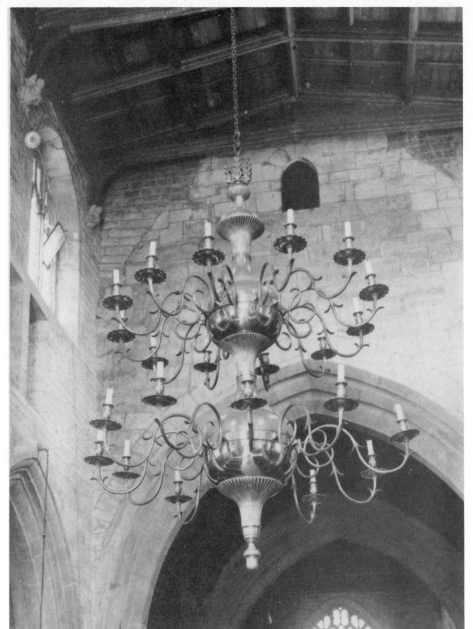

128

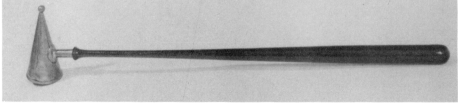

129

127 A pulley from which a chandelier was hung. A double chain from the top of the chandelier entered between the two wheels and then separated to hang down over them; the ends were attached to a central counterweight. The chandelier could thus be raised and lowered for cleaning and changing the candles. Lacquered finish.
6¼ inches high, c. 1750–1800.

128 An early nineteenth-century chandelier with twenty-four branches in two tiers, whose line more strongly reflects the neo-classical inspiration. The simplified gadrooning on the four sections of the stem provides an excellent foil to the plain polished globes. The surmount of stylised tongues of flame is a typical Bristol feature. It is signed Westcott and dated 1809. In the church of St Peter and St Paul, North Curry, Somerset.
42 inches high, dated 1809. R. J. Sherlock.

129 A chandelier-snuffer, with an ebonised wooden handle. These are more commonly found in silver or in iron, and are unusual in brass.
15½ inches long, c. 1800.

Hearth and Home

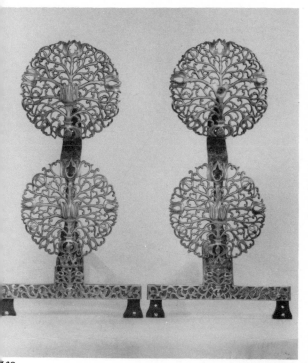

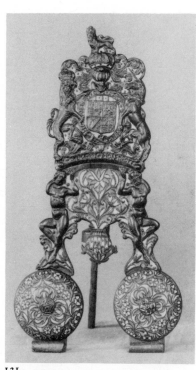

Andirons and Fire Tools

130 A rare pair of English-made brass and wrought-iron firedogs. The circular discs are cast and pierced, and are reminiscent of Stuart filigree silver wire work. The bases also have cast pierced decoration applied over the iron frame. *27 inches high, c. 1670. Jellinek & Sampson.*

131 Cast brass 'Surrey Enamel' andiron. This type of work is sometimes attributed to Jacob Monomia and Daniel Dametrius, who founded a brassworks at Esher in 1649, but the origins are not definitely known. The method of manufacture was a crude form of *cloisonné* – cast brass with shallow cavities filled with coloured vitreous enamels. The pair is sometimes known as the 'Royal' firedogs because of the Stuart coat of arms. *23½ inches high, c. 1660–80. Victoria & Albert Museum.*

132 A pair of small andirons with brass uprights and finials. The brass facing encases an iron frame. *16 inches high, c. 1740–50. Colonial Williamsburg Foundation.*

130

131

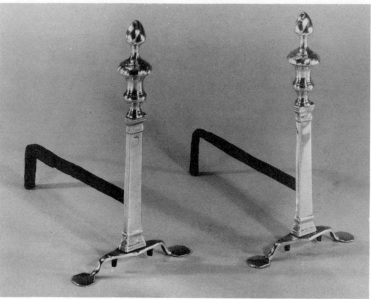

132

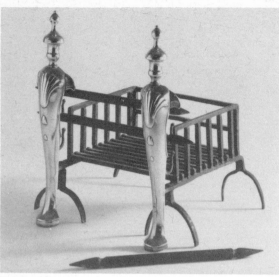

133

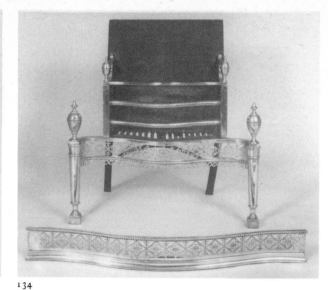

134

133 George II fire-grate, well illustrating the transition between firedogs and a proper coal-burning grate. The framework is wrought iron with brass facing on the front in the form of a cabriole leg and finial. Behind the uprights are three pairs of hooks holding the original removable iron bars. A rare survival.
20 inches high, c. 1725. Winterthur Museum.

134 A mid-eighteenth-century basket fire-grate and matching serpentine-shaped fender in Bell Metal. The bars on the front of the firebox are polished steel.
Grate: 29½ inches wide, fender: 40 inches wide, Bell Metal, c. 1765–70.

135 A pair of brass uprights in the form of cabriole legs with ball and claw feet and urn finials. The iron bar support is too short to have been used to support logs, and probably held a shallow wrought-iron basket.
15¾ inches high, c. 1740.

136 A George II basket fire-grate which has evolved directly from (133) with almost identical brass cabriole legs on the front. This free-standing model was used for burning coal and peat, and also small logs of wood. A grate of this design was more fashionable than functional since it gave out much less heat than large logs supported by andirons and burned in an open hearth.
26 inches wide, 19½ inches high, 10½ inches deep, c. 1730.

137 A fine late eighteenth-century register grate in Bell Metal with engraved and pierced decoration. The bars on the front of the firebox are steel.
34 inches wide, 36 inches high, Bell Metal, c. 1785.

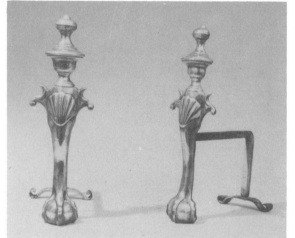

135

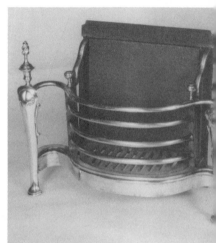

136

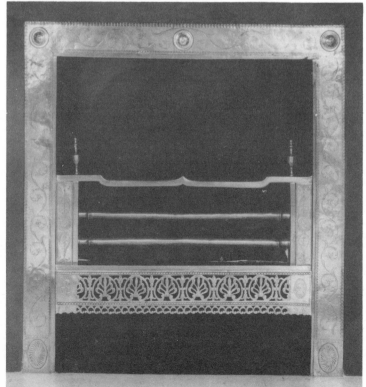

137

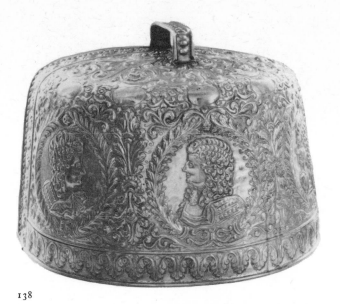

138

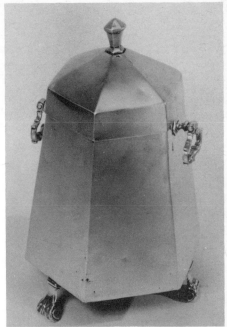

139

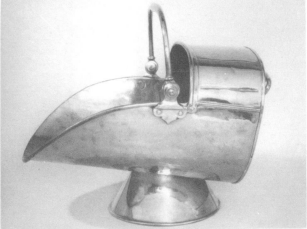

140

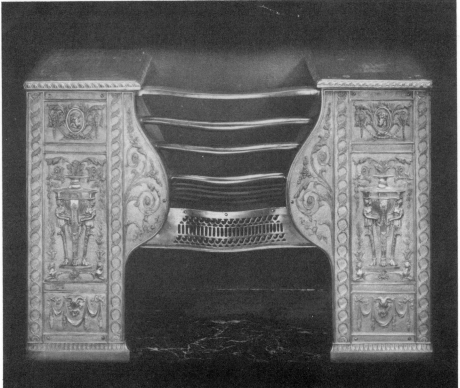

141

138 Brass *repoussé* curfew of superlative quality and design. The name is a corruption of *couvre-feu*. A semicircular hood-like metal cover was placed over the glowing embers at the end of the day to keep the fire in overnight. From this comes the word's modern meaning of restrictions placed on a community during the hours of darkness.
24 inches wide, 16 inches high, English or Dutch, c. *1685. Victoria & Albert Museum.*

139 Hexagonal tapered box, standing on three scroll feet. Used for carrying the dead ashes from the fireplace. The firm-fitting lid prevented dust from spreading while it was carried through the house. Also found in copper, and cone-shaped.
20 inches high, Dutch, c. *1740–50. Mallett & Son.*

140 Early coal-scuttle in sheet copper with cast Bell Metal handle, similar to handles used on eighteenth-century mahogany peat-buckets. Later examples of this classic design have hollow handles and were made in brass.
17½ inches long overall, c. *1800–10.*

141 As with the previous model, this was built into the fireplace and was not a free-standing grate. The cast fronts are of brass instead of cast iron, an exceptionally rare feature. The neo-classical design is extremely fine.
36 inches wide, 23½ inches high, 12 inches deep, c. *1785. T. Crowther & Son.*

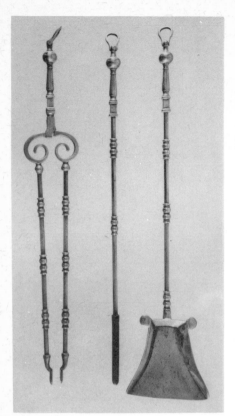

142

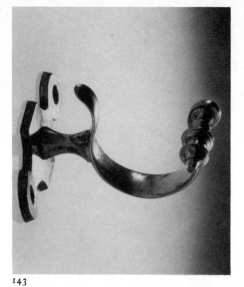

143

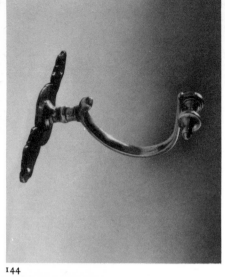

144

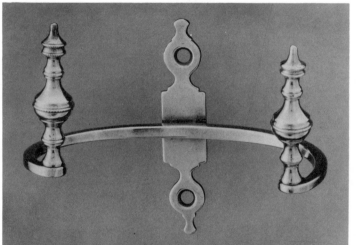

145

142 A fine set of George II fire tools, made completely in brass, except for the head of the poker, which is steel.
28 inches long, c. 1735.

143 One of a pair of chimney hooks with double urn terminal and heavy fixing bracket. Chimney hooks were made in quantities in England for the American market, but never used in England.
4 inches long overall, c. 1790–1810. Winterthur Museum.

144 A much lighter design with single urn terminal.
3 inches long overall, c. 1790–1800. Winterthur Museum.

145 An interesting variation in jamb or chimney hook design. Semicircular design with central fixing bracket and finial at either end.
5 inches long overall, back-plate 3⅞ inches high, c. 1790–1800. Colonial Williamsburg Foundation.

146 A page from a brass-founder's pattern book dated about 1794 showing a variety of designs for jamb-hooks. Although America was now independent and beginning to start up her own industries and brass-foundries, clearly even as late as 1800 the demand for imported goods still continued.

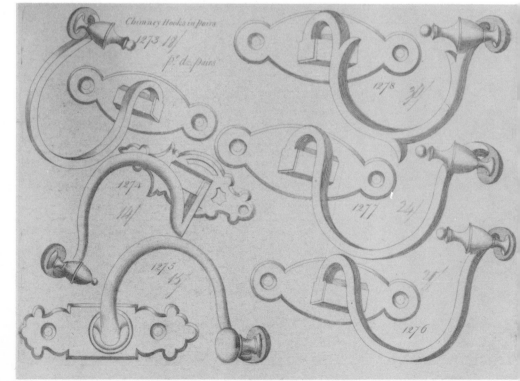

146

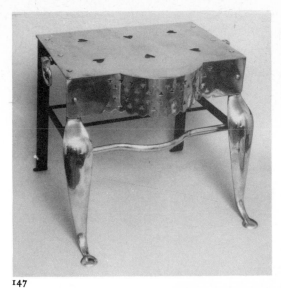

147

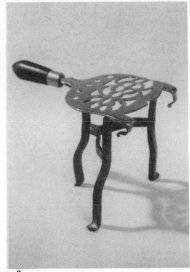

148

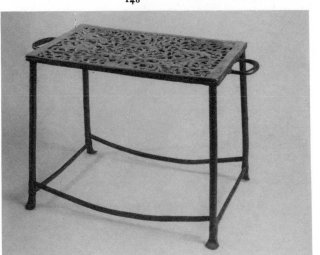

149

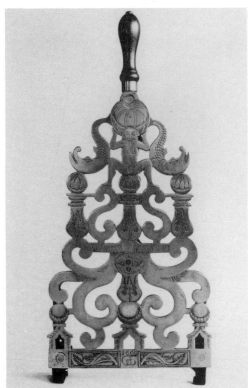

150

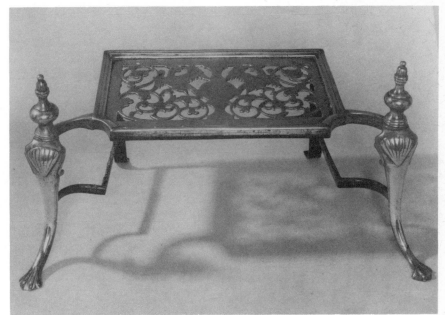

151

Trivets and Footmen

147 The top-plate, frieze and front legs are brass, the back legs and stretchers are iron. The pierced heart design is common, but it is unusual to find this footman in brass. More often it was made in steel.
15¾ inches wide, c.1770.

148 A conventional trivet pattern, which either hooked on the fire bars or stood in the grate. Brass plate, wrought-iron legs and stretchers and wooden handle. It is very small and was perhaps used as a child's toy.
5 inches long overall, c.1760. Michael Wakelin.

149 Simpler in design, with pierced cast-brass top-plate with additional engraving depicting a stag-hunt. The stand is wrought iron, which suggests a country or provincial maker.
9 inches high, 12 inches long, 7½ inches wide, c.1730–50. Rachael Feild.

150 A rare model for the period, brass with monogram and date 1668. Originally the front plate of a spit jack, but later converted to a trivet, it has no feet and was simply hung on the bars of the grate.
23 inches high, dated 1668. Victoria & Albert Museum.

151 An unusual and important footman – a small stand with four legs. Similar in design to the grates of the period.
19 inches wide, c.1740.

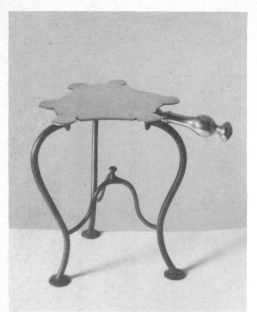

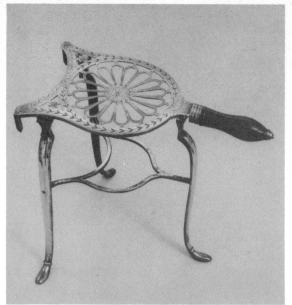

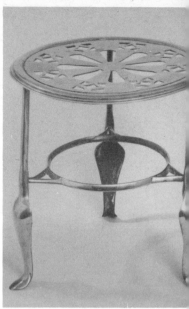

152

153

154

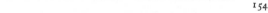

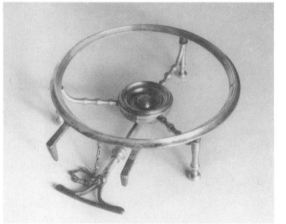

152 Brass and iron trivet used away from the fire. The top-plate and handle are both brass and the design is unusual.
$11\frac{1}{4}$ *inches high, c.1750. Winterthur Museum.*

153 An extremely elegant trivet with beautifully pierced and engraved top, brass legs and shaped stretcher.
$11\frac{1}{4}$ *inches high, Bell Metal, c.1775.*

154 A circular brass trivet of unusual design. It has no handle, and therefore must have had a permanent place and function in the hearth, perhaps being used in a household where the living-room and dining-room were one and the same.
11 *inches high, c.1770.*

155 A most unusual trivet with a dual purpose: it could either be hung on the bars of a fire-grate or used on the table as a dish or kettle stand.
$9\frac{1}{2}$ *inches diameter, c.1810.*

156 A plate from an early nineteenth-century pattern book showing an almost identical design.
Plate size: $19\frac{1}{2} \times 14\frac{1}{2}$ inches, c.1810–20. Victoria & Albert Museum.

155

156

Kitchen and Parlour

157

158

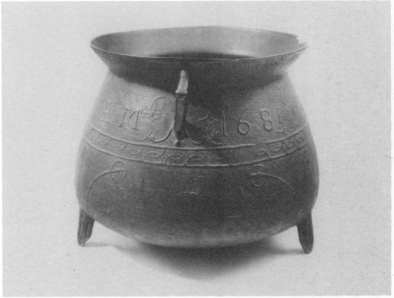

159

Batterie de Cuisine

157 A late sixteenth-century sheet-copper cauldron from a ship commanded by Captain William Barents, a Dutchman trying to find the North East Passage. The ship was caught in the ice in 1597 and the crew made camp on shore, hoping to last out the winter, but were forced to abandon it. The cauldrons were discovered at Novaya Zembla in 1870, together with candlesticks, shoes, clothing, etc.
13½ inches diameter, 11¾ inches high, Dutch, c.1590. Rijksmuseum, Amsterdam.

158 A transitional cauldron/preserving-pan. Cast brass with wrought-iron handle. This type of cooking-pan was made well into the nineteenth-century.
13 inches diameter, c.1780.

159 Bronze three-legged cauldron of typical English shape. It bears the initials of its owner or maker 'A.M.' and is dated 1685. These cauldrons were seldom decorated.
13 inches high, 17½ inches diameter, dated 1685.

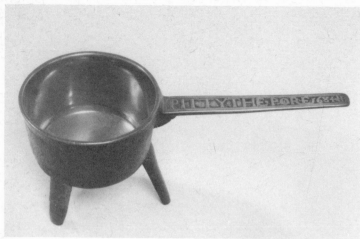

160

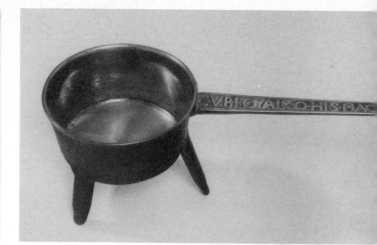

161

162

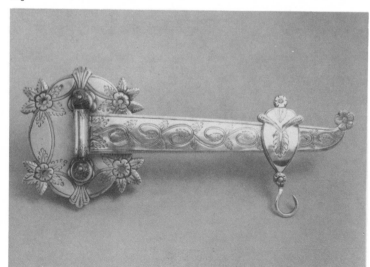

163

164

160 Bell Metal skillet. The handles often had cast inscriptions. This one has 'Pitty the Pore 1684'.
14½ *inches long overall, Bell Metal, dated 1684. Robin Butler.*

161 Almost identical to (160), except for the inscription, which reads: 'CVB Loyal to his Magistie', a cryptogram for 'See you be . . .' probably alluding to Charles I or II during the Civil War and the Protectorate.
18 *inches long overall, Bell Metal, c.1640–60. Robin Butler.*

162 Chimney-crane or pothook, usually in wrought iron. The adjustable hook was hung from a bracket in the chimney which swung over or away from the fire. This brass example was probably used in a house where the kitchen was still not a separate room and cooking was done over the parlour hearth.
28 *inches high, c.1780.*

163 Early eighteenth-century skillet with Bell Metal pan supported by a wrought-iron stand.
23¼ *inches long overall, Bell Metal, c.1710.*

164 A finely engraved jack-rack, very rarely found in the eighteenth century in brass, usually made in wrought iron, and used for hanging pots or kettles in front of the hearth. The back-plate was screwed into the wall and the hook slid along the length of the arm.
12 *inches length of arm,* 5⅞ *inches height of plate, c.1780–1800.*

165

166

167

168

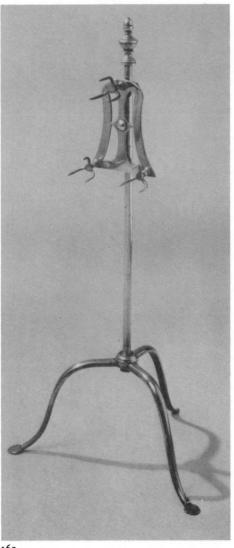

169

165 Spit jack or engine, with brass face and gears, iron frame and wheel and beechwood drum. The mechanism operates in a similar manner to that of a weight-driven clock. It is stamped 'Pearson', the name of a well-known Bristol maker.
9½ *inches high overall, c.1750. Colonial. Williamsburg Foundation.*

166 Bronze pestle and mortar inscribed 'William Hill. 1667. Bristoll'.
5⅜ *inches high, 7⅛ inches diameter, bronze, dated 1667. Michael Wakelin.*

167 A small grinder with brass drum, iron mechanism and walnut base with small drawer. Probably used to grind spices rather than coffee, judging from its size. The handle, though eighteenth-century and perfectly suited, is a contemporary clock-winding key.
8 *inches high, c.1740. Christopher Clarke.*

168 Pierced brass grater with iron frame. Graters were more usually made of tinned iron, which had more bite. Brass implements like this one were often kept for decoration only, but judging from the wear it has been used.
13 *inches high, c.1790–1810. Colonial Williamsburg Foundation.*

169 A standing toaster or lark spit with a delicate tripod base. The height of the toaster can be adjusted. Rare in brass.
29¼ *inches high, c.1750.*

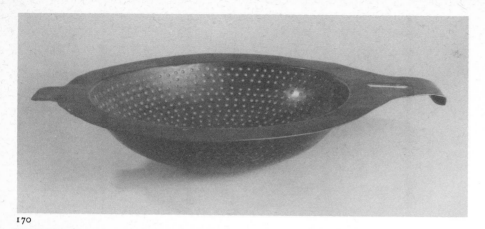

170

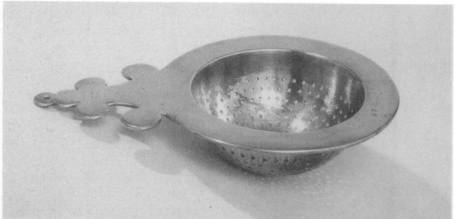

171

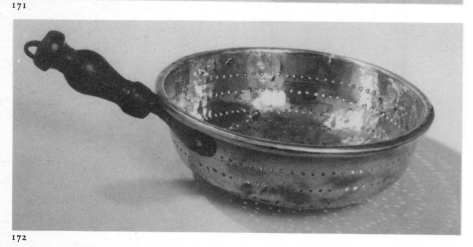

172

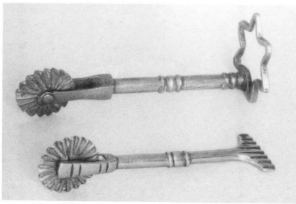

173

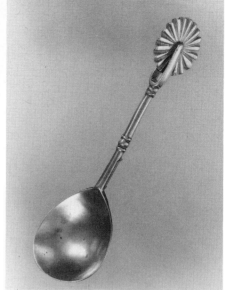

174

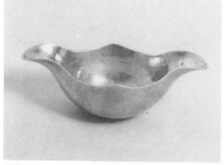

175

170 Strainer in sheet copper, probably tinned originally to avoid tainting food.
12¼ inches long, copper, c.1780. Peter Nelson.

171 Strainer in cast Bell Metal with shaped handle.
10 inches long, Bell Metal, possibly Dutch, c.1800.

172 Sheet-brass strainer or colander with iron and wooden handle.
10 inches diameter, possibly Dutch, c.1800.

173 Brass pastry-jiggers and prickers. These must have been made in large quantities because of the number which still survive.
4 inches long, c.1750–1800.

174 Combined brass spoon and pastry-jigger.
6 inches long, c.1690. Colonial Williamsburg Foundation.

175 A baby's pap-boat or feeder, with double spout instead of the conventional sauce-boat shape. Probably silvered originally.
3¼ inches long, c.1750–80.

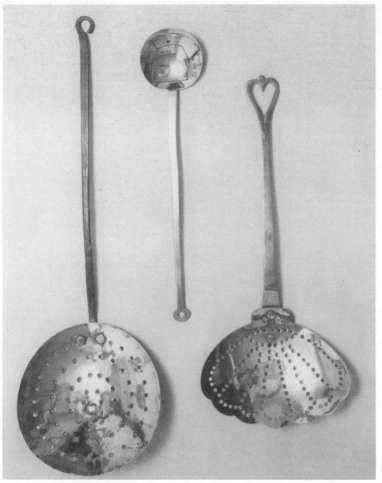

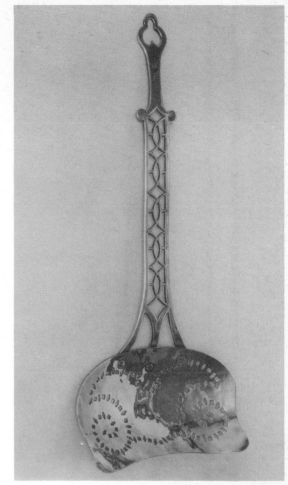

176

177

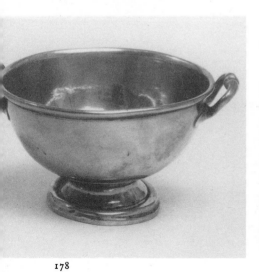

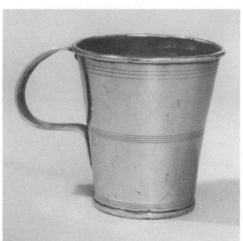

178

179

176 Two skimmers and ladle in sheet brass. The skimmer on the left has an iron handle, the one on the right is cast brass and more decorative. *22, 15 and 18 inches long respectively, c. 1780.*

177 A very decorative skimmer, possibly used in the front of the house to skim punches. The sheet-brass handle is thicker gauge than normal, and has unusual *chinoiserie* fretting. *22½ inches long, c. 1760.*

178 Small tureen or porringer, possibly for a child. It may originally have had a cover, and is an unusual object to be found in brass. *7 inches diameter, c. 1790–1810. Roderick Butler.*

179 Shaped measure with handle. Used for measuring quantities in the kitchen. The care with which it has been finished and the ring turnings suggest that it may have been a drinking-mug. *5 inches high, c. 1800.*

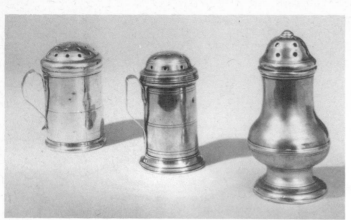

180

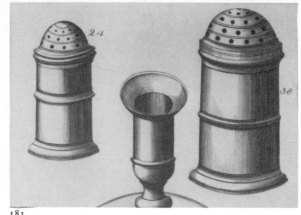

181

180 Brass shakers, sometimes called 'muffineers'. Typical mid-eighteenth-century design with rather large holes to take the more coarsely-ground flour, salt or pepper.
3, 3¼ and 4¼ inches respectively, c.1750–1800.

181 Detail from a brass-founder's pattern book showing similar shakers of a less elegant design. The catalogue dates from about 1755–60. *Martin Orskey.*

182 Two latten spoons with clear traces of tinning, similar in design to two in the rack.
7 inches long, c.1690–1710.

183 Wooden spoon-rack and latten spoons. A common item in the kitchen or parlour. The base of the oak rack has a box which probably held knives. The spoons are earlier than the rack and are all English. The tops show a variety of designs: lion sejant, apostle, strawberry-top, slip-top, seal-top and trefid. All of them bear makers' marks and most retain traces of tinning.
Spoons: 7 inches long, c.1620–1700. *Spoon-rack, c.1780. Colonial Williamsburg Foundation.*

184 A late eighteenth-century hourglass used in the kitchen rather than the parlour. These are sometimes known as 'sermon glasses'.
8 inches high, c.1790–1810.

182

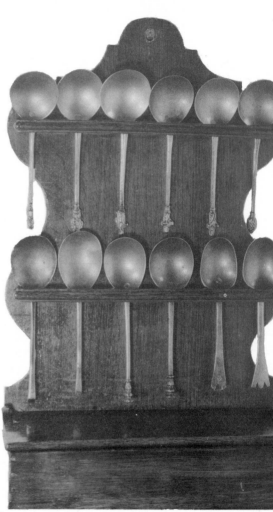

183

184

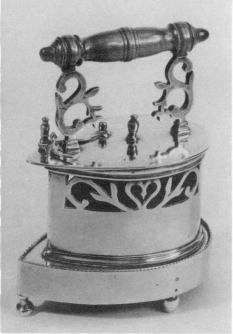

185

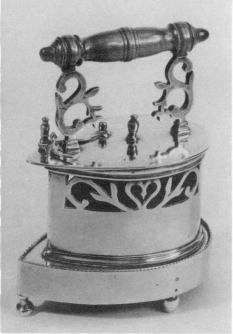

186

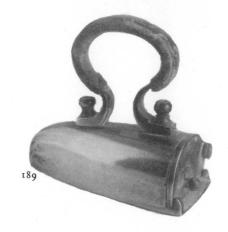

187

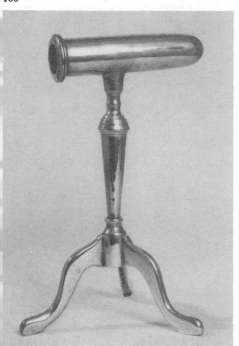

188

189

Box Irons and Tally Irons

185 An eighteenth-century box iron heated by inserting a piece of hot iron into the back compartment which was closed by a sliding door. Irons were always used in pairs, the second one being heated while the first was in use. The decoration on the top is worn.
5½ inches high, 5⅜ inches long, Dutch or Danish, c. 1720–50. Colonial Williamsburg Foundation

186 Box iron with stand, probably Danish, although it bears the inscription 'Hot Man 1837'. This is doubly misleading, since it is undoubtedly an eighteenth-century iron. It was filled with hot charcoal through the open hinged top, which was then secured by the catch in front. The heart design appears frequently on articles for domestic use.
10½ inches high, probably Danish, c. 1780. Benjamin Sonnenberg.

187 Box iron with original stand, heated in the same way as (185). Also probably Danish, it has a very neat clean shape, with serrated decoration on the stand.
8⅝ inches high, probably Danish, c. 1790. Winterthur Museum.

188 A tally iron, used for smoothing flounces and frills; the name is a corruption of the word 'Italian'. The tally iron was probably introduced into England in the seventeenth century. It was heated by inserting an iron bar which was removed before use. The material was pressed across it in circular sweeps to achieve a scalloped effect. Beer or sugar-and-water was used to stiffen the material before the introduction of starch.
10 inches high, c. 1790.

189 A ruffling-iron with leather-covered handle. The compartment for the heated iron insert has a door which rotates on a single hinge and slots into the back.
3 inches long, c. 1770. Robin Butler.

Warmers and Servers

190 Plate stand, rarely found in brass. Usually made of iron. Plates were stacked in the centre and the upper section revolves. This takes four dozen plates, which were probably made of pewter rather than pottery.
19¾ inches high, c.1740.

191 Plate-warmer in sheet brass. It was filled with plates and stood in front of the hearth. Unusual in brass – more commonly found in japanned tin.
23 inches high overall, c.1800. Anthony Meyer.

192 Braziers were portable pans or hearths in which charcoal was burned. As well as warming pans and kettles, and perhaps being used for grilling meat and fish, braziers were used to warm rooms in which a fire was not always lit, or to provide extra warmth for corners of large rooms away from the main blaze. This example is wedge-shaped, and as well as being used in a free-standing manner, may also have been placed in a hearth.
21 inches wide, 13½ inches deep, 14½ inches high, c.1740–60. At Knole Park, Kent. Photograph by courtesy of Country Life.

193 Chafing-dish with charcoal firebox in sheet brass and wrought-iron frame which originally had a wooden handle. The centre was filled with glowing charcoal, and it was put on a table to keep a kettle or pan hot. A rare survival.
12¼ inches long, 5⅛ inches high, probably Dutch, c.1680–1720. Christopher Clarke.

194 A small shovel and pair of tongs for putting charcoal into portable braziers, dish-warmers and kettle stands.
5⅝ and 5 inches long respectively, c.1740–60

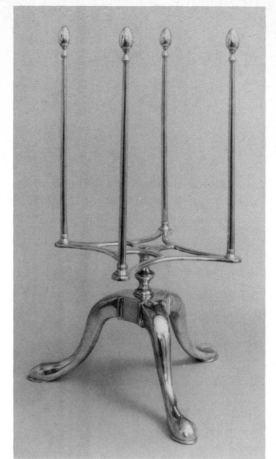

190

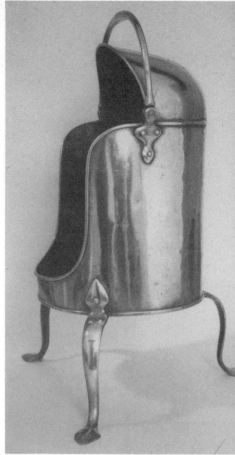

191

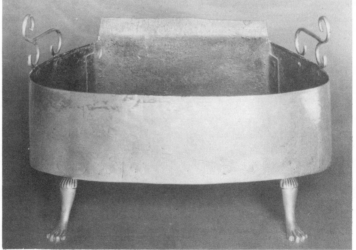

192

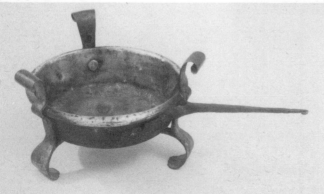

193

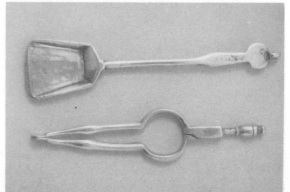

194

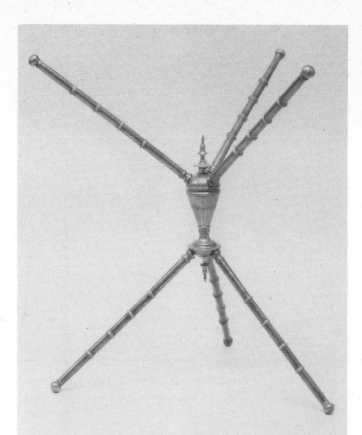

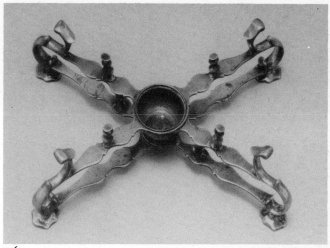

196

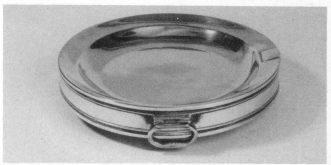

195

197

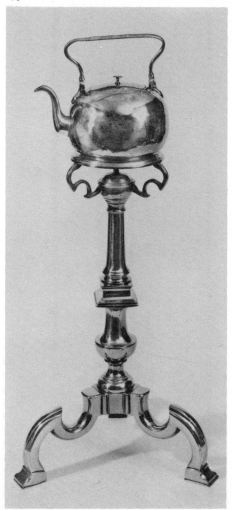

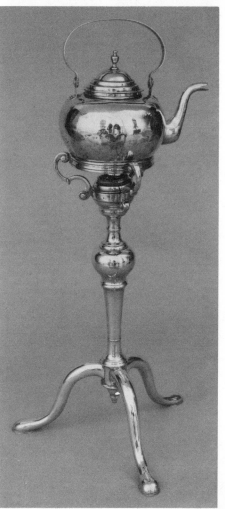

195 A type of dish-warmer known as a 'cat'. Bowls or dishes of various sizes could be held by the upper arms. As 'cats' were often made of wood it is more likely that they were used on the table and not by the hearth.
16 inches high, c. *1780*.

196 Brass dish-cross. The hollow in the middle holds a spirit lamp, the top of which is missing. Rarely found in brass. Usually silver or Sheffield plate. This one bears traces of silvering.
12 inches long, c. *1760*.

197 A hot water plate, similar to models found in pewter. It is basically a plate with a cistern beneath which was filled with hot water through the covered hole at the rim, thus keeping food warm on the plate above. Rare in brass. It retains traces of tinning.
9⅝ inches diameter, c. *1780*.

198 A most exceptional kettle stand, always rare in brass. A shaped bracket of the same unusual design as the tripod legs supports an open ring over a small spirit lamp.
32 inches high overall, c. *1740. Benjamin Sonnenberg.*

199 A more simple design but nonetheless sophisticated. Kettle stands were brought from the pantry to the drawing-room and used by the servants rather than the lady of the house. This one also has a spirit lamp, and the kettle is a later replacement.
32 inches high overall. c. 1740–5. Bayou Bend Collection, Museum of Fine Arts, Houston, Texas.

198

199

200 Kettle stand with charcoal heater. The kettle dates from about 1800.
32 inches high overall, c.1740–5.

201 Table stands for kettles were more commonly used than free-standing models. They take their form from silver counterparts. This one has fine engraved decoration round the lid and the spout suggests the head and neck of an animal. It has a small spirit burner.
11 inches high, c.1745. Winterthur Museum.

202 Good detail on the stand and handle in a plainer, less sophisticated model. The handle was originally covered with plaited cane. The spirit burner is missing.
11¾ inches high, c.1750.

203 Another kettle and stand with heavy detail. The ornate stand, shell feet and fluted spout are very fine. The whole design suggests silver, and it was almost certainly silvered originally.
12½ inches high, c.1750. Colonial Williamsburg Foundation.

204 An exceptional example of a kettle, stand and under-tray. The handle has more movement to it than the previous example, and the top of the stand has unusual gadroon decoration. The lid, kettle top and under-tray have light chasing. Traces of the original silvering remain.
14¾ inches high, c.1750.

205 A fine model with an engraved cartouche surrounding a coat of arms. The wooden handle and small bun feet are unusual. All these kettles were originally tinned inside.
13 inches high, c.1730. Winterthur Museum.

206 A late eighteenth-century tea urn similar in design to those made in Sheffield plate. This model is unusual as heat was provided by hot charcoal. The fretted vents at the base allowed circulation of the hot air, which rose up and dispersed through the open top. Normally these urns were heated with a small spirit lamp, or by inserting a heated piece of cast iron, similar in shape to a cylindrical clock-weight, which fitted into a hollow compartment in the centre of the vessel.
13½ inches high, c.1790.

207 An early nineteenth-century kettle and stand of rare design. The carrying handle and legs of the stand are of cast metal, the pierced sides are stamped. The two turned wood handles of kettle and stand are identical.
21 inches high overall, c.1810.

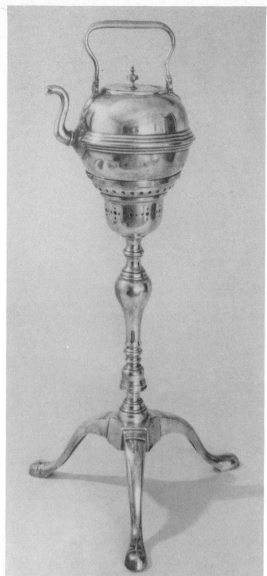

200

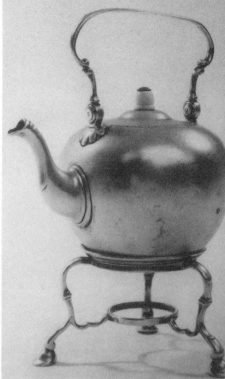

202

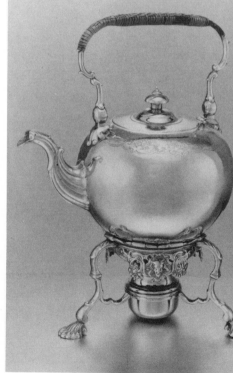

203

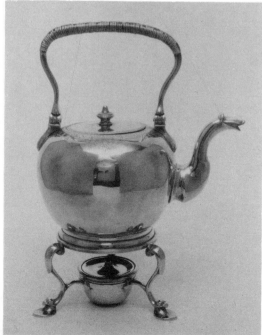

201

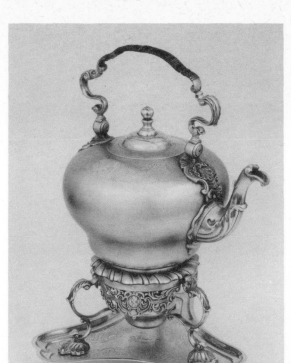

204

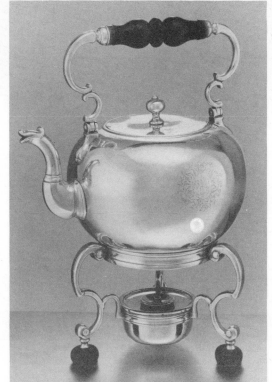

205

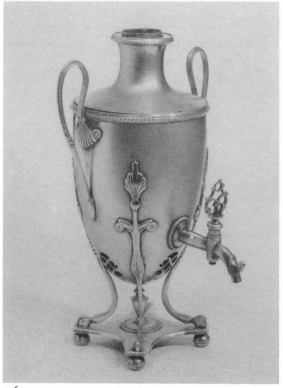

206

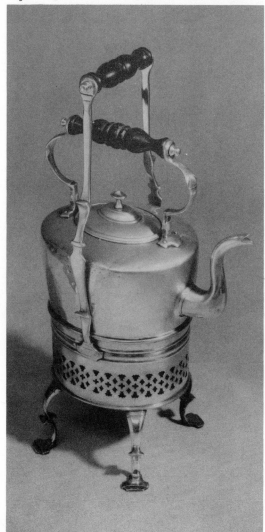

207

Tableware

208 Coffee or chocolate pot with tinned interior. The large shell handle on the lid and shaped spout and cover suggest that the maker added some silver detail to a basically simple design. *8⅞ inches high*, c. *1710–20. Colonial Williamsburg Foundation.*

209 Copper chocolate or coffee pot. The spout is cast in two halves instead of being made in sheet metal. The shaped wooden handle is a later replacement. *9¼ inches high, copper, c. 1710.*

210 Coffee pot of contemporary silver design, with a pearwood handle and engraved coat of arms. *6⅞ inches high, c. 1735.*

211 Coffee pot with traces of original silvering The coat of arms is contemporary: Bostock impaling Huddleston. The ebonised pearwood handle is original. *9½ inches high, c. 1755.*

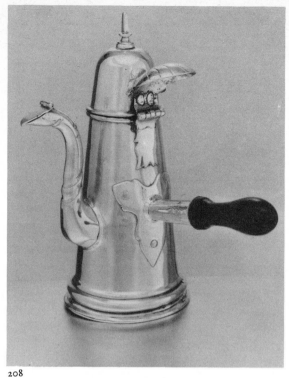

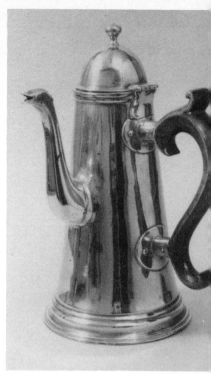

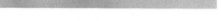

208

209

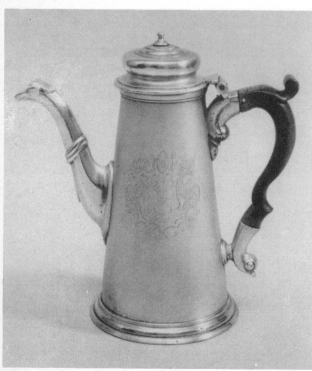

210

211

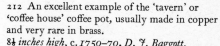

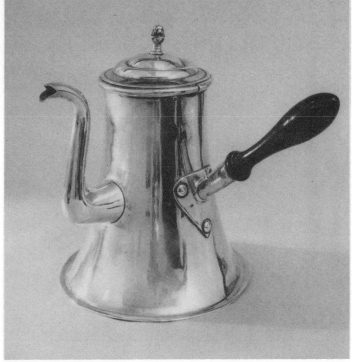

212

212 An excellent example of the 'tavern' or 'coffee house' coffee pot, usually made in copper and very rare in brass.
8½ *inches high, c. 1750–70. D. J. Baggott.*

213 A very small coffee, chocolate or milk pot, perhaps used originally in a coffee house for a single serving. The handle is ebony.
4⅜ *inches high, c. 1800. Christopher Clarke.*

214 Miniature coffee or chocolate pot, made for a child's dolls' house.
2¼ *inches high, c. 1740.*

215 A contemporary conversion from tobacco jar to coffee pot. The lid is detachable and not hinged, and the spout and handle have been added later.
8 5/16 *inches high, c. 1790. Colonial Williamsburg Foundation.*

216 A straightforward copy of a silver teapot, very rare in brass. Almost certainly silvered originally, though no traces remain. The handle is a later replacement.
7¾ *inches long,* 4½ *inches high, c. 1750. Colonial Williamsburg Foundation.*

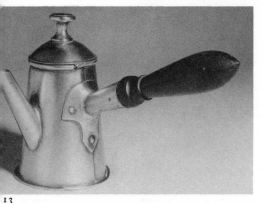

13

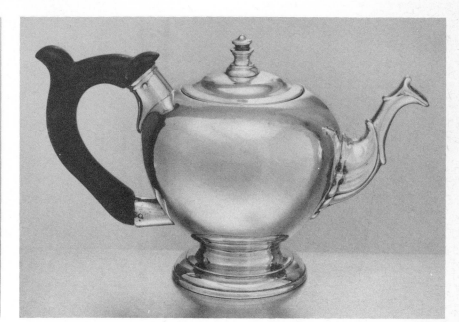

214

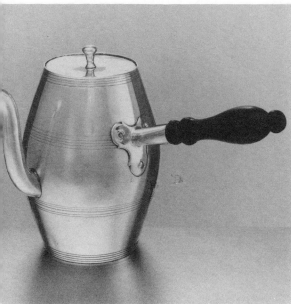

15

216

217

218

217 Classic shape for silver or pewter plate. This one has no trace of silvering and was probably used for display only.
13½ inches diameter, c.1760–1800. Mr & Mrs James B. Boone Jnr.

218 A deep circular dish of rather reddish brass, indicating a high copper content. Not dissimilar to alms or offertory dishes of the period. Probably used for display.
10⅞ inches diameter, c.1750.

219, 219a Brass *tazza*, rare in silver and exceptional in brass. The coat of arms is contemporary. *Tazzas* were used on the table to display sweetmeats or fruit, or as a stand for glasses. Originally silvered.
13½ inches diameter, 2¼ inches high, probably Italian, c.1680.

220, 220a Dessert spoon and sugar-tongs, both from the same set. The floral design is stamped; both are marked 'London' and were possibly made for the provinces or for export.
Spoon: 8½ inches long, tongs: 6¼ inches long, c.1790–1800. Tongs: Robin Butler.

221, 221a Three typical mid-eighteenth-century pairs of nutcrackers. Models like these were also made in steel. The decoration is similar to that on the models illustrated in a contemporary pattern book.
4½, 4 and 4 inches respectively, c.1780.

222 An unusual pair of sugar nips and tongs combined. The loaf sugar would be broken into pieces in the kitchen and subsequently cut smaller when needed. The cutting blades are just above the hinge.
4¾ inches long, Bell Metal, c.1780.

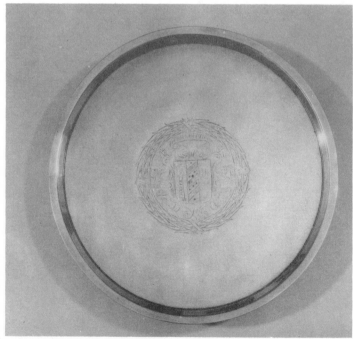

219

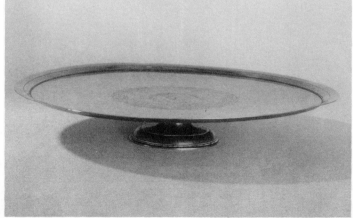

219a

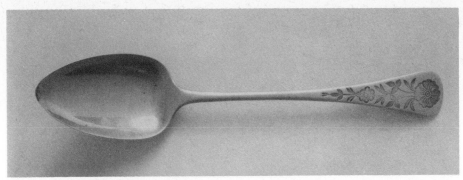

220

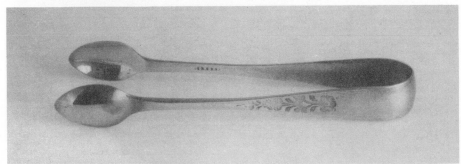

220a

221

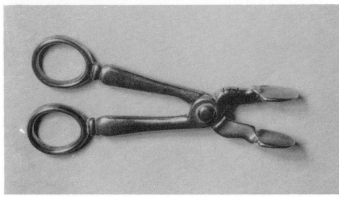

222

221a

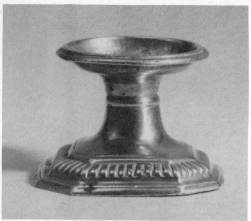

223

224

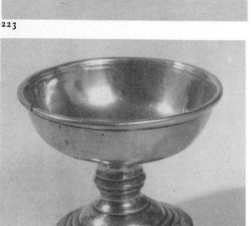

225

226

223 A capstan salt-cellar similar to designs
found in pewter, but rare in brass. The bowl
was originally heavily tinned to prevent the
chemical action of salt on brass.
*2 inches high, 2⅜ inches diameter top, English or
Dutch, c.1690–1710.*

224 An early eighteenth-century spice or salt
cellar of simple design, not dissimilar in shape to
those found in pewter.
3 inches diameter base, c.1720.

225 Small cast-brass footed bowl with turned
decoration. May have been used for salt, spices
or sweetmeats.
3⅝ inches diameter, c.1750. Michael Wakelin.

226 Porringer, usually made in pewter. Cast
metal, with the elaborate Tudor Rose cast into
the base and not engraved. Porringers were used
for drinking gruel.
7¼ inches long, c.1720. Michael Wakelin.

227 Brass *épergne*, probably German, with
traces of original silvering. Similar designs are
found in Meissen porcelain. The centre trays
held glass or porcelain dishes; the four shell-
shaped dishes under the candle-holders were
used for sweetmeats and bonbons.
8½ inches high, c.1750. Harry T. Peters Jnr.

227

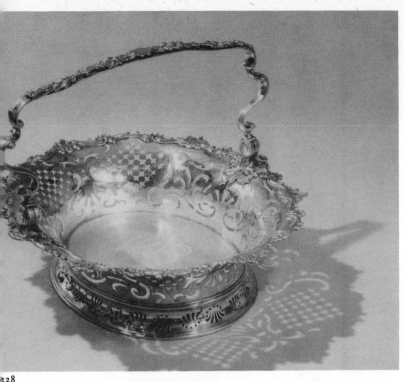

228

228 George II cake basket, pure silver in form.
A fine example of the sophistication reached by
brassware. Pierced decoration and applied cast
decoration around the rim and on the handle.
Engraved arms of the Earls of Essex impaling
the Earls of Uxbridge. Traces of original
silvering.
14½ *inches long,* 12½ *inches wide,* c.1760.

229 A pair of sugar-casters of silver design,
rarely found in brass. Originally silvered. Cream
jug in brass of pure silver shape.
Casters: 9⅛ *inches high, jug:* 4¼ *inches high,*
c.1750. *Victoria & Albert Museum.*

230 Sauce-boat – another pure silver design.
Very rare. Originally silvered.
8 *inches long,* 4¾ *inches high,* c.1740.

231 Typical mid-eighteenth century design for
a wine or toddy ladle with twisted horn handle,
in unusual gilded brass.
17¼ *inches long,* c.1760–70.

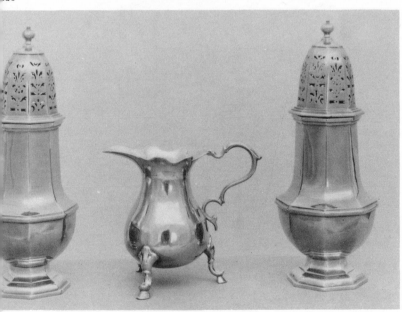

229

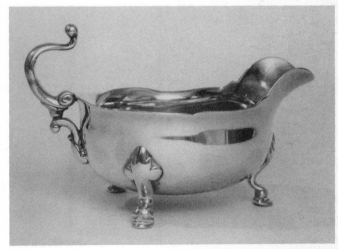

230

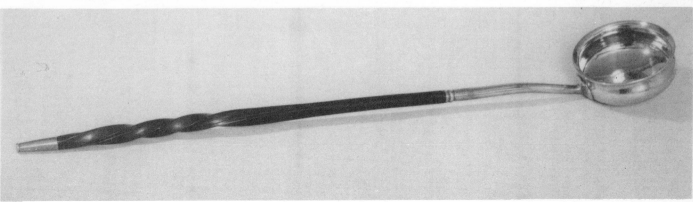

231

Wine-Coolers and Cisterns

232 Ewer or laver jug of pure silver form,
originally with companion bowl, for rinsing
hands before a meal. Its design goes back to the
mid-sixteenth century, when jugs like this one
were more common on the Continent than in
England. It has a contemporary English coat of
arms, but may have been made on the Continent
and engraved in England. Probably silvered or
gilded originally.
11 $\frac{5}{16}$ *inches high, French or English, c.1720.*
Colonial Williamsburg Foundation.

233 Oval brass wine-cooler or cistern for bottles,
more common on the Continent where they
were usually made of copper with *repoussé*
decoration, and gilded. English examples were
also made in copper, often japanned to imitate
lacquer. Judging from its simple shape it is early
eighteenth-century.
23 $\frac{1}{2}$ *inches long, c.1700. Benjamin Sonnenberg.*

234 Another oval wine-cooler or cistern, but in
copper, with fine decorative detail and
sophisticated design. It was possibly gilded
originally.
28 $\frac{1}{4}$ *inches wide, copper, c.1710. Victoria &*
Albert Museum.

235 Cistern for rinsing wineglasses or goblets,
which were notched into the grooves in the rim.
Continental cisterns usually had flared rims and
the glasses hung outside the container. Cisterns
with scalloped rims are usually called
'Monteiths', supposedly after a Scotsman who
wore a cloak with scalloped edges.
18 $\frac{5}{16}$ *inches long, 9 $\frac{1}{2}$ inches high, probably Dutch,*
c.1710. Winterthur Museum.

236 A superb example, like the two before it
made of sheet metal, but with cast legs and
handles of exceptional quality. The brazed join
can just be seen above the mask handle. This
Monteith was designed to be used on a table,
and not placed on the floor.
18 *inches long, 9 $\frac{9}{16}$ inches high, Dutch, c.1720.*
Winterthur Museum.

237 Wine-cooler or ice-bucket with very
sophisticated detail. The coat of arms of Clinton
is contemporary, engraved in England.
7 $\frac{1}{8}$ *inches high, 10 $\frac{1}{2}$ inches wide overall, French,*
c.1750. Charles Howard.

238 An early nineteenth-century table coaster,
probably from a hostelry, made to take a leather
black-jack and beakers. Oak, with a brass rim
bearing the inscription:
May we Breakfast in Health
Dine with Contentment
Drink a Horn in Mirth
And Sup without resentment.
It is stamped on its underside 'H. Roberts.
Maker'.
22 *inches long, c.1800–20.*

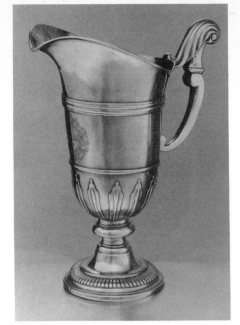

232

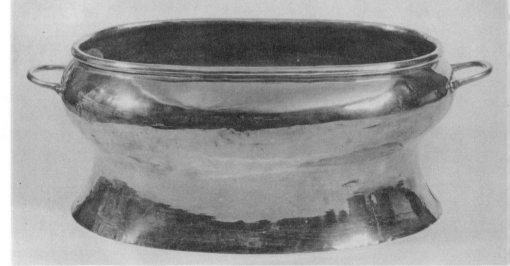

233

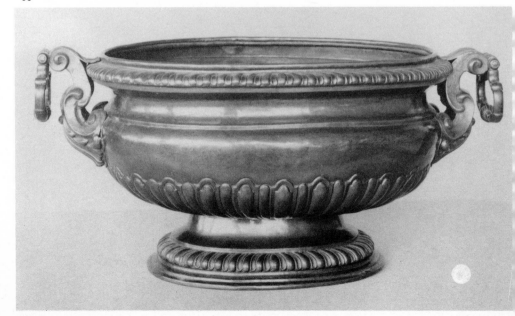

234

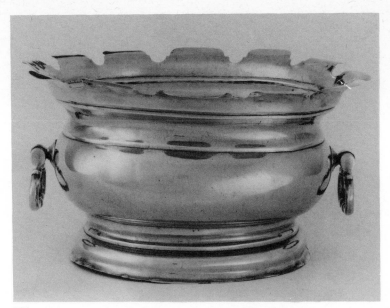

235

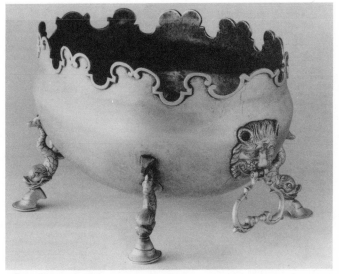

236

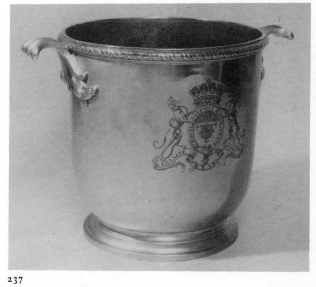

237

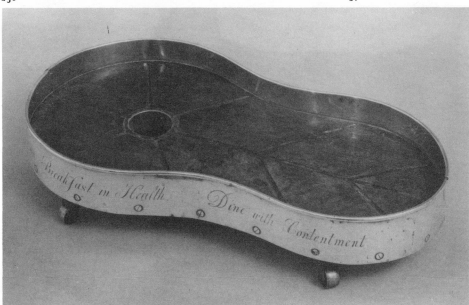

238

Tankards and Goblets

239 A superlative example of a covered tankard, taking its shape from silver. A rare survival from this period, with traces of original gilding. The contemporary coat of arms is beautifully engraved.
7⅝ inches high, c. 1680–90. Charles Howard.

240 A fine covered quart tankard with excellent detail on the handle and thumb-piece.
7½ inches high, c. 1760. Timothy Trace.

241 A similar model to the previous one, though a little more provincial in line. It has a mock hallmark on the rim just below the lid, and maker's mark 'A.C.'.
8 inches high, c. 1760. Robert S. Pirie.

241a Detail of maker's initials 'A.C.' between two identical punches of a lion passant walking left to right. This is most unusual as the lion passant on English silver faces in the opposite direction. The Augusta Stone Presbyterian Church, Fort Defiance, Virginia, has a large communion service which is made of heavily silvered copper, and one of the flagons bears identical marks. The maker of both this service and the brass tankard was a silversmith and not a metalworker, as the craftsmanship is of very fine quality. Base-metal work was sometimes undertaken by silversmiths as the article would be much cheaper than if made in solid silver. The mark is, as yet, unidentified. (*Church Silver of Colonial Virginia.* Catalogue for an exhibition organised by the Virginia Museum, 1970.)

242 An early eighteenth-century covered quart tankard in copper of rather coarse workmanship. Possibly used in a coaching-house or inn.
7⅛ inches high, c. 1705–15.

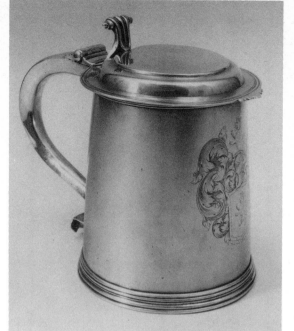

239

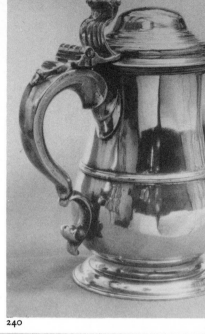

240

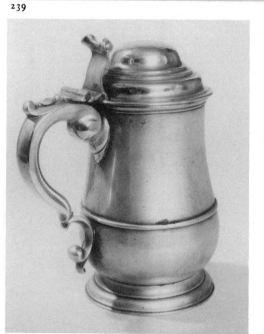

241

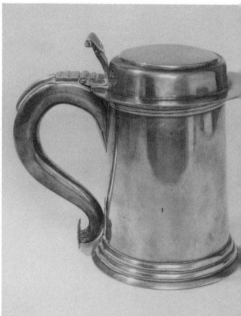

242

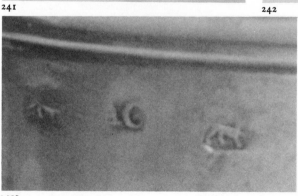

241a

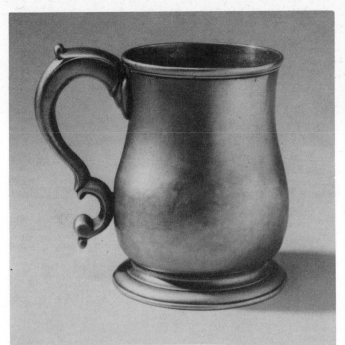

243

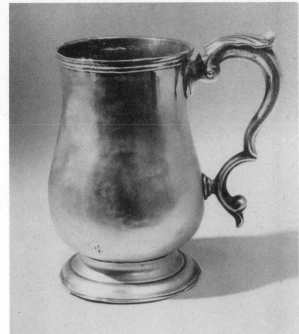

244

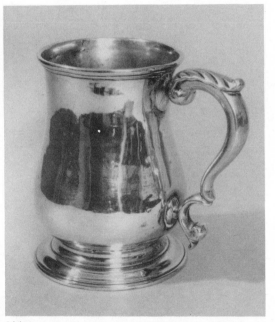

245

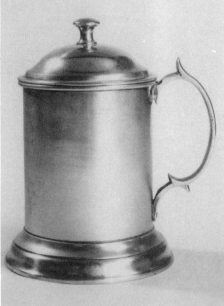

246

243 A pint tankard of simple form, with well-shaped detail on the handle.
4¾ inches high, c.1740.

244 Similar in style to the previous one, but with a more decorative handle, higher foot and slimmer line.
5½ inches high, c.1755–60.

245 Pint tankard with narrower body and wider top than the previous example.
4⅝ inches high, c.1750–60.

246 A late eighteenth-century quart tankard of elegantly simple design. Unlike the other covered tankards illustrated, the lid is not hinged but simply lifts off. Both the interior of the tankard and the lid retain their original very heavy tinning.
6¾ inches high, c.1790.

247 A rare set of four goblets. Cast and lathe-turned foot with good detail on both the stem and the foot
4½ inches high, c.1760.

247

249

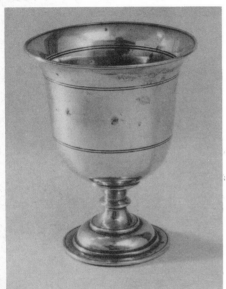

248

250

248 A well-shaped goblet, cast and lathe-finished.
4½ inches high, white brass, c.1780.

249 A two-handled loving-cup and cover of very fine quality. It is engraved with the initials 'R.B.' in a double cypher. The knob is a later replacement. Traces of original silvering.
11¾ inches high, c.1725–30.

250 A small two-handled cup standing on a simple foot. It has sophisticated line and detail, as it was originally silvered. Just below the rim are three mock hallmarks – two griffin heads and a capital 'D' – a rare feature.
5⅛ inches high, c.1735–40. Private collection.

251 Two-handled covered cup, similar to a Scottish pewter tappit-hen except in that it has no lid. The coat of arms is contemporary. Probably used for display, or as a loving-cup.
9⅛ inches high, c.1780.

252 A well-known design in silver but rarely found in brass, this beer jug was originally silvered. It has four mock hallmarks on the underside of the base.
8 inches high, c.1765.

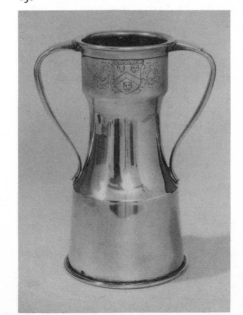

251

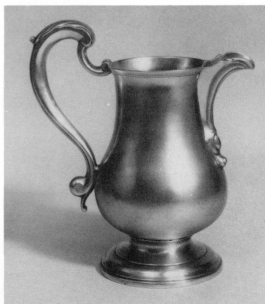

252

Accessory and Ornament

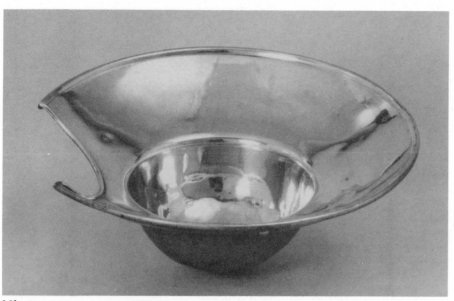

253

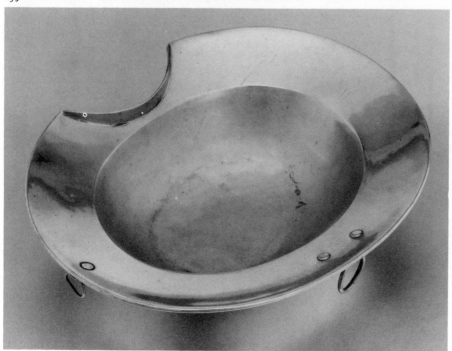

254

Washing and Dressing

Barbers' Bowls

These dishes deserve some explanation because of their dual function as barbers' bowls and bleeding-bowls. The semicircular section cut out of the rim fitted beneath the chin while the face was being soaped and sponged. It also fitted into the crook of the elbow – the most common place for letting blood. Barbers in the eighteenth century undertook minor surgery and dentistry, and many of them travelled round the country as itinerant physicians. The origin of the red-and-white barber's pole dates from this period: in order to make the blood flow more freely the patient was made to grip a pole, which was usually painted red to disguise the smears of blood. A barber-surgeon arriving in a new neighbourhood would display this pole, swathed in white bandages, outside his door. In earlier times he would also have added more repulsive signs of his profession:

His pole with pewter basons hung
Black rotten teeth in order strung,
Rang'd cups that in the window stood
Lined with red rags to look like blood,
Did well his three-fold trade explain,
Who shaved, drew teeth, and breathed a vein.

253 An unusual circular barber's bowl with a small rolled edge around the rim. Barbers' bowls were usually oval. Sheet brass.
9¾ inches diameter, c. 1750–70.

254 This one has the unusual feature of a small lip around the cut-out section of the rim. When not in use it was hung up by the two rings.
10⅞ inches diameter, probably English,
c. 1750–70. Colonial Williamsburg Fonndation.

255 A coarsely-made footed barber's bowl in copper with tinned rim and bowl.
10⅝ inches diameter, copper, English or Dutch, c.1750–70.

256 A finely-made copper-gilt shaving-mug with a hinged lid and iron handle. The saucered foot is an integral part of the mug. An accessory from a travelling toilet set carried in a fitted mahogany or morocco leather case.
4 inches high, copper-gilt, c.1810.

257 A fleam, or lancet, with three blood-letting blades and one straight blade. Inscribed 'John Barnes of Tewkesbury 1715' it also bears the maker's name 'YORK' stamped on the reverse side of the case and blades.
3¼ inches long, c.1715.

258 Commode or chamber pot, sometimes called a 'Welsh hat', which fitted into a night table or bedside commode. It is very rare indeed to find one in brass: the commonest metal was pewter. They were also made in quantity by the Leeds Pottery and the Wedgwood factory in pottery.
9⅝ inches high, c.1780. Colonial Williamsburg Foundation.

259 One of a pair of very unusual candle stands of plain brass with octagonal tops. Candle stands were usually made of wood with a circular turned base, and not with tripod feet. They were used to raise the height of the candles on either side of a toilet mirror.
7 inches high, c.1790. Bihler & Coger.

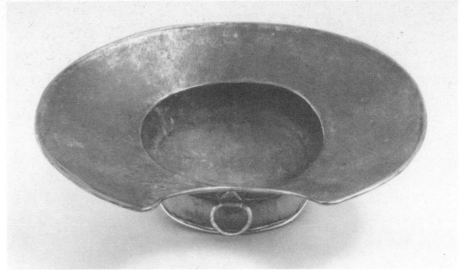

255

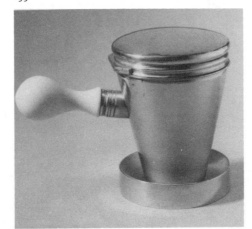

256

257

258

259

260 A chamber pot in sheet metal, with sheet-metal handle. Rarely found, these metal pots were possibly used by travellers. This one is in remarkably good condition, considering the thin, flimsy quality of the metal.
9½ inches diameter, 4¼ inches high, c. 1790–1810.

261 Part of a toilet set in cast and gilded brass of very fine quality with contemporary engraved coat of arms. In addition to the large casket, two pairs of powder boxes and a pair of clothes brushes (only one of which remains) the set would also have included an easel mirror, a pair of candlesticks, a snuffer and snuffer tray, a pair of comb brushes, a pair of spherical soap boxes, a pair of square or octagonal scent flagons and a pincushion.
Casket 9½ inches wide, c. 1730. S. J. Phillips.

260

261

Soap and Sponge Boxes

262 A soap and sponge box, hinged to open in equal halves. The perforations on the soap box were to allow the 'sweet wash balls' – a coarse mixture of lye of ashes and tallow – to dry. This pair is possibly English, though the French counterparts made at the same time are almost identical. Traces of original silvering.
3½ inches diameter, 4¼ inches high, c.1740.

263 This soap box is almost the same as the previous one except for the decoration in the piercing of the cover.
3½ inches diameter, 4¼ inches high, c.1740.

264 A larger, more ornate example, with cast-brass stylised rose surmount and beaded decoration on the rim and foot. This one is Continental, probably from Antwerp.
3¾ inches diameter, 5 inches high, c.1750.

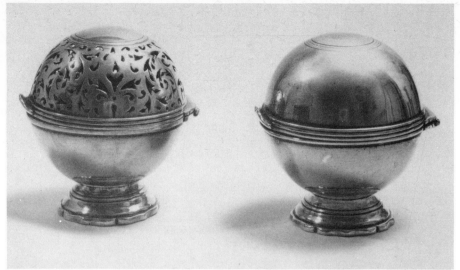

262

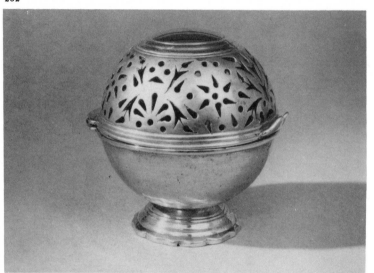

263

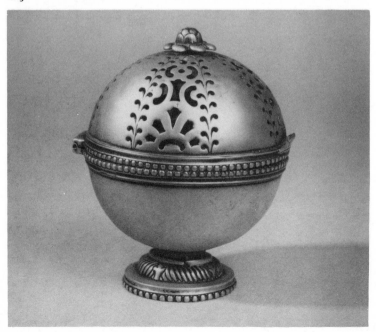

264

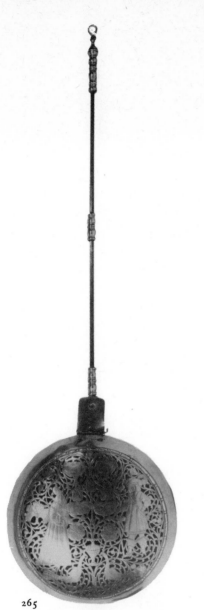

265

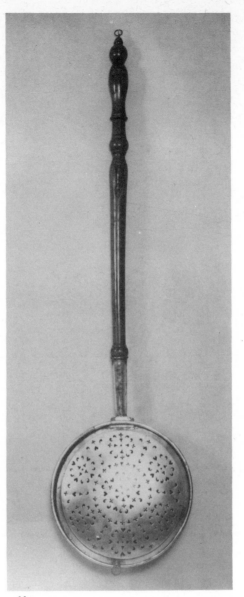

266

Warming-Pans

265, 265a A mid-seventeenth-century warming-pan with a very finely pierced and engraved top depicting male and female figures, indicating that perhaps it was a marriage gift. Warming-pans were common domestic utensils by the middle of the seventeenth century. They were not, as is sometimes supposed, left in the bed, but used by a servant just before the master or mistress retired, and were stroked swiftly between the sheets; some dexterity was required to avoid scorching the linen.
47 inches long, c.1660. Victoria & Albert Museum.

266 A mid-eighteenth-century warming-pan with an unusually pierced top of symmetrical design composed of tiny hearts. The turned walnut handle is original.
45 inches long overall, c.1750.

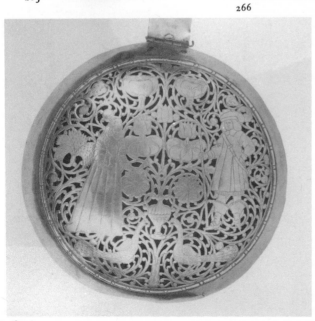

265a

Reading and Writing

267 Inkstandishes do not seem to have been made in England, but appear to have been imported from Europe for some reason which has not been discovered. This one has an inkpot and pounce pot flanking the candle-holder, underneath which is a small flat box for holding the sealing wafers.
9 inches long, Spanish, c.1750–70. Winterthur Museum.

268, 268a A very rare English inkstandish on a square tray with rounded corners. The underside of the tray shows that it was originally silvered with silver leaf, which is most unusual. Some traces of silvering also remain in the mouldings of the pots.
10½ inches long, 7½ inches wide, 4 inches high, c.1735. Tray: Roderick Butler.

269 This design suggests that it was intended for an office rather than a house. The lower section contains ink, the shaped upper section forms the pounce pot. Quills were not used with their plumage, but clipped as these are.
5¼ inches high, c.1790–1800. Winterthur Museum.

270 A rare mid-seventeenth-century pocket inkpot and pen holder with engraved and punched decoration. The open lid bears the initials I.D. and the inscription reads:
I was in Sheffield made & many can Witness: I was not made by any man.
This was a riddle sometimes used by the Sheffield maker Madin, who also sometimes signed his work 'Virgo'.
4⅜ inches long, dated 1656. Victoria & Albert Museum.

271 Small pear-shaped case to hold a pair of folding pocket spectacles. More usually found in tin covered with shagreen.
2⅝ inches long, c.1770.

272 A quizzing or picture glass with a brass frame and small turned wooden handle – with its original tooled leather case.
6⅝ inches long, c.1810.

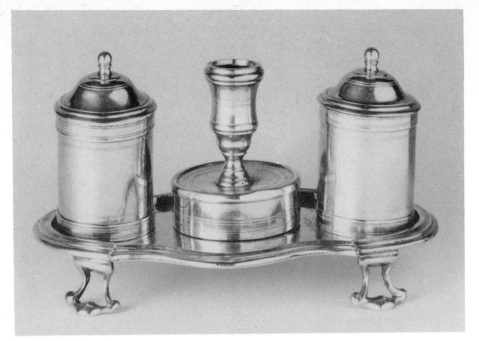

267

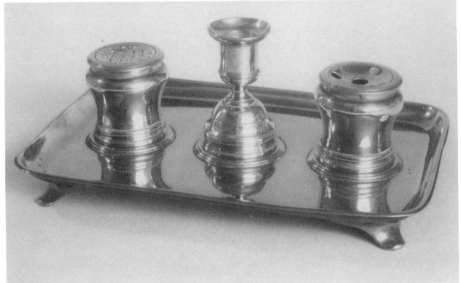

268

268a

269

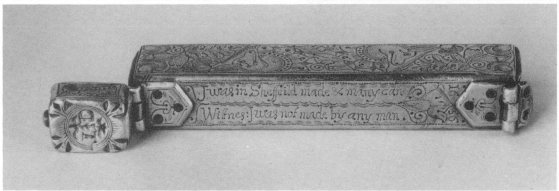

270

271

272

Buckles and Buttons

273 Buttons, in copper gilt, with *verre églonisé* and enamel centres. This type of button was in great demand in the latter part of the eighteenth century for male attire. The only functional buttons worn by women at this period were hunt buttons for riding-habits.
⅜ *inches diameter, c. 1780–1800. The James Luckock Collection, Birmingham City Art Gallery.*

274 A shoehorn of traditional shape, derived from the original horn. This design was made throughout the eighteenth century, after shoes replaced boots for everyday wear – a fashion started by Charles II and his court and generally adopted by the public by the turn of the century.
9 *inches long, c. 1770.*

275 Two late eighteenth-century copper-gilt buttons with 'basket weave' pattern. This was a very popular design for everyday use.
⅞ *inches diameter, c. 1770–1800.*

276 A traveller's sample pack in the form of a book for shoe or clog fasteners mounted on card. They are of stamped and lacquered brass, plain and decorated, and have their reference numbers and prices written beside each one.
8½ × 4½ *inches (closed), c. 1830.*

277 Another sample case of shoe fasteners in a shallow folding mahogany box. The ones on the left are brass. The top three rows on the right are blackened iron, the bottom two rows polished iron.
9 × 5½ *inches (closed), c. 1830.*

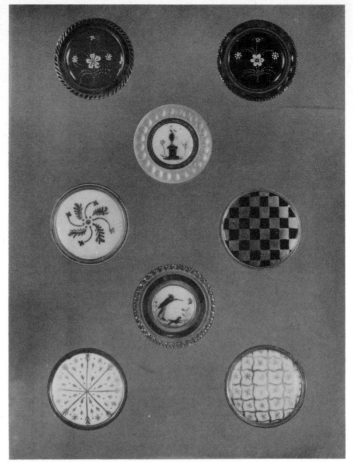

273

274

275

276

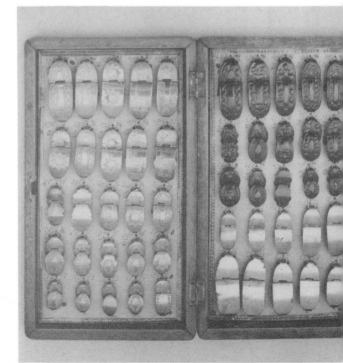

277

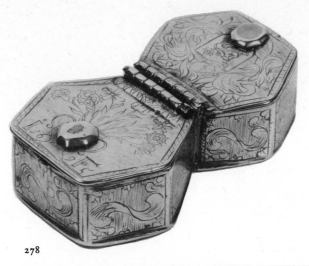

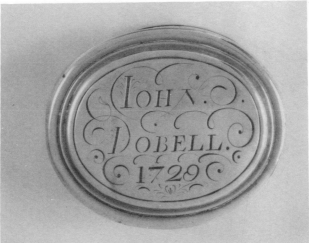

278

Tobacco and Gentlemanly Pursuits

278 Double snuff-box with finely engraved decoration, bearing the date 1695. Used either for snuff or comfits. The coat of arms is Fowle. *3⅛ inches long, dated 1695. Victoria & Albert Museum.*

279 Oval brass tobacco-box with separate lid. It bears the date 1729 and 'John Dobell', presumably the owner's name. *3½ inches long, dated 1729.*

280 A tobacco- or snuff-box with hinged lid, naïvely engraved with a ploughman in a rural setting. It is inscribed:
Drive on my boy
God speed the plough
He loves others –
Fair seasons now.
On the base is engraved the name 'Robert Siverest'.
3¾ inches long, dated 1735.

281 Oval brass tobacco-box with name, date and engraving of Old Mother Shipton, a fifteenth-century witch. *3⅜ inches long, dated 1772.*

279

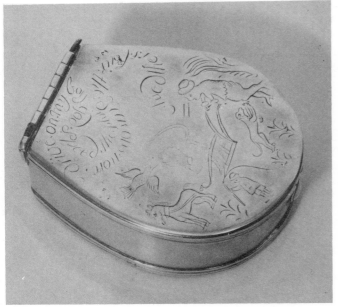

280

281

282

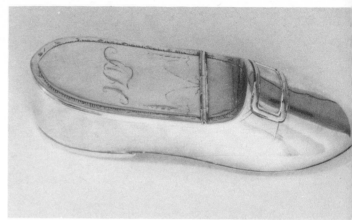

283

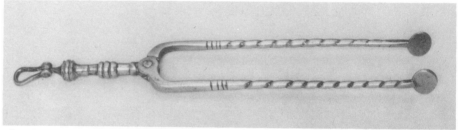

284

282 An imposing double box with additional applied copper decoration around its base and lid. The Arms are the City of York. It is engraved 'CHARLES MOSS. YORK 1775'. Possibly Moss gave it to the City Company as a table snuff- or tobacco-box.
7 inches long, 4¼ inches high, c. 1775. Victoria & Albert Museum.

283 A 'toy' snuff-box in the shape of a shoe, in brass with copper buckle. The original bright-cut decoration is worn.
6½ inches long, c. 1785. Anthony Meyer.

284 A pair of brass ember-tongs, used for lighting a pipe or putting charcoal into a small brazier. Barley-sugar decoration. Cast brass, with small hanging loop.
9½ inches long, c. 1740–1800.

285 A less ornate pair of ember-tongs in plain cast brass.
9½ inches long, c. 1740–1800.

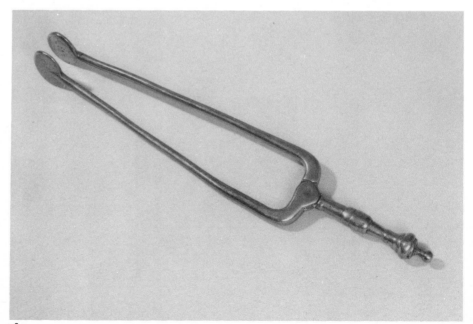

285

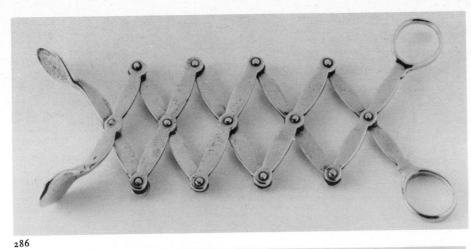

286

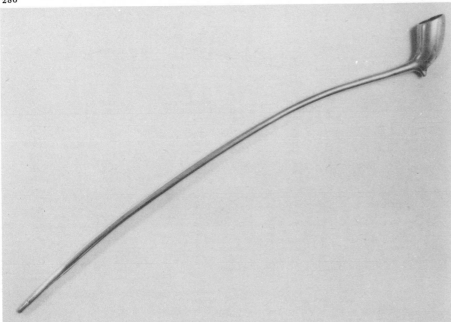

287

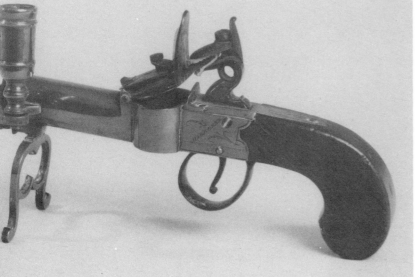

288

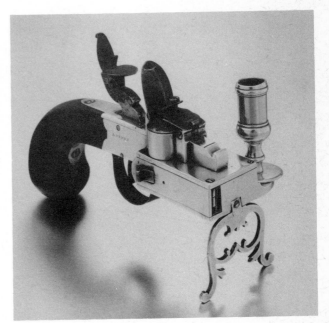

289

286 A pair of 'lazy tongs' which extend and retract, so saving the user from having to bend or stretch.
3½ inches long closed, 15⅛ inches extended, c. 1700–70. Winterthur Museum.

287 A 'churchwarden' pipe, very rare in brass. More commonly found in silver, iron or steel, but usually of clay which was cheaper and gave a cooler smoke.
15 inches long, c. 1760.

288 A late eighteenth-century device called a tinder-pistol or 'strike-a-light'. The hammer holds a flint which produces a spark when struck against the steel, under which there is a small compartment to hold the tinder or cotton floss. When the tinder was glowing, small slivers of wood dipped in sulphur were lit from it – the forerunners of matches. The candle, which was placed in the candle-holder when lit, was kept in the 'barrel' when not in use. Inscribed 'Harborne. Birmingham'.
7¼ inches long, 4½ inches high, c. 1780. Robin Butler.

289 A good-looking tinder-pistol of earlier date than the previous one. London-made and more sophisticated. Inscribed 'Burgon. London'. Brass with steel lock and wooden handle.
6¾ inches long, c. 1745–50. Colonial Williamsburg Foundation.

290 A cribbage-board with Rococo detail and decoration. It was given by William Howard to Samuel Long in 1769 and bears the inscription:
Remember You that Play this Game
Pray do not Cheat for Fear of Shame
For if You do this is Your Doome
You Shall be Kick'd out of this Roome.
The room in question was a gaming room.
8¼ inches long, dated 1769. Robin Butler.

291 An adjustable dog-collar, engraved 'George Balch – Bridgwater. 1692'. An early example of a design which changed very little over the next 150 years. In some cases the brass was lined with leather to reduce chafing.
4 inches diameter, 1⅛ inches deep. Roderick Butler.

292 This copper watering-can is a rare survival: hollow-ware items made of sheet as opposed to cast metal had short lives, and most of those which have survived are from archaeological sources. This one was excavated on the site of the Mathews Manor Plantation, which was above Newport News in Warwick County, Virginia, and can be dated to about 1655.
14 inches high, copper, Dutch, c. 1655. Photograph by courtesy of the Colonial Williamsburg Foundation.

293 Copper watering-can with punched or *repoussé* ring decoration on the body. It stands on a circular iron foot which strengthened the base. A rare survival. It is marked 'P.P.A.2.', probably an estate inventory number.
16 inches high, copper, Dutch or French, c. 1790.

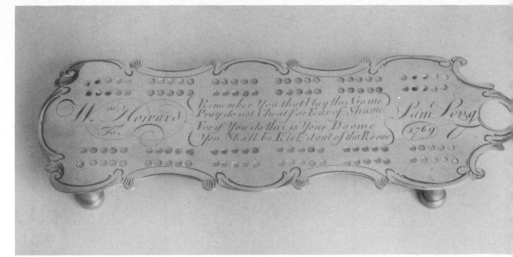

290

291

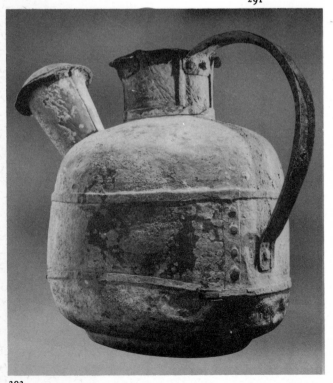

292

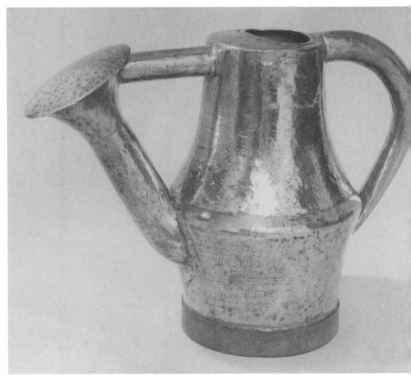

293

294

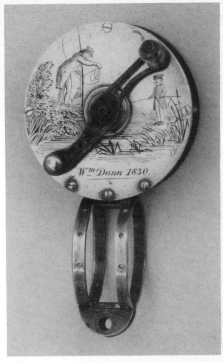

296

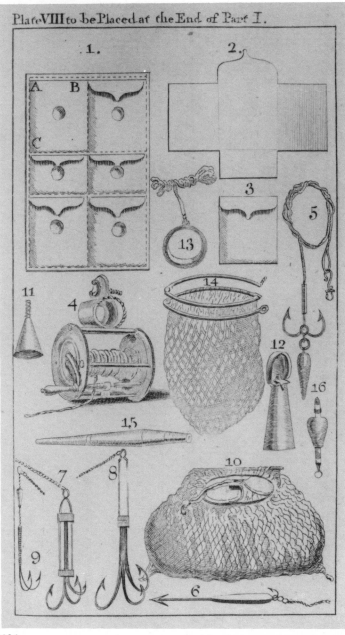

295

294 A late eighteenth-century fishing-reel with drum and shoe of brass, and drum supports of iron. Later reels were made entirely of brass because the iron rusted.
3 inches diameter, c.1770.

295 A page from a late eighteenth-century edition of Isaac Walton's *Compleat Angler* showing a selection of fishing-tackle including a reel similar in design to (294).
9 × 5½ inches.

296 An early nineteenth-century fishing-reel of superb quality, made entirely in brass. It is finely engraved with a scene of a man and a boy fishing, and bears the name of William Dann, the famous Nottingham reel-maker.
3⅝ inches overall, dated 1830.

Ornament and Extravagance

297 Cast watch-stand in Rococo style depicting Old Father Time. Watch stands stood on a dressing-table or by the bed to hold the fob watches worn at that time.
13½ inches high, c. 1765–70.

298 Cast watch-stand, similar to the previous one, but with a definitely pastoral theme. These objects were cast in two pieces and screwed together.
13½ inches high, c. 1765–70.

299 A page from an eighteenth-century pattern book showing designs for watch-stands. All the drawings were actual size, as was customary.
Plate size 19½ × 16 inches. Victoria & Albert Museum.

300, 300a A 'toy' watch which doubled as a snuff-box. The dial is Bilston enamel and the hands are steel. It retains its original silvering.
1⅓ inches diameter, c. 1770.

301, 301a A late eighteenth-century oval box with a double top. The inner lid is an iron nutmeg-grater. This box is the product of two separate processes: the top is of cast and chased metal in the Rococo manner, whereas the sides are made of two strips of stamped metal seamed together at each end.
1½ inches long, copper gilt, c. 1770–5.

302 A fine quality copper-gilt étui or *nécessaire* with belt hook and two coloured stone pomade pots. It contains a fruit knife, *aide-mémoire* and pencil, scissors, bodkin, ruler and snuff spoon. These essential accessories were worn by both ladies and gentlemen.
7¼ inches long overall, copper-gilt, c. 1760.

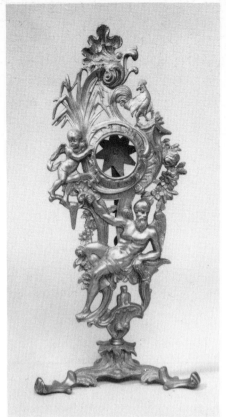

297

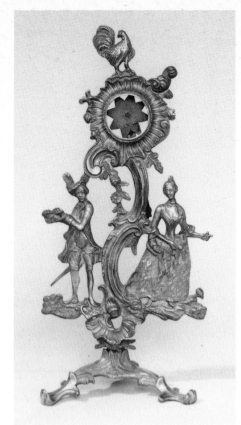

298

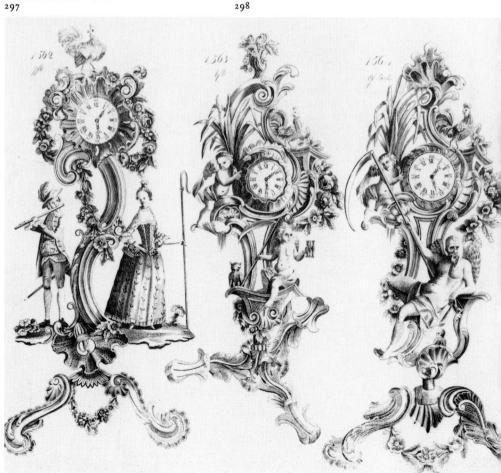

299

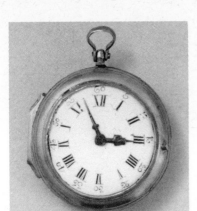

300

300a

301

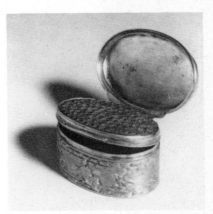

301a

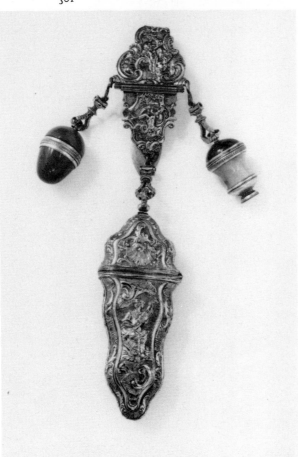

302

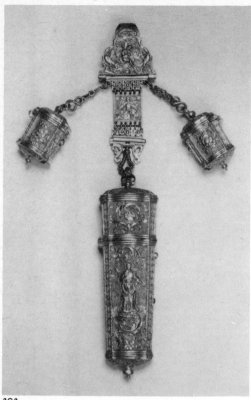

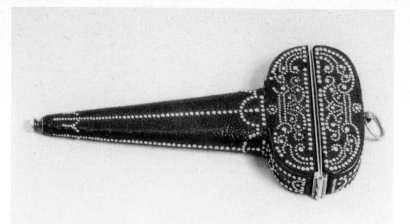

304

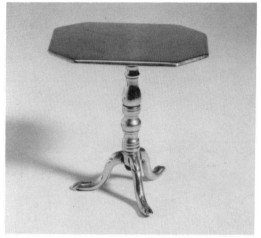

305

303

303 Another copper-gilt étui of more severe design, containing the same set of useful tools. The two little boxes were for comfits or pills. *7 inches long, copper-gilt, c. 1770–5. Edward Nowell.*

304 A scissors-case made of cast brass covered with imitation black shagreen. The piqué decoration is made up of small brass pins. *4 inches long, c. 1685.*

305 A toy table with a tip-up top on a centre pillar with tripod feet. A good example of miniature furniture made for a dolls' house. *3½ inches high, c. 1800.*

306 A miniature George I basket fire-grate for a dolls' house, brass with an iron back. *5⅜ inches high, c. 1720.*

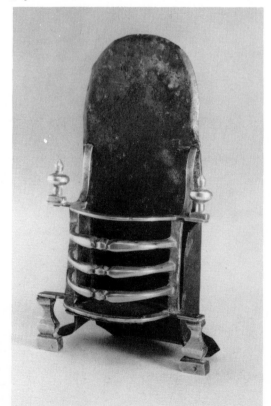

306

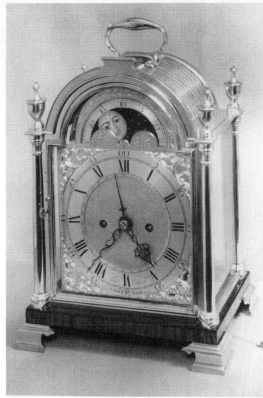

307

308

Clocks and Watches

307 An English eighteenth-century bracket-clock by Ellicott of London, in a gilt brass case with additional ormolu decoration and a white enamel dial.
11¾ *inches high, c. 1760. Aubrey Brocklehurst.*

308 A very fine bracket clock with a case made of brass, most unusual for this style. The four undecorated pillars are surmounted by urns at each corner. It stands on a mahogany plinth with four bracket feet in cast brass. By James Cuthbert of Piccadilly.
13½ *inches high,* 10½ *inches wide,* 6¾ *inches deep, c. 1790–5.*

309 The 'Titus' clock, made by Boulton and Fothergill in 1772 for George III. The case is of chased and gilded brass – the movement was fitted later by B. L. Vulliamy in 1800. Boulton and Fothergill produced a range of clocks with allegorical cases from the early 1770s onwards; this appears to be the only one made entirely of metal. The others were made in a combination of metal and marble or metal and porcelain.
14½ *inches high,* 9 *inches wide,* 5¾ *inches deep, 1772.*

310 A small mantel-clock made up of several sections of cast brass. The base is of wood with applied decoration. The metal has been 'bronzed' – a popular finish of the period.
16½ *inches high, c. 1795–1810.*

311 A fine example of a late sixteenth-century pocket-watch. It is made entirely of brass, including the movement. It is engraved with the maker's name 'Gyles Van Gheele 1591'. Van Gheele was a Dutch watchmaker who is known to have settled in London by 1590.
2 *inches long, dated 1591. London Museum.*

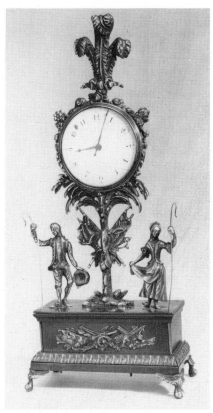

309

310

311

Door Fittings and Locks

312 An early eighteenth-century rim lock entirely bereft of engraved decoration. The various pins and stumps of the mechanism are clearly visible. The striking-plate, which fitted on to the door jamb, is missing.
6 inches long, 3½ inches wide, 1⅛ inches deep, c. 1710.

313 A similar mechanism to (312) but with engraved foliate scroll-work which hides the pins and stumps. The handle and striking-plate are missing.
8½ inches long, c. 1685–1700. Victoria & Albert Museum.

314 A superlative example of an intricate mechanism with ornate case, worked in a combination of steel and brass. The striking-plate forms part of the whole design. The keyhole is hidden by a cherub's head which swings to one side to admit the key. The double dial is a rare feature, and records the action of the lock. Made by Richard Bickford of London.
10 inches long, c. 1685. Victoria & Albert Museum.

315 The engraved foliate decoration is similar to (313) but it also has applied cast brass detail and two sliding bolt handles in the form of crowns. The lower one operates the spring-loaded latch, the other is a small dead-bolt as there is no key. The royal coat of arms of William III is worked into the decoration and the cast *appliqué* shows William and Mary's royal cypher. The striking-plate is missing.
8⅛ inches long, c. 1690. Victoria & Albert Museum.

316 A rare set of lock, key, knob, striking-plate and key escutcheon. Engraved brass cover-plate with applied steel ornamentation. The key is also steel. It is signed 'Philip Harris London Fecit'.
7⅙ inches long, c. 1690. Victoria & Albert Museum.

317 A complete suite of door fittings. Both lock and hinges have cast-brass plates which have been pierced and engraved, and laid over a polished steel back-plate. Also shown is the finely worked steel key. It is signed 'Johannes Wilkes de Birmingham fecit'. See (319).
Lock: 4½ inches long, hinges: 10¾ inches high, c. 1695. Victoria & Albert Museum.

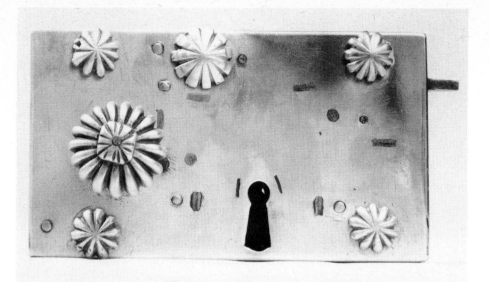

312

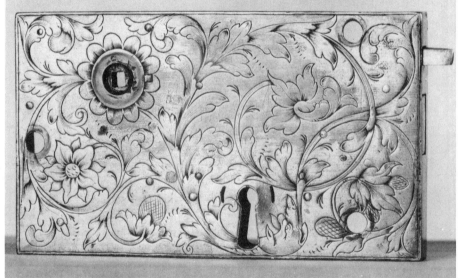

313

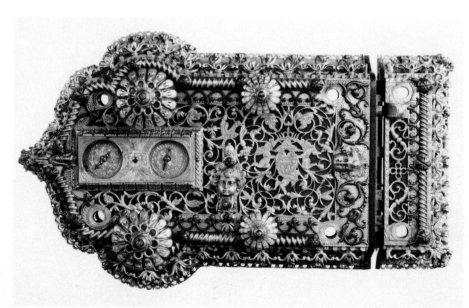

314

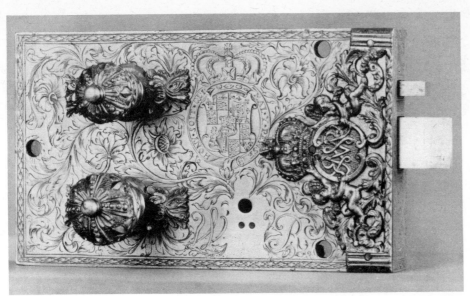

315

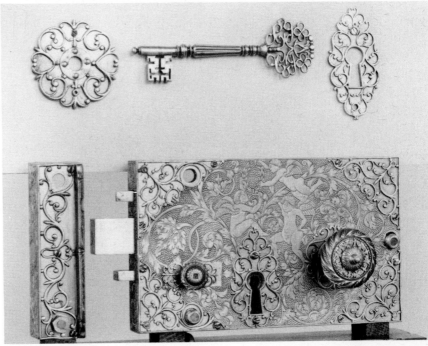

316

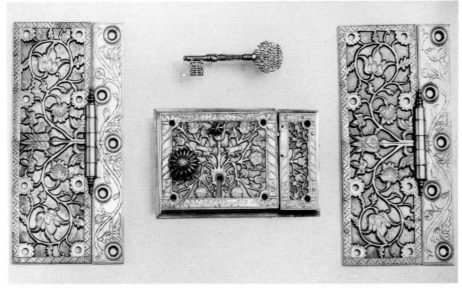

317

318

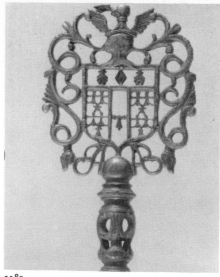

318a

319

320

318, 318a A rim lock of similar mechanism to
(317), and probably from the same workshop,
though unsigned. The pierced and engraved
brass cover-plate is laid over polished steel and
the coat of arms of the Avenant family of
Shelsley Walsh is worked into the design. The
shield hinges down to reveal the keyhole. The
original steel bow key is pierced with the
addition of a cypher 'J.A.' These initials stand
for John Avenant of Kings Norton in
Worcestershire who was living at the time of
Metcalf's visitation of Worcester, 1682–3. It is
very rare to have a lock engraved with the
arms of an un-enobled family.
7½ *inches long overall, c. 1680.*

319 John Wilkes's famous detector lock. A
number of these ingenious mechanisms made by
the celebrated seventeenth-century locksmith
survive in England and Holland. This one is in
brass. A secret catch swings the man's leg
forward to reveal the keyhole and his toe points
to an odd number on the outer ring. The staff,
whose point is missing, indicates an even
number on the inner ring. Every time the key is
turned the dials rotate. The lock bolt is released
by tilting the man's hat. The engraved
inscription reads:
If j had ye gift of tongue
j would declare and do no wrong.
Who ye are ye come by stealth
to impare my Masters welth.
Johannes Wilkes de Birmingham fecit.
6⅛ *inches long, c. 1685. Victoria & Albert*
Museum.

320 Two cast-brass knobs of a type commonly
used with rim locks, and also with escutcheons
similar to (321).
1¾ *and* 2¼ *inches respectively, c. 1680–1720.*

321

322

323

321 Pierced brass door-escutcheon. The two handles are missing. One operated the latch, the other the bolt. It was attached directly on to the door and used with a mortice lock.
5½ inches long, c. 1700–30.

322 A fine escutcheon of cast and chased gilt brass, formerly on a door in Somerset House, London.
6½ inches long, c.1770. Victoria & Albert Museum.

323 A very fine chased and gilded brass door-handle with decorative surround incorporating a mortice lock, from Osterley Park, after a design by Robert Adam. They were supplied in 1766 by 'Mr Birmingham' and were probably made by Matthew Boulton.
7½ inches long, c.1766. Victoria & Albert Museum.

324 An iron spindle with a doorknob at each end, one more decorated than the other. Knobs and spindles were made in different sizes and were used with rim locks and escutcheons. Their basic design changed little over the years.
5 inches long overall, 1⅛ inches diameter knob, c.1680–1720.

325 A late eighteenth-century padlock made of brass, with working parts of iron. The key is original.
3¼ inches long overall, c.1790–1810.

324

325

Furniture Mounts and Handles

326, 326a, 326b A fine late eighteenth-century Dutch three-drawer commode, *bombé*-shaped and veneered in tulipwood. Original English-made handles and mounts. The ram's-head corner mounts are not uncommon on fine English commodes but handles with a centre design of a head in profile were a feature much in fashion in Holland at that time and were rarely if ever used on furniture for the English domestic market.
Handles: 6 inches, c. 1780.

327 Plate from a contemporary English brass-founder's pattern book showing an almost identical handle, but without the central medallion profile.
Plate size: 19½ × 14½ inches, c. 1780–95.
Victoria & Albert Museum.

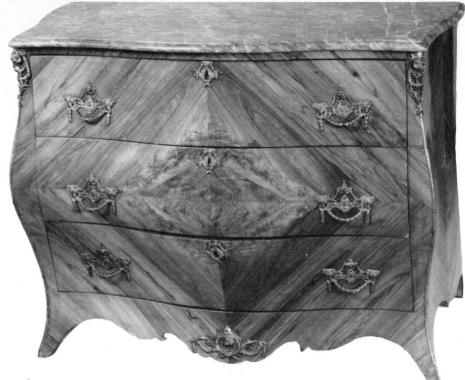

326

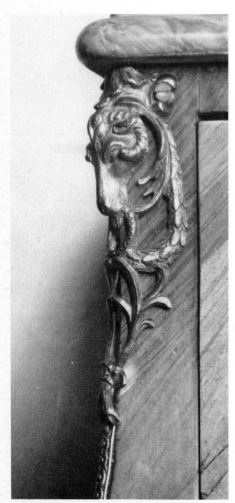

326a

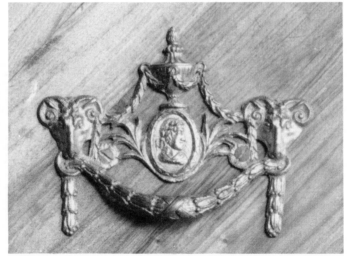

326b

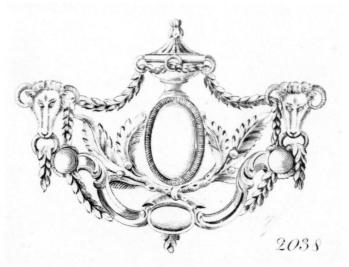

327

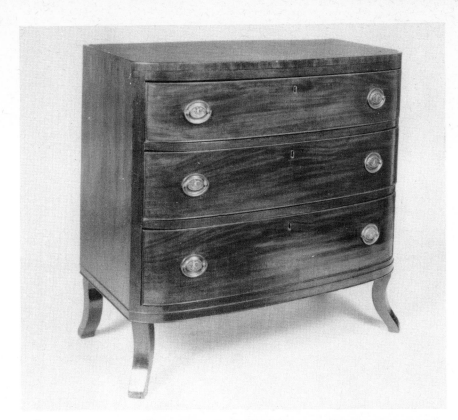

328, 328a An early nineteenth-century mahogany bow-fronted chest of three drawers. The stamped brass handles are the original ones, made for the American market. They depict the American eagle and stars of the 'Old Thirteen'. *Handle: 2⅞ inches wide, c. 1790.*

329 A plate from an English brass-founder's pattern book showing handles of similar shape and design, but later than those on (328) as the number of stars has increased to fifteen. *Plate size: 10½ × 8 inches, c. 1790. Victoria & Albert Museum.*

330 Two wall fittings for hanging cloaks or hats. The oval one, with anthemion decoration, is late eighteenth-century, the lower one is Rococo in taste and dates from some twenty-five years earlier. These pins were also used as decorative supports for mirrors. The mirrors were hung by a cord and tilted out from the wall to avoid too much direct reflection of light. *2⅜ and 2⅝ inches respectively, c. 1755–80.*

328

328a

329

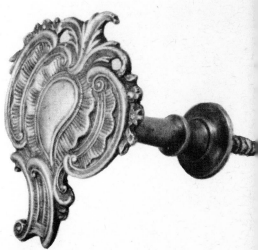
330

House Bells and Tea Bells

331 Pale Bell Metal handbell with turned decoration, wooden handle, and scalloped edges.
5 inches high, Bell Metal, c. 1760.

332 A slightly more refined version of the same design, unusual in that it has a brass handle instead of the usual wooden one.
5¼ inches high, c. 1770.

333 Plain rimmed bell with lathe-turned decoration and flattened top to the bell – an early nineteenth-century feature. The wooden handle is also finely turned.
5 inches high, c. 1810.

334 Wall bell, one of a set from a pantry passage. A system of wires and bell cranks ran under the floorboards connecting the bells to individual rooms. The bell is attached to a coiled spring, joined to a vertical bar which swivels through its centre. These bell systems were very efficient and often did not have to be replaced by electricity until well into the twentieth century.
9 inches high, c. 1800. William Cook.

335 A classic S-shaped doorknocker and rap of a type used in England and exported to America throughout most of the eighteenth century.
7 inches long, c. 1780.

336 Illustration from a late eighteenth-century pattern book showing designs very similar to (335).
Plate size: 10 × 7½ inches, c. 1730–80. Winterthur Museum.

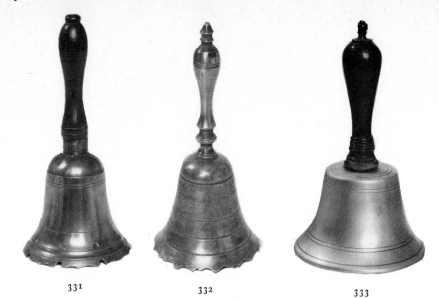

331 332 333

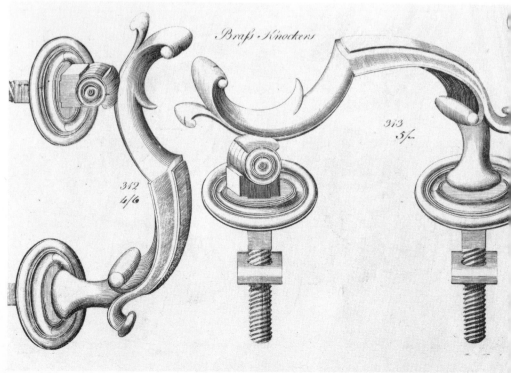

334

335

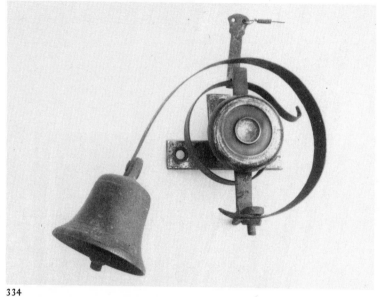

336

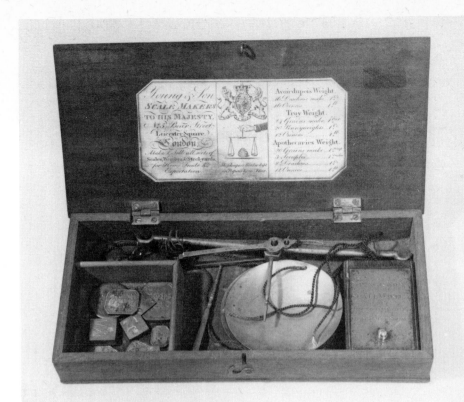

337

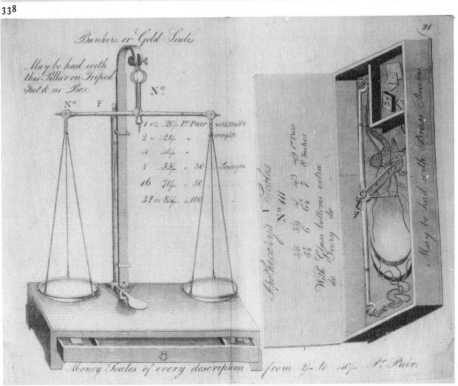

338

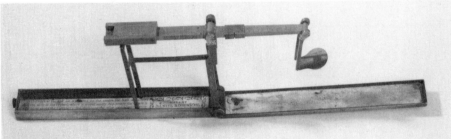

Scales and Weights

·337 Set of portable scales in a mahogany box, with engraved plate: 'Young and Son. Scale Makers to His Majesty. No. 5. Bear Street, Leicester Square, London'.
7⅞ inches long, c. 1790.

338 Conventional set of pocket 'sovereign scales' for checking coin-weight. This pair is unusual for its brass case, generally made in mahogany. The maker, 'Daniel Robinson of Prescot, Lancashire', died in 1823 aged twenty-four.
9¾ inches long open, 5 inches long closed, c. 1820.

339 Plate from an early nineteenth-century pattern book of Bourne's of Birmingham, the famous scale-makers, showing two sets of scales, one for the money trade, the other for apothecaries.
Plate size: 9½ × 8 inches, dated 1809.

340 Two sets of Bell Metal cup weights, so called because they fit into each other. Weights had to be passed by the Founders' Company as correct. These are proof-marked and are troy weight.
2¼ inches and 1½ inches respectively, Bell Metal, c. 1790.

339

340

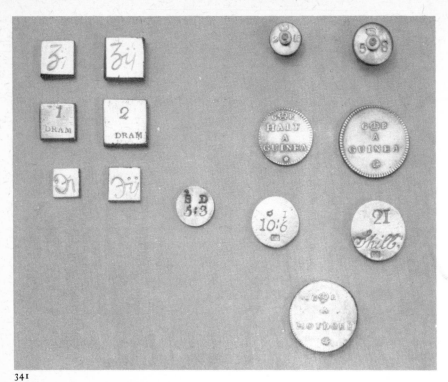

341

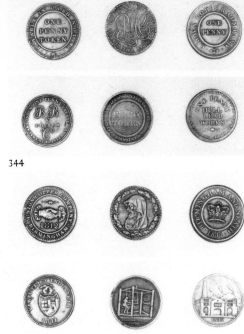

344

344a

342

343

341 A selection of brass scale-weights. The square ones are apothecaries' weights in drams and scruples. Those on the right are check weights for one guinea, half a guinea and a quarter guinea. At the bottom is a check weight for a gold moidore, a Portuguese coin equivalent to 27 shillings in 1790. The weight of one guinea coin was 5 pennyweight and 8 grams. *Guinea: 1-inch diameter, c. 1795.*

342 Trade card of James Roberts of Liverpool. Such merchants made regular visits to the provincial towns to acquire their merchandise on commission for foreign clients. Among the many services offered, he not only bought, but packed, insured and shipped merchandise as well. The Liverpool Directory of 1790 gives his address as 7 Clayton Square, Liverpool. *2½ × 3¾ inches, c. 1790. Victoria & Albert Museum.*

343 A set of proof copper coins in a presentation case covered in imitation shagreen. There is a twopenny 'cartwheel', a penny, a halfpenny and a farthing. Each bears the stamp 'SOHO'. Made by Matthew Boulton at his Soho factory, Birmingham, in 1797, the year that the Treasury placed him under contract. *Length of case: 6 inches, c. 1797. Hotspur Ltd.*

344, 344a A small selection of copper 'Trade Tokens' dated from 1788 to 1812. These particular ones were issued by Midland and Welsh metal companies, but in the 1780s most industrial companies were producing tokens to supplement the meagre supply of small change being minted at that time. *Largest token: 1⅜ inches diameter. Dated 1788–1812.*

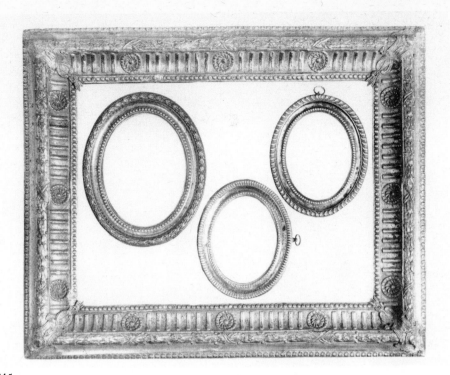

345

Stamped Brass Frames

345 Four stamped frames in thin sheet metal. The oval ones were stamped out of a single piece of metal, but the square and rectangular frames were mitred and a decorative piece added to hide the join. The brass sheathing covered a wooden frame identical in cross-section. The large rectangular frame is a rare survival.
18½ × 15 inches, oval frames 7, 5½ and 5½ inches respectively, c.1785.

346 A page from a contemporary pattern book illustrating similar frames and giving their prices. There was a very large market for these decorative objects, since the ordinary household could rarely afford the equivalent in carved and gilded wood.
Plate size: 15 × 13 inches, c.1790. Victoria & Albert Museum.

347 The frame and mount of this one have been stamped in one piece, and still hold the original mezzotint.
5⅜ inches high, 4¼ inches wide, c.1790.

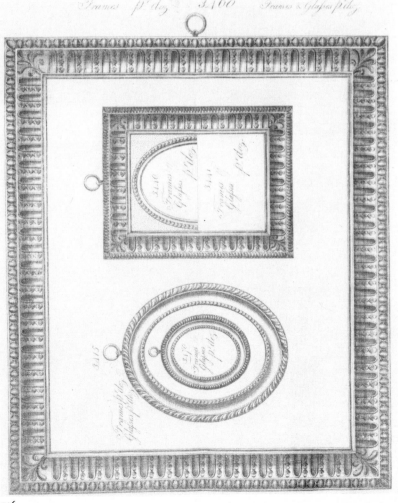

346

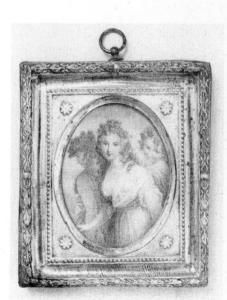

347

Brass and the Hereafter

Coffin Plates and Mounts

348 A late seventeenth-century invitation to a funeral, showing four stages of the ritual: the lying in state in the house, the church service, the wake, and the committal. It was common practice to send such invitations from the seventeenth century right through to the nineteenth century.
9 × 7½ inches, dated 1677. Bodleian Library.

349 Brass breast-plate from the coffin of Henricus Drax, recovered from the site of St John Zachary, Noble Street, City of London, when the site was cleared in 1960. The church itself was destroyed in the Fire of London in 1666 and never rebuilt.
6 × 7½ inches, dated 1653. City of London Guildhall Museum.

350 A late seventeenth-century copper breast-plate from the coffin of Sir Joseph Hearne MP, who died leaving a large family. The method of inscribing is unusual. The plate came from the church of St Stephen Coleman, Coleman Street, City of London, which was bombed in 1940.
10⅞ × 8¾ inches, dated 1699. City of London Guildhall Museum.

348

349

350

351

351 Copper breast-plate from the coffin of Robert Knight, who died in 1744. It is typical of such plates in brass or copper. The armorial cartouche is Rococo in style, but at its base is the traditional cherub's head with wings folded beneath the chin in sad supplication. The plate is from the Church of St Mildred, Bread Street, City of London, finally destroyed by bombs in 1940 after having been burnt down in the Great Fire of London and rebuilt in 1687.
$16\frac{1}{2} \times 12\frac{5}{8}$ *inches, dated 1744. City of London Guildhall Museum.*

354

352

352 A double page from a coffin-fitting maker's pattern book showing details of lettering and design with Carolean flower motif, and listing the items to be obtained in a 'set' of coffin furniture. Possibly the date 1783 is the year of the production of the book, although the cover of the book bears a label 'Tuesly & Cooper. Coffin Furniture and Ironmongery. No. 221. Borough St. London. 1799'.
$13\frac{1}{2} \times 10\frac{1}{2}$ *inches (open), c. 1780–1800. Victoria & Albert Museum.*

353 Trade card of William Westcar of Bister, furnisher of all the trappings of funeral and procession, including 'escutcheons' and armorial 'atchievements' which could be hired for the occasion. Wooden escutcheons bearing the coats of arms of the deceased were hung over the choir-stalls in the church after the burial for a designated period of time.
$8\frac{1}{4} \times 6\frac{1}{4}$ *inches, c. 1740–70.*

354 Brass plate of the wife of John Michell, Gent., placed in the flagstones of the church and 'desired by ye deceased never to be removed'.
$14\frac{1}{2} \times 10$ *inches, dated 1705. By kind permission of the Rector & Church Wardens, St Peter's Church, Milton Lilbourne, Wiltshire.*

353

355 Another funeral invitation to 'accompany the corps of Mr James Duncomb' from the Royal Oak to the church of St Mary Magdalen in Bermondsey. The bottom frieze of the funeral procession is almost identical with (353). 7½ × 6⅛ inches, dated 1768. Bodleian Library.

356, 356a These two back-plates for carrying-handles are very rare survivals. London coffin-makers did not often use back-plates, and the coffins may have come from the provinces to be interred in London. Both of these are stamped metal, dating them in the 1770s. The one on the left is high Rococo, but the one on the right is in traditional seventeenth-century style, although it was made much later. Taken from St Bride's Church, Fleet Street, London. 11 and 9¾ inches wide respectively, c. 1775–90. By kind permission of the Rector and Church Wardens of St Bride's Church.

355

356

356a

357 A late seventeenth-century burial form certifying that Gerard Higginbotham of Priestbury in Chester was duly buried on 23 September 1695 without being 'wrapt or wound up, or Buried in any Shirt, Shift, Sheet or Shroud, made or mingled with Flax, Hemp, Silk, Hair, Gold or Silver . . . but Sheeps Wooll only'. The skeletal grave-digger and well-shrouded and trussed cadaver seem strangely jocular for an official form implementing the Flannel Act, which was passed in the reign of Charles II to promote the flagging sales of wool. The 'Act of Burying in Woollen' decreed that all dead bodies should be buried in woollen shrouds only – and the Act stayed on the statute book, if not in force, for 120 years. 9¾ × 7½ inches. Paul Grinke.

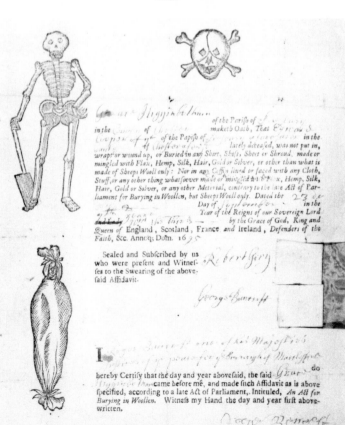

357

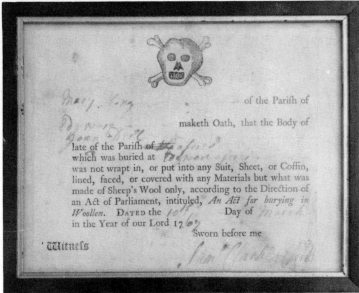

358

359

360

361

362

358 A mid-eighteenth-century burial form declaring that the body of Joan Dell was wrapped in 'wool only' before commitment to the ground.
$6\frac{7}{8} \times 5\frac{3}{8}$ *inches, dated 1767.*

359 A brass breast-plate for Jane Holden. Her husband died in 1740 aged sixty-five and they were interred side by side. It has a finely engraved coat of arms in an imaginative cartouche in Rococo style. From St Bride's Church, Fleet Street, London.
$17\frac{1}{8} \times 13\frac{1}{8}$ *inches, dated 1766. By kind permission of the Rector and Church Wardens of St Bride's Church.*

360 A brass breast-plate from the coffin of John Jollife, dated 1771. It has bold *repoussé* decoration on thick-gauge metal: with the advent of the stamping process this type of plate could be produced in quantities much more cheaply. From St Bride's Church, Fleet Street, London.
$13 \times 9\frac{1}{2}$ *inches, dated 1771. By kind permission of the Rector and Church Wardens of St Bride's Church.*

361 A strip of 'nail lace' in tinned lead or 'white metal', used for edging the outside of the coffin, or inside to hold the cloth lining to the wooden box.
$1\frac{1}{4}$ *inches wide, c. 1780–1810.*

362 Gabriel Aughtie's patented design for a coffin to baulk the efforts of body-snatchers.
Dated 1796. Patent Office. Patent No. 2128. Reproduced by permission of the Controller of H.M. Stationery Office.

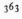

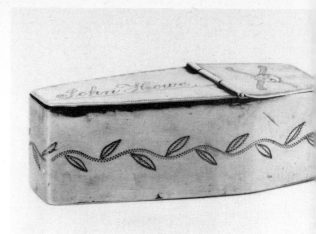

363

the houses in the bottom of red Lyon street, in the parish of S. Geo. martyr were built 1690 by arthur Tooly who built S. Geo. ch.

A Group of Coffins in the Pest house yard.

366

363 Drawing from a sketchbook of William Stukely's, dated 1722, showing a group of coffins in a pest-house yard.
Professor Frank Sommer.

364 Late eighteenth-century friendly society poleheads carried by members at their annual festivities. This collection comes mainly from the West Country, where friendly societies were a strong and important feature in the life of the rural working people. Friendly societies provided companionship, help in sickness, and a decent burial.
Central polehead: 23 inches high, c. 1770–1850.
Christie, Manson & Woods.

365 Page from a late eighteenth-century pattern book showing two coffin handles and a doorknocker, made in iron or brass. The interesting point about the illustrations is the discrepancy in style between the doorknocker, which is typically late eighteenth-century neo-classical in style, and the coffin handles. At first glance these would seem to be definitely seventeenth-century in design, and they show clearly how little the style changed for over a century. The cherub's head motif was used right up to the Gothic Revival in the 1820s.
9¾ × 6½ inches, c. 1780. Winterthur Museum.

366 Tobacco-box in the shape of a coffin with skull and crossbones and the name 'John Howe' on the lid. Although the owner may well have been an undertaker, the box is inscribed 'Not Dead Yet' on the base. The wriggle-work decoration is unusual on brass, which was more usually bright-cut. Wriggle-work is more common on softer metals, such as pewter.
4¼ inches long, 1¼ inches high, c. 1800. Professor Frank Sommer.

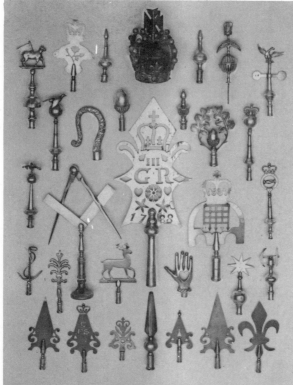

364

365